Interpreting rock movies :
the pop film and its critics in
Britain

by Andrew Caine

Interpreting
rock movies

Published in our
centenary year
≈ **2004** ✎
MANCHESTER
UNIVERSITY
PRESS

Inside Popular Film

General editors Mark Jancovich and Eric Schaefer

Inside Popular Film is a forum for writers who are working to develop new ways of analysing popular film. Each book offers a critical introduction to existing debates while also exploring new approaches. In general, the books give historically informed accounts of popular film, which present this area as altogether more complex than is commonly suggested by established film theories.

Developments over the past decade have led to a broader understanding of film, which moves beyond the traditional oppositions between high and low culture, popular and avant-garde. The analysis of film has also moved beyond a concentration on the textual forms of films, to include an analysis of both the social situations within which films are consumed by audiences, and the relationship between film and other popular forms. The series therefore addresses issues such as the complex intertextual systems that link film, literature, art and music, as well as the production and consumption of film through a variety of hybrid media, including video, cable and satellite.

The authors take interdisciplinary approaches, which bring together a variety of theoretical and critical debates that have developed in film, media and cultural studies. They neither embrace nor condemn popular film, but explore specific forms and genres within the contexts of their production and consumption.

Already published:

Interpreting rock movies

The pop film and its critics in Britain

Andrew Caine

Manchester University Press

Manchester and New York

distributed exclusively in the USA by Palgrave

Published by Manchester University Press
Oxford Road, Manchester M13 9NR, UK
and Room 400, 175 Fifth Avenue, New York, NY 10010, USA
www.manchesteruniversitypress.co.uk

Distributed exclusively in the USA by
Palgrave, 175 Fifth Avenue, New York,
NY 10010, USA

Distributed exclusively in Canada by
UBC Press, University of British Columbia, 2029 West Mall,
Vancouver, BC, Canada V6T 1Z2

British Library Cataloguing-in-Publication Data
A catalogue record for this book is available from the British Library

Library of Congress Cataloging-in-Publication Data applied for

ISBN 0 7190 6538 0 *hardback*
EAN 978 0 7190 6538 5

First published 2004

13 12 11 10 09 08 07 06 05 04 10 9 8 7 6 5 4 3 2 1

Typeset in Sabon with Frutiger
by Northern Phototypesetting Co. Ltd, Bolton

Printed in Great Britain
by Bell & Bain Ltd, Glasgow

Contents

List of illustrations

Preface and acknowledgements

I would like to thank the following people who have helped during the process of researching and writing this book: John Hartley, Roberta Pearson, Mark Jancovich and John Tulloch. Additionally I gratefully acknowledge the help from various staff at the publishers during the completion of the book. More generally, I would like to thank my former colleagues and students at Cardiff and the University of Sunderland for their assistance, while Rakesh Kaushal has offered unflinching support. Finally, I would like to dedicate the book to my family for their efforts and encouragement over many years.

Several sections of this book have been previously published elsewhere and appear here in slightly revised form. Much of chapter 3 first appeared in my article, 'Calculated Violence and Viciousness: The British Critical Reaction to Elvis Presley's *King Creole*', *Velvet Light Trap* 48 (Fall 2001). The material on Cliff Richard and the AIP beach movies originally appeared in the *Journal of Popular British Cinema*, issue 4 (2001) and *Scope* (December 2001) respectively. Those seeking the original articles should consult: '"The best teenage romp ever!": Cliff Richard and the construction of a British teenage identity, 1959–63' (Trowbridge: Flicks Books, 2001) and 'The AIP Beach Movies – Cult Films Depicting Subcultural Activities' (accessible via the *Scope* archives at www.nottingham.ac.uk/film). I gratefully acknowledge the University of Texas Press, Flicks Books and *Scope* for granting permission to republish the material in this book.

With regard to the illustrations featured throughout the text, every effort has been made to contact the copyright holders of this material. Should the holders of the copyright contact MUP, the publishers will acknowledge them in any subsequent edition of the book. The original source of publication is contained in the list of illustrations.

List of abbreviations

AIP	American International Pictures
BBC	British Broadcasting Corporation
BFI	British Film Institute
IPC	Independent Publishing Corporation
ITV	Independent Television
MGM	Metro Goldwyn Mayer
NME	*New Musical Express*

Introduction

In second-hand record stores across Britain it has become relatively easy to find old 7-inch singles. This format arguably represented the classic medium for pop expression, while capturing a sense of time and place. Examination of an original copy of the Cliff Richard single 'The Young Ones' reveals that the track originated 'from the A.B.P.C film of the same name'. Such information hints that popular music and cinema, aimed at the youth market, were often interconnected throughout the 1950s and 1960s.

This assumption partly results from my own first acquaintance with the pop films of this era. As I was born in 1973 I am fifteen years too young to have seen such movies at the time of their release. However, my first awareness of the music and the stars of these productions demonstrates how their films became part of our collective understanding of these artists. My initial consciousness of the Beatles and Elvis Presley emerged through hearing my mother's soundtrack albums of *A Hard Day's Night* (1964) and *G. I. Blues* (1960) respectively. I knew these artists as musical icons, but the record sleeves and television showings revealed their status as movie stars. Why else did the BBC show *Help!* (1965) as part of its tribute to John Lennon after his murder in 1980?

The above information reveals that the films made by pop stars during the 1950s and 1960s played a vital part in cementing their popular reputations. This book concerns the interconnections between cinema and two other media forms, popular music and the press, by exploring rock movies between 1955 and 1965. These products starred figures primarily renowned for music, not acting, and also contain significance for the attention they received from contemporary press commentators. Through examining the critical

and journalistic reaction towards rock'n'roll/pop movies today's scholars can obtain insights into not only contemporary debates surrounding the films, but also information about the wider social and cultural function of cinema. *Interpreting rock movies* details how and why critics received pop films in particular ways upon their release, linking the original discourses about the films to historical trends evident at the time. The book locates the discussion around particular issues including Americanisation, the emergence of a teenage consumer identity, the impact of rock'n'roll music, fears over juvenile delinquency, the role of young women as the moral guardians of teenage society, debates over high and low culture and the changing shape of the film industries in Britain and Hollywood.

Why begin this study in 1955 and conclude ten years later? The former date saw the release of the first film to feature rock'n'roll, when Bill Haley and his Comets performed 'Rock Around the Clock' over the credit sequence of the juvenile delinquent melodrama, *Blackboard Jungle*. This success led to a series of American rock movies throughout the mid-to-late 1950s, including *Rock Around the Clock* (1956) and *Jailhouse Rock* (1957). Such films took the association between rock'n'roll music and youth culture, evident in *Blackboard Jungle*, even further by featuring leading rock acts, such as Haley and Presley, in dramatic and musical roles. Symbolically 1955 saw the cinematic emergence and actual death of James Dean, shortly to await anointment as the patron saint of teenagers never to grow old. By 1965 the first burst of pop musicals had clearly run out of steam. The initial spurt of American films, linking popular music and youth culture, effectively ended with the multi-Oscar-winning success of *West Side Story* (1961), which confirmed the significance of movies dealing with young people as a major force in Hollywood. Although the mid-1960s saw AIP's beach movie cycle, UK pop stars and Elvis Presley dominated the British youth market between 1960 and 1965. However, the British pop film reached its commercial zenith with Cliff Richard's *The Young Ones* (1961) and *Summer Holiday* (1962) and the Beatles' *A Hard Day's Night* and *Help!*. Unlike its American equivalent, the British pop film primarily belonged to the 1960s rather than the 1950s. Yet, as chapter 6 indicates, by 1965 the British pop musical faced terminal decline. The emergence of musicians whose artistic sensibilities could not be confined within light entertainment, the importance of

television and the changing tastes of young people effectively killed this area of British cinema after 1965. As Andy Medhurst writes, about this type of production, from the mid-1960s onwards 'British pop and cinema ceased to interrelate in any sustainedly meaningful way'.[1] Before explaining the book's outline, it becomes necessary to provide some general statements about the pop film in terms of generic classification.

Defining the pop film

The pop film is a difficult concept to define. Terms such as teenpic, teen movie, rock movie and pop musical are loaded with contradictions: at various points within the book all of these classifications are used. Thomas Doherty's book *Teenagers and Teenpics: The Juvenilization of American Movies in the 1950s*, originally published in 1988 and reissued with revisions in 2002, remains the best book on the subject. It offers an impressive account of the various forces behind the development of the American teenpic during the 1950s. Concentrating upon a mixture of contemporary documentary evidence and textual readings, he divides the teen film into various categories, including 'clean teen', 'juvenile delinquent', 'rock'n'roll' and 'weirdie'. This provides the basis for extensive arguments concerning the main features of the teenpic, particularly emphasising individual films' cultural and social significance at the time of their release.

Doherty stresses that teenpics must respect the values of young people, offering some semblance of identification between the film text and its teenage audience. Even 'imperial' teenpics, which adopt a rather patronising attitude towards rock'n'roll, need to provide some opportunity for empathy between the film text and its young audience. For example, Frank Tashlin's *The Girl Can't Help It* (1956) contains a 'smugly condescending and simply misinformed' attitude towards youth culture, despite the presence of rock'n'roll icons Little Richard, Gene Vincent and Eddie Cochran.[2] Doherty also refers to the 'indigenous' teen movie product that accepts youth culture unequivocally without the need for explanation. Although writing about *Jailhouse Rock*, Doherty's comments also apply to many other films featured in this book including *Summer Holiday* and *A Hard Day's Night*. Such films through their 'narrative content and visual presentation' not only 'recognise teenage subculture',

but also indicate 'the inside knowledge and tacit respect that is the hallmark of the informed observer'.[3] In this context, Doherty suggests:

> What happens in front of the screen is as important as what happens on it. A purely narrative reading of the rock'n'roll musical, or even an appreciation of the rock'n'roll performances, misses its subcultural function as a ritual occasion for the congregation. Teenpics foster public demonstrations of teenage presence, identity, and solidarity. They provide an explicit recognition that lends a degree of implicit validation to teenagers as a subcultural group. Through the simple appearance of a teenpic at a downtown venue, the parent culture validates and reinforces, in own citadel, the teenage subculture. Whether the teenpic's affinities lean toward parent culture or teenage subculture, the prime subcultural value – legitimacy – has already been conferred by the product itself.[4]

Despite its strengths, Doherty's book is not directly applicable to a British context. First, he locates the 1950s teenpic within the framework of exploitation cinema. Such productions appealed through sensationalism, exhibiting 'controversial, bizarre, or timely subject matter amenable to wild promotion'. Second, the classic 1950s teen movie, based on the American Independent Pictures (AIP) model, was often made on 'a substandard budget' with rudimentary production values. Third, the emergence of films aimed directly at the youth market coincided with an upsurge of interest among a curious teenage audience eagerly embracing such cinematic ventures.[5] These reasons also serve as Doherty's key framework for his study of the 1950s American teen movie as a genre. For example, *I Was a Teenage Werewolf* (1957) not only facilitated AIP's growth as one of the leading independent film companies, but also typified the three processes involved with 'teenpic exploitation'.[6]

However, whether the pop film fits within Doherty's exploitation framework is questionable. Many early rock'n'roll films were designed to capitalise upon current musical tastes via cheaply produced films made in ultra-quick time to meet immediate demand. For example, Sam Katzman, the brains behind *Rock Around the Clock*, had long experience of producing topical 'B'-movies at Monogram and Columbia on low budgets. For example, he completed a Korean War offering entitled *A Yank in Korea* (1950) less than seven weeks after hearing about the outbreak of the conflict.[7] This strategy of capitalising upon the latest trends stood Katzman at

Columbia in good stead with *Rock Around the Clock* and its sequel *Don't Knock the Rock* (1956). Their success encouraged small independents, such as AIP and Vanguard, with their rock'n'roll offerings, typified by *Shake, Rattle and Rock* and *Rock, Rock, Rock* (both 1956), to replicate this situation.

Although the likes of *Jailhouse Rock, A Hard Day's Night* and *Summer Holiday* were exploitation films, in their status as commercial vehicles for pop performers, they were not cheaply produced 'B'-movies. Elvis Presley and Cliff Richard were among the most successful film stars in America and Britain respectively during the early 1960s, consistently among the biggest box-office hits during this period. Presley worked for such renowned producers and directors as Hal Wallis, Michael Curtiz, Jerry Wald and George Sidney: hardly the record of an exploitation movie star. Therefore to automatically place the pop film within this mode of production is too simplistic.

The second reason why Doherty's work requires caution when dealing with teen movies in Britain lies with his treatment of non-deviant youth culture. His description of the 'clean teens' is one of the original sections of *Teenagers and Teenpics*, containing useful observations about such figures as Pat Boone and Fabian. This information emphasises the importance of mediated, non-delinquent youth culture in any survey of the pop film. Typified by the likes of Boone and, in Britain, Cliff Richard, the 'clean teenpics' concentrated upon a middle-class teenage world, largely free of serious confrontation with parent culture. Doherty writes that, 'Their real focus was the self-contained world of the teenager, where adults were sometimes inconvenient but more often peripheral or superfluous. The teenage crisis is typical peer-group puppy love, not parental pressure.'[8] The key cinematic inspiration for such films lay with MGM's Mickey Rooney-Judy Garland cycle of the late 1930s and early 1940s. John Mundy claims that the 'young people putting on a show theme' of *The Young Ones* 'unashamedly borrowed' from the earlier backstage musicals of Garland and Rooney.[9]

More than any other form of the teen movie, the 'clean teenpic' is aimed at the family audience. Significantly the present-day equivalents of Sandra Dee's *Gidget* (1959) and *The Young Ones*, such as *Clueless* (1995) or *10 Things I Hate About You* (1999), benefit from a '12' certificate designed to attract younger teenagers without alienating parents. From the 1950s, such films have proved that the

teenage audience is not monolithic – the middle-class, female-centred, non-deviant world of the 'clean teenpic' complements the vision of youth culture presented in juvenile delinquent or horror movies. Since the late 1950s, the 'clean teenpic''s emphasis upon staples such as love, romance and dating has presented the ideal vision of youth culture for publications seeking to appease fans and anxious parents.

Despite revealing valuable information about the 'clean teenpics', Doherty's argument appears reluctant to acknowledge the importance of mediation with parent culture within the pop film. He derides the fact that clean teen idols, typified by Fabian, owed their success to the younger audiences, namely the under-16s, but as chapter 5 reveals, the concentration upon values such as dating, romance and clean-cut teenagers helped to legitimise teenage culture in Britain. Under these circumstances, it seems rather patronising for Doherty to claim that 'the clean teen phenomenon was a quite literal product of the parent culture fabricated from above, peddled down below'.[10]

In a critique of Doherty's work, James Hay claims that even the 1950s teenpics never contained a fully 'autonomous' status. As a 'rites-of-passage' or coming-of-age genre, teen movies often involved an attempt to acknowledge youth culture inside the wider parameters of adult society. He writes that films aimed at the teenage clientele regularly:

> Involve narrative conflict both over finding one's place within a relatively autonomous society of youths and over defining, negotiating and resisting differences between youth and adulthood. In the sense that teenpics were given to modelling conflict in this manner and through generic conventions that also deterritorialized and reterritorialized the conventions of traditional Hollywood genres, they can be said to define doubly the relation of 'the minor' to a 'parent culture'.[11]

Hay's concentration upon the importance of teenage life as a mediated and negotiated culture has particular relevance for the examination of teen movies in a British context. The idea of a British pop film, separate from the wider confines of family entertainment, did not exist at the time. Stars operated within the confines of traditional show business. For this reason, I refer to the British pop musical as a sub-genre, never fully autonomous from the conventions of light entertainment. In the early 1960s no one saw any contradiction in producing an annual with youth-orientated stars, such as Cliff

Richard and Adam Faith, that also offered Vera Lynn for the older generation.[12] British entertainment writers believed in a world of continuity between traditional show business and young stars. A separate youth culture threatened cosy assumptions, such as those articulated by the same 1960 publication that placed Vera Lynn and Cliff Richard side by side: 'Many of the stars whose likenesses appear in it, will be remembered nostalgically by our middle-aged readers, but equally we know many will also be teen-age favourites, and in the years to come they too will have their place in the annals of entertainment alongside the stars and idols of a new generation of teen-agers.'[13]

The British pop film has also attracted academic attention. K. J. Donnelly's *Pop Music in British Cinema*, which explores the relationship between popular music and the movies since the 1950s, provides the most notable contribution. Donnelly provides some interesting insights, especially with regard to the low cultural status of the pop film within the context of contemporary British production. He rightly suggests that:

> The prestige stratum of British film production was not concerned with representing teenagers in Britain and making films for their consumption, but was geared towards critical respectability and the possibility of international success through gaining distribution in the lucrative American market. Films that used pop music originated in a very different mode of film production, an area that was home to films that were produced quickly and cheaply, often in order to fill out exhibition programmes, rather than as mainstream blockbuster films.[14]

Despite the validity of such information, Donnelly does not provide much data into how and why this situation existed. He rightly distinguishes the pop film from blockbuster productions, but he also underestimates the mainstream status of the Cliff and Beatles ventures. Moreover his book shows little concern about why critics often disliked the pop film and ignores the music press almost entirely.

Other useful contributions include Robert Murphy's *Sixties British Cinema*, which offers an interesting chapter on British youth films made during the 1960s, and Andy Medhurst's chapter in the BFI anthology *Celluloid Jukebox*. Murphy's work remains a comprehensive account of British cinema during the decade containing insights into the numerous strands of the film industry. Writing on the Beatles' films, Bob Neaverson's work provides textual analysis

together with a detailed examination of the movies' origins of pro-
duction. Like Donnelly, Neaverson stresses the importance of
cinema as providing an important role in the career development of
British pop performers. Although well-researched, the work of Don-
nelly and Neaverson avoids mentioning the social meaning of such
musical ventures for original viewers of these movies. Neither writer
examines the connection between the British pop musical and its
place within teenage fan culture, meaning that the definitive study of
the British pop movie during the 1950s and 1960s along the lines of
Doherty's work has not yet been written.[15]

Genre and the pop film

The above information on family entertainment complicates
attempts to analyse the pop film within the framework of genre stud-
ies. Although rock'n'roll musicals should not be divorced from the
teenpic, this type of production also represented a generic hybrid.
Presley's screen output demonstrates this generic variety: he starred
in westerns (*Love Me Tender* (1956), *Flaming Star* (1960)), melo-
dramas (*Wild in the Country* (1961)), comedies (*Viva Las Vegas*
(1964)), romances (*Blue Hawaii* (1961)) and juvenile delinquent
films (*Jailhouse Rock*, *King Creole* (1958)). This supports Steve
Neale's assumption that many films involve some degree of 'overlap'
between various genres.[16] As Doherty points out in his discussion of
King Creole, this film 'is at once a star vehicle for Elvis Presley, a
musical, an urban crime drama, a familial melodrama, and (stretch-
ing things only slightly) a signature film noir of director Michael
Curtiz'.[17] Therefore the pop film constitutes the definitive hybrid
form of production.

This situation is complicated by other factors concerning genre.
First, not all musicals about young people are pop films. For exam-
ple, *West Side Story* is set within the same climate of 1950s teenage
gangs that influenced *King Creole* and *Rebel Without a Cause*
(1955). Despite its musical success (the soundtrack album reached
number one on the British LP chart), I do not consider the film a pop
musical because it does not star pop performers.[18] The films used in
this book all starred figures who were primarily pop artists rather
than actors. This explains why a juvenile delinquent film largely
without music (*Beat Girl* (1959) with Adam Faith) receives attention
unlike *West Side Story*.

Related to this point, movies aimed at the teen market do not necessarily feature performers aged between the sociologically defined youth constituency of sixteen to twenty-four-year-olds.[19] The situation is compounded by the fact that not all films featuring young people fit easily inside the teen movie formula. For example, no account of the 1950s teenpic considers *Gigi* (1958) as a youth film, despite the fact that it centres on the genre's staple coming-of-age theme. Neale writes that 'films about the young are not necessary addressed to the young, films presumed to address the young do not necessary focus on or feature young characters'.[20]

The original reviews of the films discussed in this book did not describe these movies as teenpics. Such a term is anachronistic, as during the 1950s and 1960s a critical terminology acknowledging the distinct generic status of the teen movie did not exist. In this way, the academic history of the teenpic shares similarities with writing on other genres. For example, Neale emphasises that accounts of film noir and the melodrama within the academy regularly contain little resemblance to the generic positioning of particular films at the time of their release. Movies that are now regarded as crime dramas and film noirs were initially described as melodramatic, thereby contradicting what is now meant by 'melodrama' by film scholars.[21] As Rick Altman argues, 'rather than assum[ing] that generic labels have – or should have a stable existence', scholars have to recognise 'the permanent availability' of film genres to be reclassified.[22] Although commentators regularly referred to the teenage market during the 1950s and 1960s, films tended to be labelled in traditional generic terms. For example, *Melody Maker* described *The Young Ones* as 'the best British musical yet', although the paper acknowledged the film's appeal to teenagers.[23] Movies aimed at teenagers existed, but reviewers treated them as standard musicals, dramas and comedies with appeal to the younger generation rather than as teenpics. Equally, hindsight often disguises historical context: generic corpuses can change over time. For instance, *Rebel Without a Cause* is now regarded as a classic example of the 1950s melodrama, yet at the time of its release British critics saw the movie as a realist, social problem film. Today James Dean might epitomise the advent of the teenager, but did he really differ from many of his contemporaries no longer considered part of the youth boom of the mid-1950s? His films, especially *East of Eden* (1955) and *Giant* (1956), are typical of the middlebrow family melodramas of their era, which regularly

featured some token representative of the rebellious younger gener-
ation. Dean belonged to a generation of New York-based, stage-
trained performers, most of whom played variations on the
confused youth theme. In terms of dramatic background, age and
acting style, he had far more in common with Anthony Perkins than
Elvis Presley. Death bequeathed Dean a mythical image of doomed
youth that he may not possess today if he had lived.

The difficulty in writing about the pop film in generic terms is
exacerbated by the fact this mode of production sits uneasily within
traditional genre criticism. The diversity and hybridity of rock'n'roll
movies ensure that it is impossible to fit the genre along the struc-
turalist-derived models of the Hollywood musical by Altman and
Jane Feuer.[24] For example, *A Hard Day's Night* and *Help!* do not
match Altman's dual-focus narrative paradigm, thanks to their
absence of romantic interest. Both Hay and Barry Keith Grant point
out that despite its rock'n'roll soundtrack, *Rock, Rock, Rock*'s
middle-class setting means that it shares the same socio-economic
characteristics as the 'clean teens' that Doherty condemns.[25] More-
over Grant argues that the overt sexuality of many early rock'n'roll
acts, such as Presley and Little Richard, created problems when they
diversified from music into films. He claims that such music 'initially
was antithetical to both the musical's themes and conventions', such
as heterosexual romance and nostalgia.[26] Grant then explains that
rock'n'roll movies were emasculated by 'the stressing of rock's
potential for community, and the taming of rock's energy through a
deliberate moulding of its stars'.[27] This argument contains truth
when the careers of Presley (particularly after 1960) or Frankie
Avalon are considered, but Grant's argument ignores the fact that
many contemporary critics did not consider the rock'n'roll film to
represent a legitimate cultural form along the lines of the traditional
musical. As I discuss in chapter 4, the generic prestige of the musical
was actually a means by which critics could condemn rock'n'roll
movies.

However, alternative avenues for applying genre theory to the
pop film exist. Altman's *Film/Genre* emphasises the importance of
cycles within film production, claiming that 'by assaying and imitat-
ing the money-making qualities of their lucrative films, studios seek
to initiate film cycles that will provide successful easily exploitable
models'.[28] When such a cycle is repeated consistently by the film
industry, and recognised by the public and critics alike, then the

cycle achieves generic status. Teenpics, perhaps more than other genres, have been particularly susceptible to such cyclical trends, because teen movies are usually rooted within a distinct cultural timeframe. Various cycles existed within the 1950s and 1960s pop film: for example, the original US rock'n'roll movies, AIP's beach movies and Presley productions. The British pop film represented a distinct cycle within UK film history, with the sub-genre's active life lasting less than a decade (1957–65).

Given this book's emphasis on critical discourses, another area of genre theory with relevance to this text is Neale's concept of 'relay'. This criterion ensures that the marketing campaign for a particular movie aims to connect that film with a particular target audience.[29] With a project based around reviews this concept has implications for discussing how teen films were targeted at young people, particularly through contemporary film fan magazine and music press articles. As Richard Dyer argues in *Heavenly Bodies,* 'star images are always extensive, multimedia, intertextual', with the media playing a crucial role in the dissemination of star personas.[30] For a movie to qualify as a pop film, its publicity campaign had to reach the teenage or pre-teen audience directly. Therefore such material enables scholars to examine how films were marketed and consumed. Neale writes that:

> Genre is, of course, an important ingredient in any film's narrative image. The indication of relevant generic characteristics is therefore one of the most important functions that advertisements, stills, reviews and posters perform. Reviews nearly always contain terms indicative of a film's generic status, while posters usually offer generic (and hyperbolic) description – 'The Greatest War Picture Ever Made' as anchorage for the generic iconography in pictorial form.[31]

Approach and outline of the book

Before providing a brief overview of the remaining chapters, two points of clarification are needed. First, the fact that chapter 4 largely ignores post-1960 US rock films reflects the fact that very few notable American pop vehicles were made during the early to mid-1960s. Second, I apologise for the emphasis on male stars within this book: only one film centred around a teenage girl, *Beat Girl,* is discussed in depth. This does not mean that the likes of Connie Francis or Helen Shapiro are unworthy of examination, but rather

this imbalance reflects the masculinist nature of the pop industry at the time, as well as a lack of space. Hopefully this situation is partially rectified by the emphasis on fan magazine material that contains significance for dealing with how pop films were pitched at young women. Considering the importance placed upon the 'culture of the bedroom' in sociological accounts concerning the experiences of teenage girls, the emphasis on the 'highly manufactured ... totally packaged' nature of teenage magazines appears important.[32] Given the bias of such publications towards girls, these sources touch upon issues relating to the everyday cultural and social identities and experiences of young women. Throughout the decade under discussion the pop film, chart music, teenage magazines and annuals remained dominated by male icons. A quote from Brian Epstein's ghost-written autobiography clarifies this situation: 'The disc charts cannot stand very many girls, however gorgeous they may look on stage.'[33]

Following this introduction, chapter 1 explores the importance of criticism within Film Studies, and how this concept has been narrowly defined. It explains the necessity of deploying a historical materialist and Cultural Studies approach for studying critical commentaries on pop films. Those readers less interested in theoretical debates might wish to concentrate upon the last two sections of the chapter which detail information about the key sources utilised in this book. Chapter 2 contains a full negotiation of the appropriate social, cultural and political background of the period 1955–65, dealing with the key historical themes featuring in subsequent discussions. Special emphasis lies with information concerning national pride and Americanisation, the rise of a teenage consumer and cultural identity and the notion of affluence. Chapter 3 discusses the singular most important figure in twentieth-century youth culture, Elvis Presley. It concentrates upon Presley's early career from 1956 to 1958, although some connections to his later career briefly emerge in chapter 4. Embracing issues such as cultural standards, Americanisation, rock'n'roll, juvenile delinquency and the development of a non-deviant teenage, Presley's early career provides a rich source for this project. Chapter 4 negotiates the reaction towards American rock'n'roll movies from the mid-1950s onwards. It considers the critics based at the BFI publications, *Sight and Sound* and the *Monthly Film Bulletin*, along with elaborating many of the issues mentioned in chapter 3 in further detail. Chapter 5 explores the

image and films of early British pop heroes, most notably Tommy Steele, Cliff Richard and Adam Faith. A natural companion to this information, chapter 6 concentrates upon the changing critical distinction of the British pop film during the early to mid-1960s. A final concluding chapter re-stresses key themes and theoretical information featured within the book.

Notes

1 A. Medhurst, 'It Sort of Happened Here: The Strange, Brief Life of the British Pop Film', in J. Romney and A. Wootton (eds), *Celluloid Jukebox: Popular Music and the Movies Since the 50s* (London: BFI Publishing, 1995), p. 61.

2 T. Doherty, *Teenagers and Teenpics: The Juvenilization of American Movies in the 1950s* (Philadelphia: Temple University Press, 2002, revised edn, pp. 75–6. All subsequent quotations refer to this edition unless otherwise stated.

3 *Ibid.*, p. 76.

4 *Ibid.*, pp. 77–8.

5 *Ibid.*, p. 7.

6 *Ibid.*, pp. 131–7.

7 *Ibid.*, p. 57.

8 *Ibid.*, p. 158.

9 J. Mundy, *Popular Music on Screen: From the Hollywood Musical to Music Video* (Manchester: Manchester University Press, 1999), p. 168.

10 Doherty, *Teenagers and Teenpics*, p. 181.

11 J. Hay, '"You're Tearing Me Apart!": The Primal Scene of Teen Films', *Cultural Studies*, 4:3 (1990), p. 336.

12 J. Oliver (ed.), *Top Numbers' Book of the Stars – Vol. 2.* (London: Tolgate Press, 1960), pp. 67, 91, 96.

13 *Ibid.*, p. 3.

14 K. J. Donnelly, *Pop Music in British Cinema* (London: BFI Publishing, 2001), p. 4.

15 Donnelly, 'The Perpetual Busman's Holiday: Sir Cliff Richard and British Pop Musicals', *Journal of Popular Film and Television* 25:4 (Winter 1998), pp. 146–54; B. Neaverson, *The Beatles' Movies* (London: Cassell, 1997); R. Murphy, *Sixties British Cinema* (London: BFI Publishing, 1992), pp. 115–38; Medhurst, 'It Sort of Happened Here', pp. 60–71.

16 S. Neale, *Genre and Hollywood* (London: Routledge, 2000), p. 51.

17 Doherty, *Teenagers and Teenpics*, p. 11.

18 T. Rice, J. Rice, P. Gambaccini and M. Read (eds), *Guinness British Hit Albums* (Enfield: Guinness Publications, 1986), p. 169.

19 M. Abrams, *The Teenage Consumer* (London: London Press Exchange, 1959), p. 3. He described teenagers as 'young people from the time they leave school till they either marry or reach 25'.

20 Neale, *Genre and Hollywood*, p. 119.

21 *Ibid.*, pp. 151–204.

22 R. Altman, *Film/Genre* (London: BFI Publishing, 1999), p. 82.

23 T. Brown, 'Cliff's Film is the Best British Musical Yet', *Melody Maker* (16 December 1961), p. 21.

24 R. Altman, *The American Film Musical* (London: BFI Publishing, 1989), pp. 16–27; J. Feuer, *The Hollywood Musical* (London: Macmillan, 1992).

25 Hay, '"You're Tearing Me Apart"', p. 337; B. K. Grant, 'The Classical Holywood Musical and the "Problem" of Rock'n'Roll', *Journal of Popular Film and Television* 13:4 (1986), p. 200.

26 Grant, 'The Classical Hollywood Musical', p. 196.

27 *Ibid.*, p. 199.

28 Altman, *Film/Genre*, p. 60.

29 Neale, 'Questions of Genre', *Screen* 31:1 (1990), pp. 39–40.

30 R. Dyer, *Heavenly Bodies: Film Stars and Society* (London: Macmillan, 1987), p. 3.

31 Neale, 'Questions of Genre', p. 49.

32 A. McRobbie and J. Garber, 'Girls and Subcultures', in S. Hall and T. Jefferson (eds) *Resistance Through Rituals: Youth Subcultures in Post-War Britain* (London: Hutchinson, 1976), pp. 213, 220.

33 B. Epstein, *A Cellarful of Noise* (London: New English Library, 1981 [1964]), p. 70.

Chapter 1

Defining criticism in Film Studies

Teenagers Jim Donaldson [Steve Terrell] and Fred Armstrong [John Ashley] are rivals for the attentions of Louise Blake [Fay Spain] – an attractive blond. Both boys are also 'hot rod' enthusiasts ('hot rods' are specially adjusted hand-built racing cars), and Jim has high hopes of winning a big hot-rod race. Unknown to Jim, Fred steals his car and knocks down and kills an old man while driving it. On the day of the big race meeting the police arrest Jim for murder, but Louise is able to prove that Fred is the real culprit.

A depressing and irresponsible film, presumably made for the teenage market and glorifying the defiance of law and order, lax morals and the discarding of civilised behaviour. Its dubious humour is aimed at anything that exists beyond the teenage way of life.[1]

The above commentary is the *Monthly Film Bulletin*'s review of *Dragstrip Girl* (1957). This publication was the sister publication of the BFI magazine, *Sight and Sound*; every new release in Britain obtained a critical review in its pages. Although this book concentrates upon rock movies rather than teen films as a whole, the review contains some insights dealing with how commentators reacted towards the genre. *Dragstrip Girl* involved characters and scenarios obviously based upon the pictures of James Dean and Marlon Brando: leather-clad, speed-crazy kids, participating in activities that bordered on delinquency. At various stages of the film, youngsters are seen driving hot-rod cars at excessive speeds in the streets. The rivalry between two teenage boys over the love of a girl, who enjoys racing speeding cars, leads to a cocktail of joyriding, theft and murder.

How should today's commentators interpret information nearly fifty years old? What kind of theoretical and historical approaches

are required for this task? To answer these questions, I propose to detail appropriate theoretical and methodological issues, before relating these concerns to *Dragstrip Girl* to conclude this chapter.

Theories of taste and distinction in Film Studies

The operation of cultural tastes is inseparable from the material conditions of the critical commentator. To understand the particular angle adopted by a specific critic, it becomes necessary not only to understand the socio-cultural context in which that reviewer worked, but also this task demands information about the preferences of particular publications and their readership. For such an inquiry, Marx and Engels' comments on the process of material production still contain interest, because they stress the connection between the conception and execution of an artefact and the actual lifestyle of its creator:

> The way in which men produce their means of subsistence depends first of all on the nature of the actual means of subsistence they find in existence and have to reproduce. This mode of produce must not be considered simply as being the production of the physical existence of the individuals. Rather it is a definite form of activity of these individuals, a definite form of expressing their life, a definite mode of life on their part. As individuals express their life, so they are. What they are, therefore, coincides with their production, both with *what* they produce and with *how* they produce. The nature of individuals thus depends on the material conditions determining their production. [italics in original][2]

This analysis provides a crucial explanation for the subsequent definition of cultural tastes. Through their writings, film and music critics/journalists not only reflected their own position and status in society, but also the place of their publications within the cultural sphere. Their own opinions as critics corresponded 'with *what* they produced' [sic], with the content of their publications being determined by the 'material conditions' of their production. Criticism and journalism concerning rock movies therefore did not operate in a vacuum, but rather corresponded to circumstances that affected the contemporary landscape inhabited by commentators and their readership. This implies that writer's tastes coincided with their reader's values, or at least had to adapt to achieve some form of mutual co-existence.

A useful theoretical paradigm concerning the analysis of film reviews in their historical context features in Janet Staiger's *Interpreting Films*. Stressing the importance of a historical materialist approach to film history, Staiger explains how reviewers' individual interpretations were determined by 'the variety of procedures and protocols historically available' at any given moment.[3] Adapting the concept of 'reading formations' from the work of Tony Bennett and Janet Woollacott, she emphasises the extent to which interpretations result from the interaction between critic and film text at specific periods in history.[4] Factors such as class, gender, age and ethnicity, alongside the prevailing discourses of the day, explain the various critical readings evident during any particular epoch. For example, Staiger explains how Erich von Stroheim's *Foolish Wives* (1922) alienated American film critics in the specific social, political and cultural context of the early 1920s. The climate of 'red scares' in the aftermath of the First World War, the revival of the Ku Klux Klan, an upsurge in American belligerence towards Europe and the formation of the FBI by J. Edgar Hoover are all mentioned as events coinciding with the critical disapproval for a film showing an unflattering vision of American values.[5]

Staiger's theoretical approach suggests the importance of studying reviews to uncover the political, cultural and social assumptions of any period in film history. Analysis of film texts alone risks eliminating the various struggles of disadvantaged groups from history, by potentially avoiding negotiation of the complexity of the epoch. Through studying review materials, Staiger believes that it becomes possible to determine the 'power struggles, contradictions, and overdeterminations existing in the superstructure'.[6] Therefore the task of the film historian adapting a historical materialist approach is to analyse the struggles existing at a particular time. The examination of the critical context demands an understanding of the critics and journalists and their presumed readership within their historical framework, enabling an exposé of the political and cultural issues at stake during an individual era. This project is designed as a practical application of Staiger's theoretical paradigm. By studying the reaction towards pop/rock films between 1955 and 1965, this research locates the era's key discourses to specific films and their stars. Given that youth represents a largely 'marginalised' and disenfranchised constituency, the task of this research is to reveal the various power struggles and contradictions surrounding the early years of teenage culture in Britain.[7]

More specific themes related to the operation of cultural and critical tastes feature within Pierre Bourdieu's *Distinction*, which provides the most comprehensive study concerning the operation of taste and cultural hierarchies. Echoing Marx's theories of historical materialism, Bourdieu's thesis maintains that tastes result from predetermined 'conditions of existence'.[8] Cultural preferences help to determine the exact tastes of the consumer and critic respectively. Value judgements betray an individual's own prejudices with regards to their class background, economic and cultural capital. This can range from mundane decisions concerning everyday life, such as the choice of food and the consumption of popular cultural artefacts, to major lifestyle decisions affecting educational and vocational choices. Bourdieu states: 'Taste classifies, and it classifies the classifier. Social subjects, classified by their classifications, distinguish themselves by the distinctions they make, between the distinguished and the vulgar, in which their position in the objective classification is expressed or betrayed.'[9]

Distinction's central argument revolves around the suggestion that various forms of cultural taste relate to the dominance of the social system known as the habitus. This ensures that the subject's cultural, social and political tastes remain structured according to the practices operated by those people directly opposite in the class system, social habits and political affiliation. Cultural tastes are value judgements, the products of the desire to oppose alternative groups in society via the habitus: 'social identity is defined and asserted through difference'. Through this system, each class or distinct social category, such as youth, can establish its own cultural position against the grouping with whom they are in greatest competition or fear most.[10]

Bourdieu links tastes in film viewing to cultural and economic capital, detailing how cinema attendance was much greater among young, well-educated people, usually resident in urban areas. This ensured that knowledge of directors and actors related heavily to educational capital. For example, only 5 per cent of respondents with 'an elementary school diploma could name at least four directors (from a list of twenty films)'. This contrasted with the findings that '22 per cent of those who had had higher education' could name four or more directors from the list. Interestingly these findings suggest that class and gender differences exist with regards to information about stars and their films. Bourdieu claims that women

provided the core readership of 'sensationalist weeklies' containing star gossip, yet that middle-class and professional people tended to avoid such publications.[11]

These findings contain information that requires full elaboration in a British context. Bourdieu's inquiries suggest that tastes differed among diverse groups of cinemagoers, based around around educational capital, class and gender. On the subject of pop films, the application of Bourdieu's theories would lead to a natural expectation that the elite film journals adopted different approaches to particular films and stars than fan-orientated publications. This resulted from the readership of serious film magazines being better educated and primarily interested in the artistic and technical side of the cinema, than the clientele of fan magazines. It also arose as a result of the class and gender differences among the readers of various magazines. The schoolgirl who read *Photoplay* inevitably felt differently about the latest pop star musical than the average *Sight and Sound* reader interested in the leading film directors.

However, there is a danger of overstating the differences between such publications; a facile binary opposition between elite and popular publications ignores potential contradictions. Bourdieu's work on field theory is helpful for this survey of film reviewing, as it offers a caveat when studying the nature of cultural tastes. In *The Field of Cultural Production* he differentiates between goods that belong to 'the field of restricted capital' and those intended for the 'field of large-scale cultural production'.[12] A useful explanation of 'field theory' is mentioned by the sociologist Scott Lash:

> The specific and differentiated fields are sites of collective symbolic struggles and individual strategies, the aims of which are to produce valuable cultural goods (or to be associated with their production in the case of institutions and marketers). The value of a symbolic good depends upon the value assigned to it by the relevant consumer community. These value judgments are in most fields determined by the amount of symbolic capital accumulated by the producer (or producers). Victory in a symbolic struggle means that one's symbolic goods have been judged to possess more value than those of one's competitors.[13]

The elite film journals, especially *Sight and Sound* and the *Monthly Film Bulletin*, aimed at a minority public interested in defining the cinema as art. In contrast the music press and the film fan magazines had to appeal to the largest potential readership available. Besides

the social, cultural and political influences of the time, economic priorities also dictated the editorial policy of popular publications towards teen movies. Therefore, I would suggest that critics from the various 'popular' and 'elite' sources should be treated as separate fields of production, which enables an understanding into the various contradictions within different strands of criticism.

Applying theory into practice

This research illustrates how the suggested models of Staiger and Bourdieu can be applied to a historically specific study, belonging to an interdisciplinary tradition. Its exploration of the critical reaction towards pop films in Britain, investigating their purpose and content in the context of a particular era, borrows from subjects such as history, Cultural Studies, sociology and Film Studies.

Bourdieu's writings are usefully applied to film tastes in Barbara Klinger's work on the 1950s melodrama. Concentrating upon the contemporary reaction to the films of Douglas Sirk, Klinger utilises *Distinction* as a theoretical basis for an inquiry into why the director's work faced disapproval during the 1950s. Through the use of theories of cultural discrimination, especially the disapproval of the elite towards the emotional and escapist forms of popular culture, she connects appropriate theories regarding critical disapproval to a wider social and cultural framework. She explains how the critical bias towards critical realism, and the distaste for melodramatic 'soap opera' films and mass culture, coincided with the low cultural, economic and social status of women in society in the 1950s.[14]

Klinger's work provides a precedent for the current research. First, the use of Bourdieu's theories together with an appropriate investigation into the social and cultural context in which criticism operated attempts a similar task to this work. Second, several coincidences exist between Sirk's melodramas and teen movies. Besides their chronological overlap, these films largely aimed at a largely disenfranchised and culturally derided audience segment. Critics attacked both women and young people for being vulnerable to the evils of mass culture. Pop films largely offended the prevailing realist sensibilities of the critical establishment, besides alienating the guardians of taste through their formulaic production. Considering these similarities between Klinger's paradigm and the critical reac-

tion to rock movies in Britain, this research partially attempts to replicate her findings within a different cultural context.

The theories detailed above have inspired other commentators adopting a historical materialist approach to critical discourses. The BFI volume, *Hollywood Spectatorship*, which contains several articles adopting the approaches of Staiger and Klinger, exemplifies this trend.[15] Especially notable is Mark Jancovich's account of the discourses surrounding *The Silence of the Lambs* (1991), which suggests that historical reception studies needs to consider the way review/journalistic material reveals the conflicts and contradictions within taste formations:

> Reviews and feature articles set agendas for audiences by drawing attention to what is taken to be interesting or noteworthy about a film. They also reflect the differing attitudes of different sections of the media to varying taste formations. In the process, they focus their attention on different features and employ wildly different notions of cinematic value.[16]

Another area of Film Studies influenced by Bourdieu's notion of taste is cult cinema, a category to which the 1950s and 1960s pop film belongs. In the definitive article on the subject, Jeffrey Sconce takes *Distinction*'s discussions of oppositional taste as the basis for studying cult-viewing tastes. Sconce claims that the spectrum of 'paracinema' or bad movies, dismissed in previous generations as trash, has become embraced by a generation of film enthusiasts rejecting the cinematic canon. This pantheon of bad taste includes such pop film staples as Elvis Presley musicals and the AIP beach movies.[17] Certainly, this type of film has seldom obtained praise within the academy. For example, Colin McCabe's account of *Performance* (1970) refers to 'the endless tedium of the Elvis Presley movie' and describes the pop film as 'the most minimal of genres'.[18]

Given such condescending comments about the pop film, it is easy to place this genre within the cult movie framework. However, whether cult films are the antithesis of the mainstream, as implied by Sconce and others, is debatable. First, the cultdom thesis ignores the fact that many viewers of 'trashy' movies probably never saw the films as anything other than mainstream productions. Watching a Pat Boone movie hardly 'means, for at least an instant, turning your back on seemly or fitting cinema'; yet he was a major star of the US pop film in the late 1950s.[19] Second, as I have argued elsewhere, many rock'n'roll movies are praised by their fans primarily for their

music not their cinematic qualities, which can actually entrench notions of good taste.[20]

Criticism in Film Studies

As indicated by the work summarised above, questions about critical values and tastes form an increasingly important role within Film Studies. Such work provides a necessary corrective to many traditionalist definitions of film criticism. Much of what the academy calls film criticism represents only a small amount of film writing, largely restricted to academic work and detailed textual analysis along the lines of the output of the French critic, André Bazin. In contrast, popular film writing has been designated as journalism or ignored as ephemera.

David Bordwell's treatment of reviewing practices in *Making Meaning* exemplifies this division. He separates film criticism into three 'macro institutions': journalism (i.e. newspaper/magazine reviewing and articles), essayist writing typified by distinguished, but non-academic, magazines like *Cahiers du Cinéma* and *Sight and Sound*, and academic film writing.[21] The fact that much essayistic and academic writing originates from literary criticism – hence their emphasis on close textual analysis – helps to distinguish these forms from popular journalism, which serves as a form of promotion and advertising:

> Reviewing is part of the mass media, and it functions as an offshoot of the film industry's advertising: reviews publicize the film and sustain the habit of movie going. As a piece of journalism, the review operates in the discursive category of 'news'; as a branch of advertising, it draws on material from the film industry's discourses; as a type of criticism, it draws on certain linguistic and conceptual forms, especially those involving description and evaluation.[22]

Despite the virtues of this argument, Bordwell's definitions of film criticism require caution. First, he underestimates the similarities between journalistic and essayistic writing: like the fan-orientated magazines, publications such as *Sight and Sound* are reliant on contemporary interviews and reviews, and subject to numerous contradictions. Indeed, much of the writing contained in the BFI publications and *Cahiers* during the 1950s was journalistic rather than analytical. Given his influence upon academic film criticism, it is easy to forget that Bazin's prime role was as a practising journal-

ist whose work was never intended to form a coherent account of screen realism or genre theory. Second, through his comment that journalistic reviewers 'need not deal with interpretation and its problems', Bordwell effectively relegates such criticism to secondary status, thereby providing theoretical justification to academics wishing to ignore popular reviewing.[23]

The distinctions evident in Bordwell's argument are explicitly apparent in work dealing with the nature of film criticism in Britain. For example, Robert Murphy's account of the 'critical debates', in *Sixties British Cinema*, contains a narrow definition of criticism, concentrating upon the 'elite' or 'serious' film publications. These sources include *Sight and Sound*, the *Monthly Film Bulletin*, *Films and Filming* and *Movie*, together with the trade press typified by *Kinematograph/Kine Weekly* and the leading Fleet Street reviewers. He completely ignores the 'glossies', film fan magazines such as *Picturegoer* and *Photoplay*, along with the music papers *New Musical Express* (hereafter *NME*) and *Melody Maker*.[24] This distinction remains evident in other attempts to analyse critical discourses. For example, although linked to the contemporary debates over what defined a prestigious film, John Ellis' article 'The Quality Film Adventure: British Critics and the Cinema, 1942–1948' echoes the elitism of Murphy's argument. Popular sources are unmentioned, thereby maintaining the illusion that only the elite film journals actually wrote movie criticism.[25]

This book rejects the rather dismissive attitude towards the 'glossies'. In his work on popular journalism, John Hartley describes the contemptuous attitude expressed by the cultural and political hierarchies towards popular journalism that resulted in the privileging within academia of serious 'broadsheet' journalism at the expense of 'tabloid' ephemera. A similar process has occurred with regards to academics and film criticism, with commentators privileging the elite sources over the seemingly ephemeral 'trash' of the fan magazines. This project rejects the socially constructed boundaries between 'serious' and 'popular' criticism, because, to adapt Hartley's work on journalism, 'they contribute equally to the development of ideas, arguments (and understanding)'.[26]

This study utilises the approaches proposed by Hartley and Jancovich for the selection of appropriate source materials. The project does not discriminate between various publications, because the 'glossies' provided equally rich material for the study of pop films as

the 'serious' film magazines. If anything this work contains a corrective emphasis towards the likes of NME, Melody Maker and Photoplay, for which I make no apologies. The use of the music press indicates the significance of the cross-media dimension involved in the study of teen movies. This permits a fuller understanding of the historical context of reviews demanded by Staiger. Despite their cinematic success, the likes of Elvis Presley, Cliff Richard and the Beatles were primarily musicians/singers rather than actors, and it seems natural that valuable information about these acts and their films would feature in the music press. The fan magazines and the music press should be compulsory reading for any serious investigation into the impact of the pop film in Britain for two reasons. First, these sources comprised the publications that the contemporary audience for youth films would have read. They had to fight to retain the allegiance of the young audience, which inevitably meant that the perceived values and preferences of young people figured prominently. Second, given their market position as primarily teen-centred publications, the glossies provide a vital insight into the dissemination of cultural tastes among young people. They facilitate a crucial understanding into how record companies and the cultural 'gatekeepers' of youth culture wanted particular stars and their image to appear to a predominately youthful audience.[27] Through ephemeral sources, historians of popular music and the teen movie can discover the pivotal youth trends during the 1950s and 1960s. Such materials also permit the closest opportunity to acknowledge the importance of pop films to their original audience without an oral history or survey-based project.

Relevant publications

The main written primary sources for this project are Sight and Sound, the Monthly Film Bulletin, Films and Filming, Picturegoer, Photoplay, NME, Melody Maker and Record Mail. Sight and Sound/Monthly Film Bulletin remained the most prestigious film journals in Britain throughout the 1950s and 1960s, aimed at encouraging a wider appreciation for film culture as cinematic art. Serving a predominantly educated group of cineastes, the critics at Sight and Sound/Monthly Film Bulletin held firm beliefs about commercial cinema and the role of the critic. The generation of 1950s BFI critics, including Penelope Houston, the editor of Sight and Sound from

1956, her predecessor Gavin Lambert and Lindsay Anderson, possessed two notable assumptions about cinema and society. These attitudes proved crucial for the later attitudes expressed towards teen movies inside the pages of *Sight and Sound/Monthly Film Bulletin*. First, cinema reflected society. Not only did film have the power to act as a major force for social change, but also the visual images portrayed on screen had the potential to influence human behaviour. Houston wrote in 1956 that 'the critic is failing in his duty if he disregards the extent to which films express and influence the attitudes of their audience. Both the film and criticism are in their way a reflection of society: we cannot try to reject our responsibilities by contracting out.'[28] Second, critics could exercise their responsibility through their role as the protectors of cinema's artistic potential. The 1950s generation of elite critics, especially those originating from the Oxford University film magazine *Sequence*, were left-leaning Leavisites who assumed that each new film ought to be judged in accordance with the highest cinematic standards. This belief ensured that commercial trash that damaged the cinema's artistic credibility and the public's appreciation of quality films faced certain dismissal. Lambert outlined the basis for this agenda in a late 1940s edition of *Sequence*, in which he stated that 'the important question is whether spurious elements from hack commercial films are allowed like a virus to invade good ones and vitiate their success'.[29] Under such a critical agenda it becomes obvious why many 'hack commercial' pop movies faced facile condemnation.

Films and Filming operated in a mid-market position between the fan-orientated magazines and the BFI publications. Described in 1955, a year after its first issue, as 'aimed at the public "that finds *Picturegoer* unsatisfying and *Sight and Sound* unintelligible"', the magazine managed to retain a combination of elite and popular elements.[30] No publication which featured US teen idol Troy Donahue on its front cover can be entirely dismissed as elitist, while the first major article on AIP beach movies featured in *Films and Filming* rather than *Photoplay*.[31] Combined with this genuine interest in popular cinema, the magazine ran regular articles on international film culture, especially the leading directors of the period. In this way, *Films and Filming* operated as an intermediary between the BFI journals and the fan magazines.

The actual personal preferences between commentators working for publications originating from alternate market sections perhaps

did not differ as radically as has been thought. For example, in a *Films and Filming* poll to discover the critics' choice of best picture released in 1960, both *Picturegoer*'s Margaret Hinxman and the veteran Roger Manvell chose *Saturday Night and Sunday Morning*.[32] The weekly film newspaper *Picturegoer* ceased publication in 1960 after suffering a sustained circulation decline throughout the 1950s. Bob Baker describes the paper's review policy near the end of its life as 'insipid': 'The house-style was frozen within the format that, approximately, no sentence be longer than twelve words and no paragraph longer than two sentences.' He attributes much of *Picturegoer*'s decline to its inability to branch out into the teenage market, a policy illustrated through the paper's increase in pop coverage. This aim failed as *Picturegoer*'s staff 'came nowhere near defining that audience or its requirements', and instead printed material aimed 'primarily for teenage girls ... assumed to be interested in little above the level of wishy-washy trivia'.[33]

Such comments fail to consider the importance of this shift towards teenagers from the perspective of the young fan who read the paper at the time. For example, chapter 3 suggests that although *Picturegoer* critics hated Presley, they never made the mistake of patronising his audience, therefore permitting the paper to serve an important social and cultural function for those effectively disenfranchised by other publications. Equally the standards of criticism in fan-biased outlets differed from *Sight and Sound/Monthly Film Bulletin*. Unlike these journals, *Picturegoer* had to compete in an increasingly competitive leisure market for young people's patronage. A strong case can be made that the reviews contained within the likes of *Picturegoer, Photoplay* and *NME* were more democratic than those contained in the elite film magazines. Such popular publications aimed at expressing an opinion about whether a film appeared 'good of its kind'; they sought to critique movies from the perspective of entertainment value and their potential audience appeal.[34] In this sense, the glossies' attitude towards criticism and the concerns of their readership appears more modern than the rather patronising committed cinema encouraged by the BFI publications.

Picturegoer's stablemate at the large IPC (International Publications Corporation) publishing conglomerate, *Photoplay*, also featured films alongside coverage of pop music and television. Possibly because of its status as a glossy colour monthly, the magazine managed to outlive *Picturegoer* by several decades. *Photoplay*'s impor-

tance lay in its heavy preponderance of star profiles: more than any other publication extensively used in this research, it positioned itself closest to the format beloved of girls' magazines. Bright colours, pin-up posters, news, competitions and gossip featured alongside star profiles written in the glowing romanticised language of teenage love comics. When *Photoplay* published reviews, such accounts invariably told a thin plot summary rather than a detailed analysis of the film's quality. The major British and American film companies provided glossy colour photos of their leading acts and behind the scenes access to set locations; on occasions they even funded competitions to exotic foreign locations. For example, in 1963 Disney promoted a competition prize of a trip to Florence to promote the latest Annette Funicello epic, *Escapade in Florence*.[35] Through such material, *Photoplay* served as an intermediary between fans and promoters alike, attempting to satisfy the interests of both groups.

The most prestigious music paper, *Melody Maker*, belonged to the same publishing group as *Picturegoer* and *Photoplay*. Some commentators, most notably the pop reviewer Laurie Henshaw, wrote for more than one publication. As the popular market leader in its field, for prestige with musicians if not through its sales figures, *Melody Maker* actually resembled *Films and Filming* rather than its stablemates. The paper dated back to 1926, retaining a distinct jazz slant until the early 1960s. Only after the advent of rock'n'roll and the rise of teenage consumer culture did the paper display any disposition towards pop. Even during the early 1960s *Melody Maker*'s aims resembled the higher echelons of the film press rather than the fan publications. First, it desired to inform its readers about what its critics designated as the best forms of modern popular music. Possibly resulting from the paper's jazz origins, *Melody Maker* critics believed they possessed an obligation to defend musical standards alongside acknowledging the best in current taste, as hinted at by their claim to offer 'great features on Elvis Presley, Ornette Coleman, the Beatles and Louis Armstrong'.[36] Second, *Melody Maker* regularly commented upon the state of the recording industry with populist sociological reports about young people's consumer tastes. This occasionally resulted in crude denunciations of those figures whom purist critics believed to be responsible for declining artistic standards, yet, at its best, *Melody Maker* offered a serious critical journalism that matched anything offered by the film press.

Melody Maker's bitter rival *NME* was aimed largely at the per-
ceived interests of teenage music fans. Far less critical of the music
industry and particular stars than its main competitor, *NME* quickly
became Britain's best-selling music paper after its foundation in
1952. The paper concentrated on news, reviews, competitions, star
interviews and questionnaires. Moreover *NME* was always a pop
paper, providing its core audience, teenage pop fans, with what they
wanted, thereby building a sense of solidarity with its readers. Simon
Frith describes *NME*'s attitude towards pop during the early 1960s
as 'a mixture of show-biz condescension to the youngsters' tastes
and the assumption that music criticism was the same thing as the
assessment of sales potential'.[37] This view contains some truth, but
NME almost certainly performed an important service to its readers,
providing news and information at first hand. Like other fan-related
publications, it offered people the chance to develop their own
knowledge about their favourite performers. Therefore *NME*
deserves significant scrutiny in any discussion of pop musicals and
their stars.

The other music paper used extensively for this study, *Record
Mail*, provides the closest publication to a trade press perspective.
Totally uncritical, it comprised largely of flattering reviews and
extensive tabloid size photographs. Most importantly, this paper
only dealt with artists originating from the powerful EMI conglom-
eration. As this organisation distributed the records of Cliff Richard,
the Beatles and the Dave Clark Five among others, it granted
insights into how those behind particular pop acts wanted their
image to be received by fans. *Record Mail* was an official publicity
organ, a means for the various EMI record companies to control the
image of their most popular clients.

Conclusion – the operation of cultural distinctions in 1950s film reviews

In this final section, I return to the *Monthly Film Bulletin* review of
Dragstrip Girl introducing this chapter. This methodology facilitates
a chance to place theory into practice, demonstrating how I intend
to deploy historical materialist analysis for the book's duration.

Under the editorial guidance of Lambert and Houston, *Sight and
Sound/Monthly Film Bulletin* operated a preference for social-real-
ist cinema: works of art that spoke directly about contemporary

society, typified by the likes of *Rebel Without a Cause*. Lambert's *Monthly Film Bulletin* review of the movie proclaimed 'a film of outstanding talent', with 'some brilliantly written and directed scenes' investigating the family unit in a realistic fashion.[38] In *Sight and Sound*, Derek Prouse wrote that the film 'infer[red] a liberty to observe and make sense of the current scene that film-makers in England can only envy'.[39] Perhaps the best articulation of this critical position occurred with Lindsay Anderson's vigorous defence of realist criticism in 1956, which remained convinced that cinema ought to reflect the wider social and artistic environment:

> The importance of the cinema as a cultural and propagandist force is a matter of fact also. Everyone who has seen more than half a dozen films with his eyes open knows that the cinema does not just create the significant social movements of our time, it intimately reflects them. And that it provides a reflection just as intimate – and just as significant – of social stagnation. A further point worth emphasising is that the cinema makes its appeal above all to the youthful; that is to say, above all to those whose minds are unformed, and open to impression.[40]

Anderson later complained about the absence of serious British films dealing with the major social problems of the age including 'strikes; Teddy Boys; nuclear tests; the loyalties of scientists; the insolence of bureaucracy [and] the presence of American troops'. His thinly veiled elitism became explicit when he denounced popular British genres and stars, such as Second World War films and Diana Dors.[41] However, given the support for *Rebel Without a Cause*, such views underline the problems associated in designating British commentaries about US popular culture as radical or conservative. The critical line adopted by Lambert, Houston and Anderson had precedents within the operation of critical cinematic tastes. John Ellis details how the British critical preferences in the 1940s towards realist/humanist cinema often involved a critical rejection of highly popular genres and stars. Support for the 'quality' British film often depended on a cinematic text displaying evidence of an attempt to investigate the human condition via the recreation of an authentically realistic story. These critical tastes not only neglected the cinematic form, pleasures and style of popular cinema, both its stars and genres, but also ensured that these middlebrow assumptions regarding what exactly constituted a 'quality' film remained influential for decades.[42] Inevitably the critical hierarchy of the mid-1950s still operated under the influence of their immediate prede-

cessors, whose biases in favour of realism ensured the fragmentation of cinema 'into discrete departments [which] sealed the sense of superiority or inferiority of both individual film-makers and genres'.[43]

These critical values meant that films that failed to meet such exacting standards faced disapproval. This fate greeted not only numerous rock'n'roll movies, but also other productions aimed at teenagers, typified by *Dragstrip Girl*. The second paragraph of the *Monthly Film Bulletin* review contained particular significance. Considering that realism played such an important role in the critical positioning of *Sight and Sound* and the *Monthly Film Bulletin*, elite commentators felt that *Dragstrip Girl* featured minimal artistic quality. This situation traced back to the issues of realism and cinema as a reflection of society. As stated earlier, socio-realist films provided the favoured viewing of the critical establishment: a discussion of the reaction towards *Dragstrip Girl* also connects to Anderson's comments regarding realist-informed criticism. British commentators developed an interest in discussing the impact of society and the cinema upon teenagers, because they believed that youngsters possessed 'unformed' opinions that appeared particularly 'open to impression', particularly at a time of social disorder. Violent activities appeared synonymous in the public imagination with cinematic images of teenage violence; for example the flick-knife fights in *Blackboard Jungle* and *Rebel Without a Cause*. The Dean movie and *The Wild One* (1953) featured 'chicken runs' with cars and motorbikes respectively. To hostile commentators, the cinema could easily have been envisaged as a means for glamorising delinquency. This historical background helps to reveal the political and social concern evident within the *Monthly Film Bulletin*'s comments on *Dragstrip Girl*. It presented 'a depressing and irresponsible film', explicitly 'aimed at the teenage market'. This situation materialised because critics like Anderson did not believe that the young audience possessed the discriminating faculties to distinguish between fact and fiction.

The reviewer's list of three key accusations confirms this view. The film faced charges of 'glorifying the defiance of law and order, lax morals and the discarding of civilised behaviour'. On the first issue, the film shows the protagonists enjoying displaying contempt for law and order. For Jim, Fred and Louise, activities including driving hot-rods on the streets at dangerously high speeds are shown to

be pleasurable and exciting adventures. Fred represents a devious and dangerous delinquent who enjoys joy riding and stealing Jim's car, an event which culminates in the murder of a pedestrian through his irresponsible behaviour. His callousness is emphasised by his futile attempts to save himself from justice by framing Jim: through his nastiness and unstable actions, the character articulates everything that adults felt to be wrong with contemporary youth. This is a position strengthened by the critic's denunciation of the film's 'lax morals'. In *Dragstrip Girl* this not only refers to Fred's open deceit and criminality, but also to the behaviour of Louise. To critics who believed that the cinema reflected society, her character would have posed a moral and social threat to established codes of behaviour. Here a comparison with *Rebel Without a Cause* becomes instructive. In Nicholas Ray's movie, Judy (Natalie Wood) adopts a more stereotypical 1950s vision of American femininity, often remaining in the background compared to the male characters. Although during the 'chicken run' scene, Judy delights at the prospect of dangerous thrills, this event appears to contrary to her subsequent function in the film. For much of the movie, Judy functions as a girlfriend/mother symbol to Buzz, Jim and Plato (Sal Mineo). In the concluding scene at the deserted mansion, she adopts a traditional maternal role upon Jim and Plato, serving as a moderating influence. Judy provides the catalyst for Jim to realise his destiny as a man, enabling him to mature and accept responsibility.

This contrasts with *Dragstrip Girl*. Louise does not emerge as a passive 1950s dumb blonde stereotype, perpetually in the background as a love interest for the rival male leads. Instead, she adopts a tomboyish persona, in a society that did not encourage such female role models. She enjoys hot-rod racing on the city streets, an illegal activity, despite her mother's condemnation of racing cars as 'dangerous' and 'unfeminine'. Moreover, her delight in racing cars appears as being akin to sexual thrills. Her hot-rod racing enables Louise to impress boys like Jim and Fred: indeed, it provides the principal reason for initiating the film's main narrative focus. As the love affair with Jim commences, Louise adopts a more stereotypical female role, performing the role of a loyal supporter rather than actively participant in the motor racing. Yet, Louise never completely plays second fiddle to the boys, as in the final decisive race she takes on the evil Fred and manages to overcome personal danger to defeat him. Such a role could have led many young women to

identify with her character, especially in a society in which the leisure activities for young women were distinctly conservative. *Dragstrip Girl* presented a heroine whose actions partially broke with 1950s taboos, and who eventually succeeds in achieving her objectives against the odds.[44]

The above discussion of *Dragstrip Girl* and its potential to disrupt the cosy social attitudes towards girls in 1950s Britain helps to explain some of the critical antipathy displayed by the *Monthly Film Bulletin* critics towards AIP teen movies. For example, we read that 'its dubious humour is aimed at anything that exists beyond the teenage way of life'. It is not insignificant that the review includes a preliminary definition of hot-rods: ('hot-rods are specially adjusted hand-built racing cars'). Not only did the reviewer fail to provide any understanding of the teenage way of life, but also a critical desire to distance itself from a supposedly 'bad' movie emerged.

The criticism of *Dragstrip Girl* also contained a thinly veiled dislike for what the film represented with regards to the changing nature of Hollywood film production. While the critically approved *Rebel Without a Cause* emerged as a prestigious film produced by a major studio (Warners), *Dragstrip Girl* offered an inexpensive monochrome product from a newly established company which operated on the fringes of Hollywood (AIP). In spite of the presence of Dean and a maverick director and its contemporary subject matter, Ray's movie actually represented a continuation with the old Hollywood studio system that faced crisis by the mid-1950s. Its high-calibre production values and subject matter made *Rebel Without a Cause* the sort of film of which critics had previous experience. Significantly, Prouse's review referred to the film's line of descent from Warners' juvenile melodramas of the 1930s.[45] This situation did not apply in the case of *Dragstrip Girl*; the result of a new trend in American film production which saw small companies, typified by AIP, emerging to obtain a slice of the teenage market via artistically unambitious, low-budget movies. The youngsters featured in the movie are simply caricatures; figures adopting cliched behaviour and language ('hip', 'square'). To the British critical elite, such films and their methods of production posed a threat to the dignity and purity of cinema as an art form. Writing in 1963, Houston offered a caustic eye on the entire teen movie phenomenon:

> But, as the age-level of the audience has fallen, so the films have gone out to meet it. We have had the rock films and the twist films and the

hey-day of Elvis Presley; Hollywood has offered us *Hot Rod Girl*, *Dragstrip Girl*, *Reform School Girl*, *High School Confidential*, *School For Violence*, *Monster On The Campus*, and that ultimate fantasy *I Was A Teenage Werewolf*; the misunderstood adolescence theme is always with us, from Culver City to Tokyo. Efforts to cultivate the teenage audience have sent middle-aged film-makers out on forlorn expeditions into hot-rod and Espresso territory; or have encouraged them to flirt naïvely with the censor, to put on displays of self-conscious daring intended to suggest that their really rather respectable wares are a sort of cinematic equivalent to reefer cigarettes.

The shoddiness of a lot of entertainment film-making can be explained in these terms. There are plenty of people around trying to gauge what teenagers want and making some strident or pitiful or plainly silly bids for their attention.[46]

Notes

1 'Dragstrip Girl', *Monthly Film Bulletin* 24:283 (August 1957), p. 101.

2 K. Marx and F. Engels, 'The German Ideology', in *Karl Marx – Selected Writings*, ed. David McLennan (Oxford: Oxford University Press, 1977), p. 161.

3 J. Staiger, *Interpreting Films: Studies in the Historical Reception of American Cinema* (Princeton: Princeton University Press, 1992), p. 34.

4 *Ibid.*, p. 34, 79–81; T. Bennett and J. Woollacott, *Bond and Beyond: The Political Career of a Popular Hero* (New York: Methuen, 1987), pp. 64–8.

5 Staiger, *Interpreting Films*, pp. 124–38.

6 *Ibid.*, p. 80.

7 *Ibid.*, pp. 80–1.

8 P. Bourdieu, *Distinction: A Social Critique of the Judgement of Taste*, trans. Richard Nice (London: Routledge, 1984), p. 178.

9 *Ibid.*, p. 6.

10 *Ibid.*, pp. 171–2.

11 *Ibid.*, p. 27.

12 P. Bourdieu, *The Field of Cultural Production: Essays on Art and Literature*, edited and introduced by Randal Johnson (Cambridge: Polity Press, 1993), p. 115.

13 S. Lash, 'Cultural Economy and Social Change', in C. Calhoun, E. LiPuma and M. Postone (eds), *Bourdieu: Critical Perspectives* (Cambridge: Polity Press, 1993), pp. 197–8.

14 B. Klinger, *Melodrama and Meaning: History, Culture and the Films of Douglas Sirk* (Bloomington: Indiana University Press, 1994), p. 79.

15 M. Stokes and R. Maltby (eds), *Hollywood Spectatorship: Changing*

Perceptions of Cinema Audiences (London: BFI Publishing, 2001). See the chapters by A. M. Davis and M. Shingler on *Fantasia* and *All About Eve* for examples of this approach.

16 M. Jancovich, 'Genre and the Audience: Genre Classifications and Cultural Distinctions in the Mediation of *The Silence of the Lambs*', in Stokes and Maltby (eds), *Hollywood Spectatorship*, p. 37.

17 J. Sconce, '"Trashing the Academy": Taste, Excess, and an Emerging Politics of Cinematic Style', *Screen* 36:4 (Winter 1995), pp. 371–96; A. Ross, *No Respect: Intellectuals and Popular Culture* (London: Routledge, 1989), p. 115.

18 C. McCabe, *Performance* (London: BFI Publishing, 1998), pp. 48–9.

19 J. L. Crane, 'A Lust for Life: The Cult Films of Russ Mayer', in G. Harper and X. Mendik (eds), *Unruly Pleasures: The Cult Film and its Critics* (Guildford: FAB Press, 2000), p. 87.

20 I argue this point in 'The A.I.P. Beach Movies: Cult Films Depicting Subcultural Activities', *Scope: An On-Line Journal of Film Studies*, November 2001. Available at www.nottingham.ac.uk/film/journal/articles/aip-beach-movies.html.

21 D. Bordwell, *Making Meaning* (Cambridge: Harvard University Press, 1989), pp. 19–20.

22 *Ibid.*, p. 35.

23 *Ibid.*, pp. 38–9.

24 Murphy, *Sixties British Cinema* (London: BFI Publishing, 1992), pp. 58–69.

25 J. Ellis, 'The Quality Film Adventure: British Critics and the Cinema, 1942–1948', in A. Higson (ed.), *Dissolving Views: Key Writings of British Cinema* (London: Cassell, 1996), pp. 66–93.

26 J. Hartley, *Popular Reality: Journalism, Modernity, Popular Culture* (London: Arnold, 1996), p. 6.

27 S. Frith, *Sound Effects: Youth, Leisure and the Politics of Rock'n'Roll* (London: Constable, 1983), p. 165.

28 P. Houston, 'The Front Page', *Sight and Sound* 26:2 (Autumn 1956), p. 59.

29 P. Houston, *The Contemporary Cinema* (London: Pelican, 1963), pp. 113–14.

30 J. Morgan, *Sight and Sound* 24:3 (January–March 1955), p. 161.

31 *Films and Filming*, 8:1 (October 1961), front cover; R. Bean, 'Muscles and Mayhem', *Films and Filming* 10:9 (June 1964), pp. 14–18.

32 'The Year', *Films and Filming* 7:4 (January 1961), p. 29.

33 B. Baker, 'Picturegoes', *Sight and Sound* 54:3 (Summer 1985), p. 208.

34 M. Hinxman, 'Even a "Fan" Deserves an Honest Answer', *Films and Filming* 5:10 (July 1959), p. 15.

35 Advert for *Escapade in Florence*, *Photoplay* (June 1963), pp. 52–3.

36 'Welcome to the New MM!', *Melody Maker* (14 September 1963), front cover.
37 Frith, *Sound Effects*, p. 167.
38 G. Lambert, 'Rebel Without a Cause', *Monthly Film Bulletin* 23:265 (February 1956), p. 17.
39 D. Prouse, 'Rebel Without a Cause', *Sight and Sound*, 25:5 (Winter 1955/56), pp. 161, 164.
40 L. Anderson, 'Stand up! Stand up!', *Sight and Sound* 26:1 (Summer 1956), p. 66.
41 L. Anderson, 'Get Out and Push', in T. Maschler (ed.), *Declaration* (London: MacGibbon and Kee, 1958), p. 160.
42 Ellis, 'The Quality Film Adventure', pp. 66–93.
43 *Ibid.*, p. 68.
44 A succinct discussion the climate of morality confronting American teenage girls in the 1950s and early 1960s is to be found in B. Ehrenreich, E. Hess and G. Jacobs, 'Beatlemania: A Sexually Defiant Consumer Subculture?', in K. Gelder and S. Thornton (eds), *The Subcultures Reader* (London: Routledge, 1997), pp. 523–36.
45 Prouse, 'Rebel Without a Cause', pp. 161–4.
46 Houston, *The Contemporary Cinema*, pp. 175–6.

Chapter 2

British society, culture and politics, 1955–65

Post-war Britain lived under the shadow of the events between 1939 and 1945. The nation's 'finest hour' had implications for domestic and foreign policy for at least twenty years after the cessation of hostilities. Economic and social reconstruction was essential to repay war costs of £28 billion obtained through taxation and domestic borrowing, not withstanding the huge financial debts owed to the US and Canada. Harold Perkin writes that:

> In addition to about 4 million houses damaged, nearly half of them destroyed, much of the industrial base – factories, mines, railways, power stations, gasworks and so on – had either been bombed or was worn out and needed replacement. In short, Britain was transformed overnight from a first-rate (if no longer the largest) military, political and economic power to a near-bankrupt nation completely outclassed by the United States and Russia.[1]

The cultural and social landscape in which pop films reached Britain during the mid-1950s had its origins in the legacy of the post-1945 political and economic settlement. Clement Attlee's Labour government of 1945–51 shaped British society and politics until the age of Thatcherism. The implementation of the wartime Beveridge proposals which established a full system of national insurance, child allowances, pensions and the creation of a National Health Service bequeathed a network of social provision that became part of British national life. Full employment rather than the control of inflation became the key economic priority. Britain simultaneously had to adapt to being an ally of the United States rather than acting as a great power. This transition did not mean the nation abandoned its previous imperial status, but rather ensured that the country now relied economically and militarily upon the Americans. Marshall Aid

contributed greatly to the avoidance of economic collapse in 1947–48, while by becoming a founder member of the North Atlantic Treaty Association (NATO) British foreign policy effectively became tied up with American interests.

The Eden and Macmillan governments, 1955–63

The period covered by this book almost directly coincides with the Conservative governments of Anthony Eden and Harold Macmillan. After succeeding Winston Churchill as Prime Minister in 1955, Eden automatically called a General Election; he obtained a landslide victory. Despite this success, he proved a disastrous Prime Minister burdened by ill health. The calamitous Suez crisis of late 1956 totally overshadowed Eden's tenure. Together with Israel and France, Britain intervened in Egypt to prevent Colonel Nasser from nationalising the Suez Canal. An illegal act of Victorian-style gunboat diplomacy, condemned by the United Nations, which threatened oil sanctions, and the Americans, the Suez crisis 'demonstrated with brutal frankness . . . that Britain was no longer in the great power league'.[2] The US threat to withdraw financial support for the pound culminated in a humiliating climbdown and illustrated that economic and political reality took precedence over Imperial sentiment.

Suez had three major consequences. First, the crisis fatally undermined Eden's political credibility, facilitating his resignation in January 1957. Second, Suez effectively killed the illusion about Britain's international status. During the premiership of Eden's successor Harold Macmillan, Britain decreased her military and Commonwealth commitments. Conscription was abandoned, while many former colonies, especially in Africa and the Caribbean, obtained full independence. The third, and most important, consequence of Suez, lay with the perception that Macmillan's leadership coincided with an age of optimism, an unprecedented era of consumer prosperity and affluence. In 1957, the Prime Minister stated that, 'Let's be frank about it, most of our people have never had it so good.' The popular image of 'Supermac', as depicted ironically by the left-wing cartoonist Vicky, a figure empowered with apparently magical abilities to conjure economic prosperity, received conformation by another Conservative landslide at the 1959 General Election.[3]

Statistical information appears to justify claims on behalf of the late 1950s as a golden age. Full employment remained a vital eco-

nomic priority; between 1948 and 1970, in 'only eight years out of twenty-three did the number of registered unemployed average as much as 2 per cent'.[4] The average weekly wage rose from around £11 pounds in 1955 to over £18 by the end of Tory rule in 1964, 'rising at a rate double that of prices'.[5]

The most spectacular elements of this affluence occurred through the increasing consumption of luxury goods, including televisions, cars, washing machines and vacuum cleaners. The percentage of households with refrigerators increased from around 8 per cent in 1956 to 33 per cent by 1962.[6] Similar trends occurred with regards to television ownership, especially after the introduction of commercial competition via ITV in 1955. In 1955 the total proportion of the population with access to television viewing was 40 per cent, rising to 75 per cent by 1959. By 1964 television reached over 90 per cent of the British public.[7]

This era marked a period of transition for the British film industry. The decline in cinema attendances that followed the record peak of 1,635,000 million in 1946 became obvious by the mid-1950s. In the decade after 1946 over 500 cinemas closed down, while by 1956 the total number of film admissions for the year declined to 1,101 millions. This fall accelerated, as 'between 1957 and 1963 the numbers of cinemas halved and admissions fell from 915 and 357 millions'.[8] While many adults began to stay away from the cinema, deciding to opt for the comforts of television at home, young people continued to visit the pictures. By 1959, it was estimated that teenagers comprised almost 30 per cent of the nation's consumer spending at the cinema, a figure that hinted at their relative demographic and financial strength.[9]

The issue of affluence remains controversial. In the early 1970s Vernon Bogdanor and Robert Skidelsky recalled the era 'as an age of illusion, of missed opportunities, with Macmillan as the magician whose wonderful act kept us too long distracted from reality'.[10] The positive material benefits of the consumer boom should not disguise the obvious problems within contemporary Britain during the late 1950s and early 1960s. Economic prosperity could only be achieved through the policies of boom and bust, which contributed to the financial difficulties that faced Harold Wilson's Labour administration between 1964 and 1970. Poverty did not disappear, while Clarke et al. state that the myths surrounding affluence and the apparent 'embourgeoisment' of the working class *obscured* the fact

that the *relative* positions of the classes remained unchanged' [italics in original].[11]

Despite the retreat from Empire and the emergence of modern consumer technologies Britain remained a conservative nation. Capital punishment continued until the mid-1960s, while homosexuality and abortion remained illegal. Women did not receive equal pay nor benefit from anti-discrimination legislation until the 1970s. Divorce was unavailable unless adultery could be proved. Young people under the age of twenty-one faced treatment as second-class citizens, remaining unable to vote or claim property rights, while being subject to conscription and the death penalty until 1960 and 1965 respectively. Racism remained at a time when thousands of British citizens from Commonwealth countries in Asia, Africa and the Caribbean migrated to Britain. The 1958 race riots in Nottingham and Notting Hill saw clashes between communities of West Indian origin and racist thugs. Controls were placed upon the numbers of potential immigrants with the 1962 Commonwealth Immigrants Act, which introduced a voucher system to those wishing to study, work or join their families in Britain. An indication of the hostility towards Commomwealth immigration occurred through contemporary opinion polls, which stated that 90 per cent of the population agreed with the legislation and that over 80 per cent of Britons believed that the country already possessed too many immigrants.[12]

Ultimately, the Macmillan era symbolised an age of transition. It witnessed the consolidation of the post-war reconstruction together with the initial stirrings of a multicultural society and the end of Empire. Politically, the Tory hegemony did not see the major social legislation introduced by the Attlee and Wilson governments. By the time of Macmillan's resignation in 1963, the Conservatives looked outmoded given the increasingly youthful face of Britain. The infamous Profumo affair only exacerbated the sleazy and moribund image of the ruling party as an upper-class elite. Burdened by this 'grouse moor' image, the Tories went down to defeat under Sir Alec Douglas-Home at the 1964 General Election.

Youth in the age of affluence

The 1950s boom in leisure consumption became synonymous with the rise of a teenage cultural and consumer identity. According to

Clarke *et al.*, British youth appeared to represent 'the prime beneficiaries of the new affluence'.[13] The period witnessed the important consequences of various demographic, social and cultural changes within Britain and America. The post-war baby boom in Britain ensured a significant increase in the number of young people reaching their teenage years between the mid-1950s and mid-1960s. Mark Abrams reported that in 1959, the country possessed 5 million teenagers, while the Albemarle report into 'The Youth Service in England and Wales' claimed that 'for every five young people between the ages of 15 and 20 today [1960], there will be, in 1964, six young people'.[14] From the early 1960s British youth also became more visible with the abolition of conscription which freed an estimated 160,000 young males per year from the prospect of National Service.[15]

Abrams' work concerning youth consumerism during the late 1950s particularly influenced discourses relating to teenage affluence. His widely quoted 1959 survey *The Teenage Consumer* described the emergence of 'distinctive teenage spending for distinctive teenage ends, a distinctive teenage world'.[16] He claimed that by the late 1950s youngsters possessed 'a grand total of £900 millions a year' to spend 'at their own discretion', illustrating the quantifiable changes within the world of the young compared to earlier generations: 'As compared with 1938, their *real* earnings (i.e. after allowing for the fall in the value of money) have increased by 50 per cent (which is double the rate of expansion for adults), and their real 'discretionary' spending has probably risen by 100 per cent' [italics in original].[17]

These findings are vulnerable to several criticisms. Abrams' definition of 'teenagers' as being aged between fifteen and twenty-four and unmarried is problematic, because of the widespread differentials among the people eligible for this category. For example, these conditions probably underemphasised the numbers and spending power of young married women. The survey never stated the geographical location of its empirical findings, the socio-economic background of its youthful informants or the exact number of people utilised during Abrams' work. As Bill Osgerby argues, these flaws ensured that the research largely avoided discussion of the widespread differences that existed among young people.[18]

Several important areas of Abrams' research retain significance. First, he acknowledged the importance of class and gender differen-

tials among teenagers. As an area primarily dominated by working-class boys, teenage consumption became 'very much a male world'.[19] Rejecting the connection between youth affluence and the decline of the class system, principally evident in the novels and journalism of Colin MacInnes, Abrams emphasised the importance of such considerations:

> The average boy spends 71s 6d a week; this is nearly one-third more than the weekly expenditure of 54s by the average girl. At the same time male teenagers outnumber girl teenagers (by 5 to 4), and one consequence of these two disparities is that male spending accounts for nearly two-thirds (63 per cent) of all teenage spending. The average boy spends over 22 shillings a week (31 per cent of his total) on drinks, cigarettes and entertainment admissions. For the average girl, expenditure on these comes to only 7s 6d, or less than 14 per cent of her total spending.[20]

Second, Abrams documented the importance of specific teenage markets such as cosmetics and food products. The real significance of his findings lay with his acknowledgement of the strength of the youth market for films and popular music. For example, teenagers bought an estimated 44.1 per cent and 42.5 per cent of all records and record players as a percentage of all consumer spending in 1957 and 1959 respectively. In each year, they also comprised over a quarter of all spending at the cinema.[21] The development of the teen movie and the impact of rock'n'roll both testified to the importance of the increased consumer status of teenagers.

Third, Abrams acknowledged the potency of Americanisation. In his first report, he stated that:

> Post-war British society has little experience on providing for prosperous working class teenagers; the latter have therefore, in shaping their consumption standards and habits, depended very heavily on the one industrial country that has such experience, i.e. the United States. For various reasons it is difficult for the middle-aged British manufacturer to adopt the styles and appeals of American manufacturers connected with the teenage market.[22]

This preference for American consumer products existed not only through new types of consumer goods, typified by jeans, but also through the musical and cinematic artefacts offered to young people. The key catalyst for this process centred around the emergence of rock'n'roll.

Early rock'n'roll in Britain – teenage identity, juvenile violence and fears of Americanisation

The mid-1950s teenage cultural revolt chiefly revolved around two iconic figures, James Dean and Elvis Presley. The significance of each star concerned their apparent personification of the anxieties of youth. Through his performances in *East of Eden* (1955) and *Rebel Without a Cause*, Dean encapsulated the apparent confusion of his generation. The star's early death perpetuated his image as a timeless symbol of youth struggling against adult indifference. In the years immediately following his death, a death cult emerged around the star's image. Throughout the mid-to-late 1950s, the pages of populist film publications, such as *Photoplay*, *Picturegoer* and *Picture Show*, regularly contained items relating to the deceased icon. To a certain extent, this logically resulted from the posthumous British releases of *Rebel Without a Cause* and *Giant* (1956). In retrospect the positioning of this material on Dean to appease his teenage fans appears particularly significant. Film newspapers sold on the basis of featuring reproductions of the star's last-ever signed photograph, while the classified sections of the music press and popular film publications advertised commemorative souvenirs.[23] Articles concerning the actor's life story appeared frequently together with the occasional investigation into the death cult that developed around his star persona, which undoubtedly contributed to the popular myth of Dean as a martyr for teenage anxieties.[24]

Presley presents a slightly different case. Although John Mundy claims that the star's screen roles actually operated according to the standards of the Hollywood musical through their emphasis on entertainment, heterosexual romance and support for American capitalism, such a view underestimates the way in which 1950s audiences and critics saw Presley as something very different from previous stars.[25] Of course, Bill Haley was the first rock'n'roller to achieve success in Britain, while the crooner Johnny Ray aroused the condemnation of the press for his 'frankly dreadful' use of 'extraordinary showmanship' that made 'havoc of our national character'.[26] Both of these American performers caused an often forgotten stir within Britain before anyone in the country had heard of Presley. However, they lacked Presley's youth and generational appeal: despite press denunciations neither Ray nor Haley ever completely became outlaw symbols of youth separateness and isolation from

adult tastes. As one observer comments about Haley, 'at the age of 32, he was a little too old to be seen as the voice of teendom, and his personality was more avuncular than erotic'.[27] Famously Haley's popularity declined after his visit to Britain, while Presley always possessed a mystique because of his failure to perform outside North America. As one Presley fan explained in the January 1957 edition of *Photoplay*, when the magazine asked 'why do teenagers worship young stars who, in their film roles at least, represent youth – and human nature – at its worst?', perceived deviance only increased the attractiveness of such icons:

> First and foremost, Elvis is like one of us . . . He is a little frustrated, unsure, impulsive . . . He is no child, yet he is still not an adult . . . He is sure about some things but confused about others, just as we are. To me, Elvis represents everything that is uninhibited and unconventional. He's an outlet – an escape for our feelings. He demonstrates a wild, free emotion that we teenagers would like to express but can't . . .[28]

Rock'n'roll music and films quickly became associated with juvenile delinquency, the Teddy Boys and perceived immorality. The notorious Teddy Boy subculture predated rock'n'roll by several years. Fears over teenage delinquency achieved moral panic status during the 1950s thanks to several high-profile cases. The notorious Bentley-Craig case of 1952, which brought about the execution of the mentally retarded Derek Bentley for the killing of a policeman committed by his sixteen-year-old co-defendant, Christopher Craig, seemingly owed something to the glamorous screen images of gangster chic. The 1954 Clapham Common murder involved the death of a seventeen-year-old at the hands of a slightly older youth after a series of gang fights among Teddy Boys. Alongside the Edwardian-style draped suit, the flick-knife and the bicycle chain became the symbols of the subculture. The period also saw a substantial increase in juvenile crime, with the most spectacular cases often involving a combination of flick-knives and Teddy Boys. In 1955 the total number of males 'convicted of an indictable offence in England and Wales' among the 14 to 17 and the 17 to 21 age groups totalled 13,517 and 11,269 respectively. By 1958, these figures had risen to over 21,000 for each age classification. In 1961, the numbers convicted among these age groups reached 28,244 and 27,667.[29] Perhaps more alarming figures occurred in the statistics concerning 'those convicted for offences of violence against the person', which

included crimes such as assault, grievous bodily harm and murder. For these felonies, in 1956 among the 14- to 17-year-olds and the 17- to 21-year-old categories, the numbers of convicted criminals totalled 461 and 1,248 respectively. By 1960, figures relating to the same categories numbered 1,416 and 3,006.[30] These statistics, combined with high-profile incidents of juvenile delinquency, appeared to present a major social problem. The Teddy Boys became perceived as the greatest moral and physical threat to the social cohesion of 1950s Britain. The other side to the cosy, consumerism of the 'You've never had it so good' era featured thuggish, racist youths armed with flick-knives. According to T. R. Fyvel, by the mid-1950s 'juvenile delinquency had for the first time in Britain become elevated to the status of a national problem'.[31]

For the nation's moral and cultural arbiters, the Teds' apparent preference for rock'n'roll linked the music with delinquency during the mid-1950s. The first genuine rock'n'roll movie, Haley's *Rock Around the Clock*, established a popular connotation between rock-'n'roll and juvenile delinquency. During cinema performances scenes of violence and disorder occurred at regular intervals in numerous theatres. Indeed the movie attracted the interest of young people fascinated by the scent of trouble.[32] John Lennon, then a rebellious teenager whose behaviour verged on the antisocial, later expressed disappointment that at his viewing of the film no dancing in the aisles or destruction of the cinema seats with flick-knives took place. He claimed that 'I was all set to tear up the seats too but nobody joined in.'[33]

NME, the more populist of the two leading music papers, blamed the Teddy Boys rather than ordinary fans for the trouble. According to the paper, Haley's music and the film contained 'nothing in it to incite people to go wild, or to indulge in hooliganism'.[34] This view was probably correct, yet *Melody Maker*'s Steve Race simplistically equated rock'n'roll music and movies to social dislocation. He claimed that 'a great many juvenile delinquents' belonged to the Teddy Boy subculture. Race connected this threat to the social order to the Ted style of dress, which featured conspicuous long-length draped suits, drainpipe trousers and long hair gelled back in the manner of Dean and Presley. This clearly differed from the 'nice quiet suit' demanded by Race and the rest of adult society.[35] Rather than accepting prescribed codes of dress and behaviour, the Teddy Boys confronted the dullness and regimentation of post-war Britain.

Their apparent tastes in rock'n'roll also threatened this cosy consensus. Race, a jazz enthusiast, recognised the possible threat posed by rock'n'roll to his own musical preferences. Invoking the name of a contemporary rock'n'roll movie, *Rock, Rock, Rock*, he crudely compared the sober, educated jazz collector with the disorderly working-class louts:

> The quiet jazz student working in a solicitors' office suffers because while he was playing 'Ella and Louis' to himself at home last night, 300 of his contemporaries were marching down the High Street shouting 'Rock, Rock, Rock!'
>
> The girl behind the counter at Boots gets funny looks because 10 teenagers who swing bicycle chains at a dance are jazz enthusiasts, and so is she. Just how far can we go in fouling our own nest, I wonder?[36]

The alleged immorality of the music exacerbated the mythical association between rock'n'roll and deviance. Race denounced several unnamed Presley songs for possessing 'cheap, meretricious lyrics which in my view cross the borderline between harmless fun and lightly disguised filth'.[37] Moral panics surrounding Presley's stage gyrations and the notorious marital activities of Jerry Lee Lewis cemented the connection between rock'n'roll and moral laxity.[38] Several churchmen, most notably the Rev. Albert Carter of the Pentecostal Church, Nottingham, actively believed that rock'n'roll aimed to turn teenagers into 'devil worshippers'. His comments, originally published in the *Daily Mirror* and then in *Melody Maker*, obviously provide an extremist denunciation of rock'n'roll, but considering the *Mirror*'s position as the leading popular newspaper in Britain at the time, they undoubtedly contributed to the negative public image of rock'n'roll: 'Rock-'n'-Roll is a revival of devil dancing . . . the same sort of thing done in black magic ritual.' Its effect on young people, he said, was '[t]o turn them into devil worshippers: to stimulate self-expression through sex; to provoke lawlessness, impair nervous stability and destroy the sanctity of marriage'.[39]

The association between rock'n'roll and delinquency extends into a discussion of another pivotal issue that reoccurs in subsequent chapters, namely the association between Americanisation and the apparent deterioration of cultural standards. Most famously, Richard Hoggart offered his critique on what the Americanised 'world of fantasy' possessed for young people in his 1957 book *The Uses of Literacy*:

Girls go to some [of these milk-bars], but most of the customers are boys aged between fifteen and twenty, with drape-suits, picture ties, and an American slouch. Most of them cannot afford more than a succession of milk-shakes, and make cups of tea serve for an hour or two whilst – and this is their main reason for coming – they put copper into the mechanical record-player . . . The young men waggle one shoulder or stare, as desperately as Humphrey Bogart, across the tubular chairs.

Compared even with the pub around the corner, this is all a peculiarly thin and pallid form of dissipation, a sort of spiritual dry-rot amid the odour of boiled milk. Many of the customers – their clothes, their hair-styles, their facial expressions all indicate – are living to a large extent in a myth-world compounded of a few simple elements which they take to be those of American life.[40]

Hoggart's commentary attributed negative cultural and social practices to American influences. In this way his attitudes coincided with the prevailing intellectual and class-determined discourses at the time that perceived Americanisation as symptomatic of declining artistic standards. For example, Fyvel wrote that: 'To the refined middle-class ear, the raucous sound of an infernal machine blaring out something like [Presley's] "Jailhouse Rock" at deafening volume in a small confined space, i.e. a small café crowded with overdressed Teddy Boys and their girl friends, may seem like a good idea of hell.'[41]

In his account of the artistic discourses which attacked various strands of US popular culture, Dick Hebdige claims that 'the debates about popular taste tended to revolve around two key terms "Americanisation" and the "levelling down" process'. Considering the context of an increasing political and economic alignment with the United States, British observers during the 1950s often believed that the dissemination of American popular culture exacerbated national decline: 'The erosion of fundamental "British" or "European" values and attitudes and taste associated this "levelling down" of moral and aesthetic standards with the arrival in Britain of consumer goods which were either imported from America or designed and manufactured on American lines.'[42]

For over a century British intellectuals had attacked American culture as inferior, commercial and debased. Victorians such as Charles Dickens and Matthew Arnold saw the democratic spirit within US society, culture and politics as a threat to British traditionalism: the old world represented ancient civilisation, while transatlantic influences typified vulgarity. Throughout the twentieth century influen-

tial commentators, including F. R. Leavis and J. B. Priestley, negatively compared the 'Admass' of US popular culture to the organic vitality and community spirit of British folk and popular art.[43] Only a few years before the rock'n'roll explosion a major campaign headed by educationalists, and initially communist activists, sought to ban American horror comics from British shores. In each case, much of the hostility towards the feared influx of US culture resulted from a belief that such material endangered British cultural standards. Specifically, Americanisation potentially threatened the nation's youth. John Davis claims that 'the theme of "youth-as-a-natural-asset"' provided an important discourse within contemporary government reports. Youth could serve as the basis for an optimistic future, a reinvigoration of the nation's esteem after the turmoil of the previous twenty years, providing educators and those with cultural influence could guide the adolescent towards a promising tomorrow.[44]

From a cultural angle, this assumption that youth represented Britain's future meant that young people had to receive training to be able to discriminate between 'good' and 'bad' culture. Very often the task of improving teenage tastes connected to Americanisation. In 1958 *Melody Maker* launched a campaign for better pop music, declaring that 'the time has come to call a halt in the amount of trash consistently being fed to the public, under the guise of entertainment'.[45] Similar comments, explicitly related to young people's cultural tastes, featured in a 1956 *Sight and Sound* article entitled 'The Cynical Audience'. The cinematographer and close ally of the BFI film critics, Walter Lassally, expressed fears that the public's tastes faced manipulation by devious producers. He claimed that 'the atmosphere of contemporary America – impotent and cynical, with overtones of hysteria – . . . will at the moment most strongly influence mass audience taste, tending in many ways to depress it'.[46] Both *Sight and Sound* and *Melody Maker* saw themselves as educational organs, performing the task of improving the public's cultural tastes in film and popular music respectively. Each publication believed that critics and influential persons inside the cinema and music industries possessed an obligation to inform teenagers unable to discriminate between good and bad culture:

> The effect of bad films on their audience, and especially on juvenile and adolescent minds in that audience, has been a discussion for many years. Now, however let us be concerned with the effect not on their

actions in real life, but on their reactions to good films. However often film producers may have been exhorted to lead public taste rather than to follow it, they still seem to be doing the latter. So the films produced today are a reflection of contemporary audience taste – notably of the ideas and standards held by the younger section of the audience – and this in turn is partly a reflection of contemporary American attitudes.[47]

Do they really complacently accept the fact that the men in control of our music business have no qualms about turning Britain into a musical 50th State of America?

When profits are at stake, some of them would be quite prepared to abandon any sort of national representation at all.

As it is the situation is grotesque. How ridiculous it is when a Cockney singing American folk songs in a fake accent can become a star! And at the time English popular songs are pushed entirely out.[48]

Second, the complaints against American films and popular music linked back to the issue of British national pride. The extracts from Lassally and Vic Lewis contained not only an obvious anti-American sentiment, but also articulated a strongly pro-British stance. This raises the question about whether statements displaying resentment against US culture really disguised a pro-British position. In his work dealing with the horror comics moral panic Martin Barker discusses how the campaign changed from a 'crude' anti-Americanism to a defence of traditional British values. Although, in various interviews, those involved with the early Communist Party motivated agitation claimed that their desire 'to get back to some kind of English tranquility' rather than resentment against US culture inspired their actions, Barker writes that 'there is no doubt that, in the early days, the expression was anti-American'.[49] The implication emerging from Barker's research is that statements supporting British pop culture, values and stars effectively involved a patriotic reassertion of the nation's strength. Commentators might have denied that they possessed anti-American feelings, but often their mistrust concerning certain trends in US popular culture became evident. Support for British performers, especially Cliff Richard and Tommy Steele, provided a means for defending national esteem during a time of uncertainty. If the future of Britain lay with its youth, then the success of the country's young cultural talent provided a new avenue for national pride.

Another crucial aspect of British cultural thinking resulted from notions of what constituted good entertainment. Much of the

importance of rock'n'roll lay with the assumption that such a trend posed a threat to British assumptions about quality entertainment, embodied by the Reithian concept of public service broadcasting. Established by the founder of the BBC, John Reith, in the 1920s, this ethos influenced how pop films would be consumed and produced in Britain. First, British cultural mediums, specifically broadcasting, possessed an obligation to serve the entire nation. Radio and television programmes intended to create a sense of communal values and national pride among the diverse classes, nations and ages of Britain. Certain key national events received official approval through being listed events, occasions for national celebration typified by sporting landmarks such as the Grand National and the FA Cup Final. Solidarity was encouraged through the BBC's maintenance of a centralised system of broadcasting, which left little space for the various nations and regions of Britain to develop their own broadcasting policies separate from London, although the introduction of the regionally based ITV system in the mid-1950s did partially redress this imbalance.

Second, the key element of public service broadcasting resulted from its unwritten/unspoken assumption that good entertainment meant family entertainment. A quality television programme, film or entertainer ideally offered something for every member of the family, regardless of age. For example, many British television programmes during the 1950s operated around the premise of attracting an inter-generational audience. Variety shows, typified by *Sunday Night at the London Palladium*, quiz programmes and later soap operas, such as *Coronation Street*, all appealed to a wide range of viewers. The same effectively occurred with the BBC's first programme to respond to the teenage consumer culture, *6.5 Special*. This show owed its place in the schedule to the 'toddler's truce', referring to its timing after the programmes devoted to children. Its broadcasting slot at six o'clock on Saturday evenings not only attracted ratings of between six and seven million viewers, but also ensured that the show consciously embraced children, teenagers and adults alike. It presented the classic case of a family entertainment show that possessed an assumed target profile of 'the family gathered around the television set while eating'.[50] This accounted for the varied nature of the programme's content featuring publicity for the Duke of Edinburgh Award Scheme, a concert pianist, reports on outdoor pursuits and comedians, besides pop music. *6.5 Special* was not

a rock'n'roll show: jazz bands, skiffle and British stars influenced by the music hall variety tradition also featured prominently. Live appearances from American rock'n'roll stars seemed conspicuous by their absence, although importantly extracts were shown from US rock movies such as *Shake, Rattle and Rock* and *The Girl Can't Help It*.[51] The programme firmly subscribed to the classic BBC public service broadcasting model. *6.5 Special* attempted to educate and entertain through its attempts to cater for the entire family rather than solely the sectional interests of teenagers. Appealing to just the young audience would have betrayed the ethos of family entertainment vital to British popular culture during this period.

To a large extent the British pop movie developed along these lines until its demise as a significant sphere of film production in the mid-1960s. As chapter 5 reveals, the pop film marked an attempt to link chart performers to the family entertainment tradition. The British pop film was as often aimed at pre-teenage children as teenage consumers in their mid-to-late teens. The audiences for the concert in *A Hard Day's Night* are clearly aged around twelve or thirteen, while Bob Dylan is greeted by screaming 'teeny-boppers', evidently of school age, in the documentary film about his 1965 British tour *Don't Look Back* (1967). This raises a question about whether the pop film could ever have been anything other than a mediated product designed to appeal to the wider family unit. The remainder of this book shows how the rock'n'roll movies endorsed the sub-cultural status of teenagers without alienating parental influences.

Notes

1 H. Perkin, *The Rise of Professional Society: England Since 1880* (London: Routledge, 1989), p. 408.

2 P. Clarke, *Hope and Glory: Britain 1900–1990* (London: Penguin, 1996), p. 263.

3 *Ibid.*, p. 255.

4 *Ibid.*

5 *Ibid.*

6 A. Marwick, *British Society Since 1945 – 3rd edition* (London: Penguin, 1996), p. 117.

7 T. O'Sullivan, 'Television Memories and Cultures of Viewing, 1950–65', in J. Corner (ed.), *Popular Television in Britain: Studies in Cultural History* (London: BFI Publishing, 1991), p. 161.

8 R. Murphy, *Sixties British Cinema* (London: BFI Publishing, 1992), pp. 102–3.

9 M. Abrams, *Teenage Consumer Spending in 1959* (London: London Press Exchange, 1961), p. 4.

10 V. Bogdanor and R. Skidelsky (eds), *The Age of Affluence* (London: Macmillan, 1970), p. 7.

11 J. Clarke, S. Hall, T. Jefferson and B. Roberts, 'Subcultures, Cultures and Class: A Theoretical Overview', in S. Hall and T. Jefferson (eds), *Resistance Through Rituals: Youth Subcultures in Post-War Britain* (London: Hutchinson, 1976), p. 22.

12 Marwick, *British Society Since 1945*, p. 164.

13 Clarke *et al.*, 'Subcultures, Cultures and Class', p. 18.

14 Abrams, *Teenage Consumer Spending in 1959*, p. 3; Ministry of Education, *The Youth Service in England and Wales* (The Albemarle Report), Cmnd. 929 (London: HMSO, 1960), p. 13.

15 B. Osgerby, *Youth in Britain Since 1945* (Oxford: Blackwell, 1998), p. 20.

16 Abrams, *The Teenage Consumer* (London: The London Press Exchange, 1959), p. 10.

17 *Ibid.*, p. 9.

18 Osgerby, *Youth in Britain Since 1945*, p. 25.

19 Abrams, *Teenage Consumer Spending in 1959*, pp. 7–8.

20 *Ibid.*, p. 7.

21 *Ibid.*, p. 4; Abrams, *The Teenage Consumer*, p. 10.

22 Abrams, *The Teenage Consumer*, p. 19.

23 For evidence of this 'death cult' via contemporary advertising see: *Picture Show* (12 January 1957), pp. 1, 9; *Picture Show* (13 February 1958), p. 13.

24 Examples of this tendency include: W. C. Mellor, 'The James Dean I Knew', *Picturegoer* (29 December 1956), p. 17; 'The James Dean Story', *Picturegoer* (7 December 1957), pp. 12–13; 'Suicide? I say No . . . and here's why', *Photoplay* (January 1959), pp. 32–3, 46, 50–1; P. Tipthorp, 'Dean Hysteria: Is it Starting Over Again?', *Photoplay* (April 1959), pp. 7–8, 53.

25 J. Mundy, *Popular Music on Screen: From the Hollywood Musical to Music Video* (Manchester: Manchester University Press, 1999), pp. 115–23.

26 D. Cavanger in the *Financial Times*, quoted in 'Johnnie Ray – Yes!', *NME* (29 April 1955), p. 6.

27 C. Larkin (ed.), *The Virgin Encyclopedia of Fifties Music* (London: Virgin Books, 1998), p. 173.

28 P. Evans, 'The Rebels', *Photoplay* (January 1957), p. 8.

29 T. R. Fyvel, *The Insecure Offenders: Rebellious Youth in the Welfare*

State (London: Penguin, 1963), p. 15.

30 *Ibid.*, p. 17.

31 *Ibid.*, p. 18.

32 *Melody Maker* (15 September 1956), p. 4.

33 M. Braun, *'Love Me Do!' – The Beatles' Progress* (London: Penguin, 1995 [1964]), p. 35.

34 'The New Musical Express Rck'n'Roll Supplement', *NME* (21 September 1956), p. 7.

35 S. Race, 'Teddy Boy Element is Fouling Jazz', *Melody Maker* (26 January 1957), p. 6.

36 *Ibid.*, p. 12.

37 S. Race, 'Here's How to Stop the Rot', *Melody Maker* (15 February 1958), p. 12.

38 For example see: H. Lucraft, 'It's Striptease Presley', *Melody Maker* (9 November 1957), pp. 8–9; 'Questions asked about Jerry Lee Lewis in Parliament', *NME* (27 June 1958), p. 6.

39 M. Burman, 'Rock-and-Roll on Radio', *Melody Maker* (20 October 1956), p. 5.

40 R. Hoggart, *The Uses of Literacy: Aspects of Working-Class Life with Special Reference to Publications and Entertainments* (London: Penguin, 1992 [1957]), pp. 247–8.

41 Fyvel, *The Insecure Offenders*, p. 70.

42 D. Hebdige, 'Towards a Cartography of Taste, 1935–1962', in *Hiding in the Light* (London: Routledge, 1988), p. 47.

43 D. Webster, *Looka Yonder! The Imaginary America of Populist Culture* (London: Routledge/Comedia, 1988), pp. 180–91.

44 J. Davis, *Youth and the Condition of Britain* (London: Athlone Press, 1990), pp. 93–117.

45 'Pop Rot! Call a Halt Now', *Melody Maker* (8 November 1958), p. 3.

46 W. Lassally, 'The Cynical Audience', *Sight and Sound* 26:1 (Summer 1956), p. 13.

47 *Ibid.*

48 V. Lewis, 'They Deserve a Better Deal', *Melody Maker* (1 November 1958), p. 3. This article initiated *Melody Maker*'s 'better pop campaign'.

49 M. Barker, *A Haunt of Fears: The Strange History of the British Horror Comics Campaign* (London: Pluto Press, 1984), p. 27.

50 J. Hill, 'Television and Pop – The Case of the 1950s', in Corner (ed.), *Popular Television in Britain*, p. 92.

51 *Ibid.*, pp. 93–4.

Chapter 3

The rock'n'roll films of Elvis Presley

Unquestionably one of the definitive icons of our time, Elvis Presley is arguably the greatest figure in twentieth-century popular music. His career trajectory from poverty to stardom before entering a tragicomic decline articulates the triumphs and tragedies permitted by the American Dream. The repercussions resulting from his initial impact at the vanguard of the rock'n'roll explosion of the 1950s have influenced popular culture ever since. This chapter investigates several of these developments within a particular historical context, Britain between 1956 and 1958, emphasising how commentators from the music press and film periodicals reacted towards Elvis' image and cinematic career.

By necessity any examination of a cultural icon, particularly one of Presley's standing, requires a selective use of material. This chapter does not intend to evaluate his achievements, nor seek to explain the meaning of the star through close readings of his films. The work of the leading Presley chroniclers, Greil Marcus and Peter Guralnick, amply covers the former condition.[1] While interesting conclusions emerge from a textual study of certain Elvis movies, for instance the consistent promotion of American values such as self-reliance and the characterisation of his screen suitors, these studies belong outside of the parameters of this book.

Both Guralnick and Marcus stress the impossibility of writing the definitive account of Elvis Presley. According to Guralnick, 'no such thing' as '*the* story of Elvis Presley' exists [italics in original], while Marcus states that, owing to his significance as an icon and as a symptom of wider socio-cultural change, the star remains a 'mystery', an enigmatic figure whose precise importance represents 'something that cannot be exactly figured out or pinned down'.[2]

Presley's omnipresence, together with his impact during his lifetime, not only means that 'the world became something other than it would have been had he not done what he did', but also that the star has always lacked a precise cultural identity.[3] Since the 1950s, Presley has operated as the classic polysemic star, providing different meanings to millions determined by such conditions as cultural capital, age, gender and class.

Elvis' multi-layered image always existed under historically specific conditions and continues in this vein. During the 1950s and 1960s, Presley became not only the world's most popular musical performer – at least until 1964, but also throughout the period covered by this research the star was one of Hollywood's leading box-office attractions. As early as 1957, unprecedented deals made Presley one of the world's most highly paid movie actors, a situation that continued over the next decade.[4] Such unprecedented success, and the inevitable public interest which followed, ensured that Presley (or what he represented) never moved far from the era's cultural debates.

Presley – Americanisation and the impact of rock'n'roll

Before exploring Presley's film career, it is necessary to provide details about the initial British reaction to his music in 1956/57. His popularity, like the emergence of rock'n'roll music, in Britain is inseparable from the issue of Americanisation. Although Presley's UK chart success occurred after that of Bill Haley, and long-standing fears over the Americanisation of British culture existed, apprehension over these two processes reached their apogee via his fame. Not only did Presley emerge as the figurehead of the new trends in popular music and film production, but also he epitomised what cultural commentators feared most with regards to the burgeoning US influence within Britain.

Iain Chambers claims that analysis of the trends associated with American youth culture provides ample space for investigating the reception among British critical commentators and consumers of the latest transatlantic ideas.[5] Although much of the animosity towards Presley's first British record and film releases centred around debates concerned with the Americanisation of Britain, fears over US cultural imperialism did not provide the sole reason for such apprehension. As commentators such as Chambers, Dick Hebdige and

John Street observe, the attacks on rock'n'roll appeared symptomatic of wider anxieties embracing debates surrounding the differences between high and low culture, attitudes towards the commercialisation of the music and film industries, the obligations of light entertainment and the cultural education of young people.[6]

If Presley represented a symbol of Americanisation, then logically he emerged as a natural target for anti-US sentiments. This claim contains some truth: criticism against Presley's music in 1956 and 1957 often coincided with anti-Americanism. Many previous accounts of the emergence of rock'n'roll in Britain deployed the figure of Steve Race, the *Melody Maker* columnist, jazz musician and broadcaster, to highlight the antipathy towards rock'n'roll among leading music critics.[7] Race certainly proved capable of firing a virulent tirade against rock'n'roll and the Americanisation of popular culture; specifically he loathed Elvis Presley. His notorious condemnation of 'Hound Dog' invoked the issue of British national security:

> I fear for this country which ought to have had the good taste and good sense to reject music so decadent.
>
> I don't pretend to know what you and I can do about all this apart from stand by and watch it happen. Perhaps our only course is simply to register protest: to leave Elvis Presley with his 'rectinbutter houn dogger' and merely echo his last and only comprehensible line: 'You ain' no friend of mine'.
>
> You certainly ain' Elvis. And the sooner you and your nudderhudder rabidian return to the kennel, the better it will be for all of us.[8]

Race adopted the position of the bewildered outsider, spitefully protesting from the sidelines against this tide of musical 'repulsiveness', 'monotony' and 'incoherence'.[9] He depicted Presley as the vanguard of an American cultural invasion, that left the true defenders of musical taste (i.e. himself and other censorial colleagues at *Melody Maker*) helpless to prevent this tragedy, in the face of teenage demand and Presley's publicity machine. Race presented Presley as an enemy and, through his use of metaphor, as a threat to Britain's independence. The destruction of rock'n'roll, and the repatriation of Elvis Presley's music to America, became necessary to save the nation's youth and music from degradation. This comprised Race's solution to the twin threats to national unity and family entertainment, which comprised the ethos of British popular culture and broadcasting. He obviously believed that without Presley, that 'demented age-group', the teenagers, would no longer reign

supreme; instead Race hoped for a revival of the days when British families enjoyed together 'a tuneful song, tunefully sung'.[10]

Such comments deserve designation as anti-American. They contradicted Race's earlier claim that anyone who accused him of antagonism towards American popular culture talked 'insidious nonsense'.[11] He regarded US performers such as Frank Sinatra and Ella Fitzgerald as representing the highest musical standards, but his latent disgust at Presley displayed extreme anti-American prejudice. Yet the critical disgust for Presley largely resulted from an assumption that rock'n'roll represented 'bad' music. To what extent did commentators fully appreciate the origins of the music and its 'fusion' of the European and African-American musical codes?[12] Chambers rightly points out that Presley triggered 'the discovery of a previously unknown musical continent'.[13] This analysis accounts for anti-Presley hostility from commentators lacking sufficient musical knowledge, but such a diagnosis does not apply when considering the attitudes of the two leading music newspapers. The critics at *Melody Maker* and *NME* displayed awareness of rock'n'roll's origins, with each publication recognising that rock'n'roll utilised the 12-bar blues format. *NME* outlined the music's origins from earlier blues, jazz and country performers, while even Race admitted the 12-bar blues origins of the early rock'n'rollers.[14] The very fact that *Melody Maker* critics realised that earlier blues and jazz performers, such as Louis Armstrong and Bessie Smith, had worked within a musical paradigm not too distantly removed from rock'n'roll became a weapon in the fight against Presley and his contemporaries. Music critics described these earlier acts as proper musical artists with sophistication and good taste: Presley personified a commercialised pop culture that represented fundamentally bad music, a dilution of the musical integrity and complexity of his antecedents.[15]

Why did critics classify Presley's early recordings as 'bad' music? Dick Bradley suggests that many people considered rock'n'roll music 'too loud'.[16] Presley's music especially breached the boundaries of appropriate musical volume. For Race, 'Hound Dog' offered a 'thoroughly bad record', lacking in 'tone, intelligibility, musicianship, taste [and] subtlety', through defying 'the decent limits of guitar amplification'.[17] Prior to rock'n'roll in Britain, 'the guitar was considered a rather exotic instrument, largely confined to the rhythm sections of dance bands'.[18] Not only did 'Hound Dog'

include a lead guitar solo that refused to remain in the background, but also the track features a battle for individual volume between vocals, guitar, bass and drums. Presley's early work did not represent the then dominant form of popular music where the orchestrated string arrangements remained decisively in the background behind a crooning vocalist.

Critics also complained about the allegedly unintelligible nature of Presley's vocal style. Race's dissection of 'Hound Dog' compared Presley's vocal delivery to Sinatra and Fitzgerald, figures renowned for their clear, smooth, swinging jazz vocal styles. For the likes of Race, Elvis typified the decline of musical standards away from audible diction and music that conformed to the traditional European/Broadway mode of vocal delivery:

> The Rock-and-Roll technique, instrumentally and vocally, is the antithesis of all that jazz has been striving for over the years – in other words, good taste and musical integrity . . . It is a monstrous threat to the moral acceptance and artistic emancipation of jazz. Let us oppose it to the end.[19]

Chapter 2 discussed the intellectual disdain towards teenage culture. This disposition undoubtedly influenced critical opinions about teen movies, pop music and youth idols, most notably Elvis Presley. In a 1957 *Melody Maker* article, significantly entitled 'Rubbish on Record', Tony Brown attacked the operations of the music industry, albeit putting the blame for declining musical standards on disc jockeys, record company bosses and the so-called 'gimmick' singers typified by Presley. It contained an explicit contempt for the teenage record buying public, unable to discriminate between 'gimmick' material and 'really talented singers': 'a tousled head, a writhing torso count for so much more than intelligent phrasing and vocal chords that make musical sounds'. Brown even described the record industry as a world of 'musical prostitution' with 'shady salesmen pushing junk'.[20] This attitude explains why Brown found Presley's debut film, *Love Me Tender*, impossible to take seriously either musically or cinematically:

> Elvis Presley's success on record stems from a cynical policy of giving the undiscerning what they want; and as the undiscerning have no ear for understatement, for any kind of subtlety, the recorded Presley is a manifestation of the repetitious exaggeration necessary to penetrate and impress the record-buying mass nowadays.[21]

Presley represented the definitive 'gimmick' artist. The attention accompanying his overtly sexual stage gyrations, brooding looks and musical innovations permitted critics to dismiss his talent. To the anti-Presley brigade, the star's success resulted from his novelty value and the commercial acumen of his publicity machine rather than his musical ability. This position becomes clear with an analysis of reviews regarding *Loving You* (1957) by Brown and John Cutts in the *Monthly Film Bulletin*. Here the above material provides essential background to any understanding of the hostility directed towards Presley. The film tells the story of a young country and western/rock'n'roll singer, Deke Rivers (Presley), who becomes the key member of a touring troupe of country performers. His publicity agent, Glenda (Lizabeth Scott), uses Deke as a 'gimmick' to attract teenagers to the show, thereby sustaining the declining career of her client and erstwhile husband Tex Warner (Wendell Corey). The movie details Deke's rise to pop adulation, besides exposing Glenda's employment of manipulative methods, such as bribing crowds and stirring up anti-rock'n'roll hysteria among the elderly moral majority, in order to strengthen publicity for the new musical sensation.

The film's content enabled Brown and Cutts to confirm their anti-Presley prejudices. Several commentators consider Presley's screen career as a means of integrating the rebel into family entertainment, permitting him some agency (at least initially) via rock'n'roll musical routines, but ultimately serving to downgrade the rebellious lifestyle and music on screen for 'material success', love and an 'ability to *keep his place*' [italics in original].[22] In effect, the early Presley rock'n'roll films simultaneously celebrate and condemn the star and his music. In *Loving You*, this operated by emphasising the 'gimmick' status of Deke's performances. He achieves success partly through his musical talent and stage charisma, but also via gyrations that lead the moral crusaders to campaign for his prohibition. Although its hero achieves exoneration, the film hints that Deke would never have achieved his fame without the 'gimmick'. John Cutts interpreted the film and Presley's career in this way, in a review that condemned both as trashy mass culture for the cinematically and musically illiterate:

The phenomenon of Elvis Presley is one of the most puzzling and less agreeable aspects of modern popular music. Basically a rhythm-and-blues singer, Presley adopts a slurred and husky style of delivery and a

series of grotesque body gestures to impose on his otherwise innocuous material a suggestive meaning. In his first film, *Love Me Tender*, Presley's affected exuberance was somewhat subordinated to the demands of the Civil War melodrama; in *Loving You* he is allowed more scope and is at all times both the cause and sum total of the film's somewhat doubtful entertainment value.[23]

Loving You also offers a satirical insight into the machinations of the music industry. Tony Brown welcomed this hostile critique of the rock'n'roll industry, proudly declaring that 'if the time has come for a little plain speaking, I'm all for it'. Although he acknowledged that Presley responded to 'the elementary demands of the part admirably', Brown did not mention how the star achieved this success, nor does the reader receive any information about his musical performance.[24] Brown's enthusiasm was unsurprising, because *Loving You* coincided with his own antagonistic attitude towards rock'n'roll. At various points in the movie, Glenda engages in dubious activities designed to further Deke's notoriety. These include encouraging teenage girls to scream at concerts, bribing elderly women to complain about Deke's alleged immorality on stage, manipulating press coverage over fights and love interests and purchasing a Cadillac for the singer – supposedly as a gift from a rich Texan widow. In her own words, sex represents 'a successful American commodity, which sells Coke, ice cream, steam engines, shampoo, real estate and tooth paste. It can sell singers too.'[25]

In this sense, the film attributes musical success to dishonest practices, exactly the stance adopted by Brown's critiques about 'Rubbish on Record'. The same commentator celebrated the cinematic dissection of the manipulative publicists. As he felt that gullible fans faced exploitation by these devious charlatans, the undiscerning public required information about the 'sham and deceit' of the music business that permitted 'gimmick' performers, such as Deke Rivers/Elvis Presley to achieve adulation. Brown's comments indicated his glee that rock'n'roll and Elvis Presley, in an autobiographical role, received condemnation directly in a teenage pop vehicle, which simultaneously celebrates these phenomena. He unwittingly exposed his own lack of understanding of the underlying causes of Presley's success by regarding the sub-plot as more important than the star's singing and acting:

> *Loving You* amounts to a pretty hefty indictment of the publicists of
> the pop world. This kind of exposure is going to cause as many gasps,

I fancy, as Presley's knee-trembling and noticeably tight trousers.
I applaud Paramount for exposing the sham and deceit.
They certainly had a nerve making this film. [italics in original][26]

The intellectual contempt expressed by Cutts and Brown towards
Presley's fans also hinted at the low critical esteem for fans. Henry
Jenkins describes how the term 'fan' is derived from the negative
connotation of 'fanatism'. Fandom contains associations with the
inability of female teenage fans 'to maintain critical distance' from
their heroes.[27] Therefore the attacks from Cutts and Brown emerged
as thinly veiled condemnations of young women unable to disasso-
ciate themselves from a critically despised form of popular culture.
For these critics, fans' worship of Elvis Presley replaced sober, con-
sidered value judgements with passionate enthusiasm based upon
aspects other than musical and cinematic quality. Sex appeal,
charisma and teenage solidarity had no place in the good taste artis-
tic agenda desired by the upholders of cultural hierarchies.

Love Me Tender – Elvis and teenage identification

The most popular film fan magazine of the 1950s, *Picturegoer* pos-
sessed a circulation of 349,000 in 1959.[28] Unlike the music press, the
paper featured in Mark Abrams' survey *The Teenage Consumer* pub-
lished in the same year. His findings calculated that in 1957/58, 14
per cent of Britain's 16- to 24-year-olds read *Picturegoer*.[29] Although
the results probably exaggerated the title's significance, its presence
in the research indicated that this film newspaper provided a major
source of cultural information for the nation's teenagers. This
ensured that the publication needed to maintain its circulation by
appealing directly to the preferences and sentiments of its reader-
ship, current and potential. As Stuart Hall and Paddy Whannel com-
mented, the teenage press and the star 'both thrive on mutual
admiration and goodwill'.[30] Therefore, the publicity in *Picturegoer*
could prove economically beneficial for Presley and his films, as a
means of expanding his popularity, and for the fan paper itself as a
means of strengthening its bond between the publication's writ-
ten/pictorial content and the changing teenage musical and cine-
matic trends.

This situation meant that space could be found to challenge the
anti-Presley hegemony. *Love Me Tender*'s initial coverage inside *Pic-
turegoer* displayed little sympathy for Presley. The publication's film

reviewer, Margaret Hinxman, gave the movie only one star, signifying, in her view, minimum artistic merit, describing the film as a 'dreary Pseudo-Western', 'a crashing bore' and occasionally 'unintentionally riotously funny'.[31] In a more detailed article about the film, Hinxman described the production as 'attempted manslaughter' of Presley's film career. Significantly, she directed the main body of criticism against Twentieth Century-Fox's 'over-eager rush to jump on the Presley bandwagon', rather than upon the star himself. Hinxman did not appreciate Presley's acting ability, but avoided condemning the star and his audience. She depicted the icon as the victim rather than as a puppet manipulated by the culture industries to lure the teenagers away from quality cultural forms:

> From where I was sitting in the stalls it seemed perfectly clear that Twentieth Century-Fox has simply used Presley for his big name reputation with the teenage rock'n'rollers, without any serious consideration for his future as a screen actor.
>
> He's not a bad actor. – But he simply isn't ready or experienced enough for a leading *acting* rôle. [italics in original]
>
> But, because this was Presley, it had to give the fans what they came for: long, lingering close-ups that sadly show up his ineptness.
>
> Everything about the film and Presley's part in it suggests this over-eager rush to jump on the Presley band-wagon.
>
> . . . So there's an embarrasingly contrived folksy interlude on the front porch where Presley sings to his family.
>
> . . . Believe me, I've no axe to grind about Presley one way or another. He doesn't send me. I don't actively dislike him either.
>
> But I do regret that in *Love Me Tender* Presley just doesn't get a chance.[32]

Hinxman's attitude indicated a more open-minded, and arguably democratic, form of film criticism evident within the pages of the popular cinema publications. Regardless of her own negative attitude towards *Love Me Tender*, Hinxman did not patronise her readership's tastes. Several weeks later in an article describing events at a special screening of the Presley movie, Hinxman raised pivotal points associated with the development of a teenage cultural and consumer identity. She detailed an active enthusiasm for Presley, American rock'n'roll and the culturally liberating aspects of teenage fandom, with a critical respect for Elvis' audience:

> Oh, what an evening! Up on the screen was Elvis Presley, girating [sic] furiously through *Love Me Tender*. Down in the cinema were

about fifty teenagers . . . screaming their heads off at every Presley twitch.

IN *PICTUREGOER*'S HISTORY WE'VE NEVER EXPERIENCED ANYTHING QUITE LIKE IT. [capitals in original]

. . . As soon as the lights dimmed and the title was flashed on the screen, a chorus of 'Ooohs' and 'Ahs' broke the silence. For some minutes, while Richard Egan was engaging in some elementary plot action, the air was thick with anticipation.

It was obvious that these picturegoers knew all about the story. When Egan talked about the girl he was going to marry (Debra Paget) there were nudges: 'She married Elvis'.

Then on the screen in the distance, there appeared a figure handling a plough. Then all round the theatre it was 'Elvis!' The first close-up provoked a near riot.

But that was just the beginning. When he sang there was no holding them.

They yelled with delight. And every appearance of Presley – tender, mad, vicious, tormented – was joyously welcomed.

As the film progressed, the Twentieth Century-Fox publicity girl feared for the safety of the Cinemascope screen, particularly when the moment was approaching for Presley to be killed in battle.

She needn't have worried. 'Don't shoot Elvis', they cried. And when the villain did the dirty deed, many of the girls were in a tearful misery.[33]

In conjunction with Hinxman's written text, *Picturegoer* displayed photographs and captions indicating audience pleasure at Presley's screen appearance. Photographs showed three teenage girls, screaming and raising their arms at the sight of the notorious Presley wiggle with the caption: 'That wiggle . . . it SENDS us. Oh, go man, go, Elvis!' Another teenager appeared smiling, yet placing her hands over her ears in a state of ecstasy at the star's presence, together with the comment that 'It's heaven just to see him at all – tender or sad'. The fans were shown crying with apprehension and dismay at the prospect of Presley's cinematic death, clasping their hands over their mouths and on the verge of tears. Here the captions again fitted the mood of the photographs very well: 'Watch out, Elvis, there are bullets flying everywhere', and 'Oh no, don't shoot Elvis. You just can't kill him.' Perhaps the caption that sums up the fan's sentiments best is: 'Oooh, isn't he wonderful now we can SEE him, too.'[34] [capitals in original]

These summaries highlight the genuine enthusiasm for Presley and his musical and cinematic personae. British teenagers actually

enjoyed this new American star and his music, a fact other publications found difficult to accept. Conspicuously, the article gave a platform of expression for Elvis fans, usually disregarded in critical accounts. Hinxman's title 'YOU go for Presley' symbolised Presley's status as a representative of a peculiarly teenage form of cultural taste. The second half of the article largely comprised of comments from audience members explaining their impressions of the film, its music and the star himself. In this way, *Picturegoer* permitted itself to become a medium for discussion among Elvis fans over the subject of *Love Me Tender*. The article provides historical support for Jenkins' claim that fans view 'texts with close and undivided attention, with a mixture of emotional proximity and critical distance'.[35] An example of this occurred with the conflicting opinions regarding Presley's screen death:

> Some were against it. 'Yes, it was a mistake. It was a mistake. It is wrong to make him die considering the title song', bemoaned sixteen year-old typist Valerie Hodges, Brixton.
> Not so, thought thirteen year-old Shelia Haines of Willesden: 'It's a very touching ending'. While Ann Mahoney (sixteen) from Fulham summed up the mass reaction: 'Just as long as I know he's alive in real life, it's alright'.[36]

Hinxman's admission that teenagers proved capable of elucidating their own comments about Presley and popular culture made a welcome difference from elsewhere. Her recognition concerning the gap between the critics and the audience seemed equally honest: bad reviews had no impact upon Elvis' following, something that the more intolerant critics never grasped. With the help of Presley, Britain's teenagers began to develop their own cultural identity whether censorious commentators liked it or not, but this marked a scenario which *Picturegoer* celebrated rather than condemned:

> What impressed US with these youngsters, though, was that, behind the uninhibited screaming and applause, many of them had clear, logical opinions about this boy Presley.
> They liked him a lot. But most of them realised that this was, after all, just a first film and were anxious to see him develop and improve in future rôles. And they *felt* that he would too.
> . . . If ever critics have been proved wrong about a film – this is it. Obviously, you're just wild about Elvis – AND THOSE PICTURES ON THE TWO PREVIOUS PAGES PROVE IT![37] [emphasis in original]

King Creole – Elvis and juvenile delinquency

Memorably described by the *Monthly Film Bulletin* as featuring 'calculated violence and viciousness', *King Creole* not only represents Presley's best screen performance, but also his most violent film.[38] This section negotiates the various discourses involved with the critical and journalistic reaction to *King Creole* in Britain.

The historical context of the late 1950s, explained earlier, raises theoretical issues that connect Presley to the transformation of youth culture through commercialisation. Dick Hebdige's discussion of youth subcultures claims that once-rebellious movements are tamed after being incorporated into mass-produced commodities. The process not only leads to the 'diffusion of the subculture's subversive power' but also hints at the 'imminent demise' of the erstwhile deviant youth culture.[39] At first sight this view would appear applicable to this study of *King Creole*. The publicity material for the film featured in the music press represented a moment when Presley's star persona moved away from an image associated with rock'n'roll rebellion towards a wider identification with non-deviant teenagers. However, this overlooks the extent to which youth culture is not autonomous but shaped by the various strands of the mass media, particularly film, television, pop music and the press. Such media forms are critical to the legitimisation of youth culture, often bringing musical forms previously exclusive to subcultural communities to the attention of wider audiences. Arguing for the importance of the mass media in encouraging the dissemination and wider acceptance of subcultures among teenage consumers, Sarah Thornton writes:

> Journalists and photographers do not invent subcultures, but shape them, mark them, mark their core and reify their borders. Media and other culture industries are integral to the processes by which we create groups through their representation. Just as national media like the BBC have been crucial to the construction of modern national culture, so niche media like the music press and style press have been instrumental in the development of youth subcultures.[40]

Given the importance of such sources for the study of youth culture, *King Creole* permits opportunities for an insight into the mediation of Presley's image in Britain by examining three 'niche' publications: the *Monthly Film Bulletin*, *Melody Maker* and *NME*.

Directed by Michael Curtiz, *King Creole* was Presley's fourth and final film before entering the US Army. In many ways, the plot rep-

resents the classic routine 1950s juvenile delinquent movie: Danny Fisher (Presley) a misunderstood young man with a weak father, becomes involved with a gang of mobsters and teenager hoodlums headed by the vicious Maxie Fields (Walter Matthau) and Shark (Vic Morrow). At various points within the film, we see Danny fighting with a flick knife and helping to carry out a robbery at a grocery store by playing his guitar, thus distracting staff and customers, while his acquaintances execute the theft. Simultaneously, Danny succeeds in establishing a singing career, which eventually results in his disassociation from the world of crime and brings about reconciliation with his family.

The *Monthly Film Bulletin*'s review of *King Creole* provided further evidence of the critical disposition that identified teenage culture with fears over American cultural influence, declining artistic standards, and juvenile delinquency: 'This entangled series of cliches, each with more unlikely motivation than the last, provides the most unattractive Presley vehicle so far. His numbers only offer intermittent relief from the calculated violence and viciousness, and he can do little to balance the disagreeable story.'[41]

The review gave *King Creole* a 'III' rating, denoting a 'poor' piece of work. Although the *Monthly Film Bulletin* never clarified this terminology, evidently it considered the film representative of the worst types of film being produced during the late 1950s. Quoting the work of Tony Bennett, Janet Staiger claims that the material appearance and positioning of particular texts actually places individual products 'within a specific ideology of consumption'.[42] The movie was singled out for special criticism: by classifying *King Creole* in the 'shorter notices' section, the periodical effectively condemned the film as being unworthy of serious critical and artistic scrutiny compared to productions granted the privilege of a named reviewer.

The critical leanings of the BFI-affiliated critics made *King Creole*'s critical disapproval virtually inevitable. Their realist and canonical preferences not only ensured that the film was found wanting against more distinguished works of cinema, but also that the production had the potential to influence potential deviants. Chapter 2 illustrated the importance of contemporary discourses surrounding juvenile delinquency and the Teddy Boys. Successive moral panics concerning flick-knives, Teddy Boy violence and rock-'n'roll riots helped to establish the new musical trend as morally and

culturally disreputable for the arbiters of public taste. Granted that Presley epitomised the potency of rock'n'roll's threat to the social fabric, a film like *King Creole*, which arguably glamorised teenage violence, could easily have illuminated elite fears about the star's influence. Although never associated with the rock'n'roll cinema riots to the extent of Haley, Presley could not escape the negative connotations between his style of music and juvenile delinquency. In January 1959 *Photoplay* described the violence at a screening of one Presley film, where the anti-social audience behaviour made the *Picturegoer* crowd appear positively sedate:

> The film had been running for about forty minutes. So far it had been comparatively peaceful, with only a few cat-calls showered at the screen.
>
> Then Presley started to sing.
>
> For a moment there was silence.
>
> Then a group of boys began to stamp their feet. A girl shrieked. The foot-stamping grew louder as it spread throughout the cinema.
>
> There were more screams and shouts. People left their seats and walked out of the cinema. A group of teenagers got up and started jiving in the aisles.
>
> In minutes the audience in front of the stalls had reduced the cinema to pandemonium.
>
> Ice-cream cartons were thrown at the screen. Boys in jeans and loose-fitting jackets ripped up a row of seats and turned them over. Fights were in progress all round.
>
> As Presley finished his song the shouting died. The cinema manager restored order more or less. Many of the youngsters were driven out of the cinema – following the older people they had driven out themselves.
>
> The sudden, spontaneous outburst of violence was over.[43]

The *Monthly Film Bulletin* review epitomised the critical assumption that scenes of delinquency easily influenced young people. Events such as those described by *Photoplay* represented exactly what the critical elite feared: the prospect of teenage thugs getting excitement from Elvis Presley. They obviously dreaded that youngsters might imitate Elvis via knife fights, robberies and underage sexual encounters. The *Monthly Film Bulletin*'s reviewer was unable to distance him/herself from the prevailing realist critical ethos or the presumption that teenagers appeared incapable of distancing themselves from images of screen violence and immorality.

Equally *King Creole* was attacked for being a formulaic and cliched teenpic. It appeared this way because it utilised the stereo-typical plots and characterisation of the 1950s teen movie. The delinquent, knife-wielding teenage gangs, the misunderstood son, the weak father, the innocent romantic interest, and the good-girl-turned-bad were all stock types from *Rebel Without a Cause* and *Blackboard Jungle* onwards. Indeed, Thomas Doherty comments that Vic Morrow's role as Shark stands as a 'virtual reprise' of his earlier performance as a knife-brandishing delinquent in *Blackboard Jungle*.[44]

This reliance upon formulaic and clichéd content also contributed to a decline in cinematic standards. As explained in Chapter 1, the critical establishment greatly welcomed *Rebel Without a Cause* due to its realistic and psychological insight into the American family unit. Presley's performance in *King Creole* obviously owed a debt to Dean and Marlon Brando. Danny Fisher's position as an anxious yet misunderstood young man appeared to mirror that of Jim Stark (Dean) in *Rebel Without a Cause*, particularly with regards to his relationship with a vacillating father. The New Orleans location of the Presley film echoes *A Streetcar Named Desire* (1951), starring Brando, set in the same city. Presley's white T-shirt and greasy hair during *King Creole*'s opening 'Crawfish' sequence resembles a pret-tified reconfiguration of the young rebel image, with Elvis adopting the slouch and the dress code of his two predecessors as the defini-tive 1950s youth icon. However this conscious imitation of Dean and Brando could easily have been seen as a threat to cultural stan-dards. Despite their rebel status Dean and Brando appeared in pres-tigious middlebrow dramas often with literary credentials, while *King Creole* originated from a pulp novel by Harold Robbins. Their links with the New York theatre and method acting ensured that they were affiliated with a distinguished acting tradition that appeared refreshing during the 1950s, especially to critics who appreciated the method's association with a more realistic style of performance. Hence, the BFI commentators could happily accept *Rebel Without a Cause*. Presley represented something very differ-ent: he was primarily a rock'n'roll singer rather than an actor. The attempt to integrate Presley into the Dean/Brando mode could easily have been seen as a deterioration of the artistic standards associated with those actors. The *Monthly Film Bulletin*'s comments concern-ing *King Creole* disguised an attempt to police the boundaries of

cinema against the negative artistic and moral connotations of rock-'n'roll and teenage culture. Denunciations of the film's 'calculated violence and viciousness' articulated the anxieties evident among elite critics at a time of immense social and cultural change that threatened their own aesthetic and critical values.

In both *NME* and *Melody Maker*, *King Creole* received the full event movie treatment and exceptionally positive reviews. Figure 1 reproduces *NME*'s front cover coinciding with the film's release. It displays three large Presley photographs, together with two sub-headings stating: 'ELVIS PRESLEY • Four Extra Pages • ELVIS PRESLEY' and 'SPECIAL 4-PAGE SUPPLEMENT IN THIS ISSUE' [emphasis in original].[45] These promotional lines located the purpose of the week's paper around the personality of Presley: the singer, the actor, the brave action hero and the icon. The front page written details explained the editorial slant towards his changing persona and the expectations of the paper's and by implication, Presley's target audience:

> ROCK and RIOT!
> Elvis Presley's latest film, *King Creole*, is released next week. He divides his time in it between singing with his guitar in a night club and . . . defending himself in dark alleys against the New Orleans 'Teddy Boys', whose boss is out to get Elvis.[46]

Presley's erstwhile nemesis Tony Brown reviewed the film for *Melody Maker*. Instead of the venom with which he greeted *Love Me Tender* and *Loving You*, Brown amazingly appreciated *King Creole*, an occurrence even more unlikely in view of the movie's theme and content. Under the headline 'Elvis Can Act!', he wrote:

> Sometimes it seems that the teenagers are smarter than the experts. They latched on to Presley and the other gimmick kings despite sneers that their idols were the progenitors of a no-talent race of entertainers.
>
> Now Presley has proved beyond all doubt that he has talent, a trick of personality – projection that made the rockers buy his records in the first place, a trick that has expanded on the screen into something a great deal more impressive.
>
> *King Creole* – Presley's latest film – confronts us with one irrefutable fact. Presley is an actor. He may not be in the Marlon Brando class, but he certainly can match most Hollywood-type stars, who never even so much pretend characterisation in depth – but draw crowds into the cinema.[47]

Why would such a trenchant enemy of Presley display enthusiasm for his acting ability in a film that makes the connection between rock'n'roll and juvenile delinquency explicit? Displaying enthusiasm for Presley's charismatic acting, Brown recognised that *King Creole* was a far better movie, dramatically and musically, than either *Love Me Tender* or *Loving You*. This could easily explain his change of

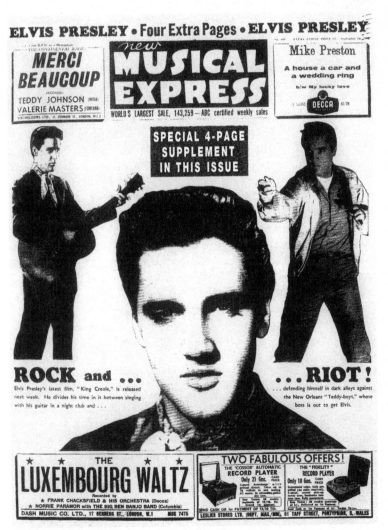

1 The multi-dimensional image of Elvis Presley

heart, but another reason deserves consideration. Brown's new attitude possibly lies within the context of the changing financial position of the two leading music papers at the time. Pierre Bourdieu rightly mentions the operational task which journalists working for commercial publications must fulfil in order to boost the market strength of their employer. He comments that such writers 'must endlessly work to maximise their clientele, at the expense of their closest competitors in the field of production . . . without losing their core readership which defines them and gives them their distributional value'.[48] This reflected the situation that occurred with the music press coverage of *King Creole*. The film reviews not only emerged in the context of a burgeoning teenage consumer identity, but also coincided with a circulation battle between two rival publications each attempting to reach out to young record buyers. Crucially, in July 1958, *NME*'s circulation outstripped that of *Melody Maker* for the first time. As the former's editorial boasted at the time, their sales had 'reached the staggering average weekly figure of 143,259 copies . . . a weekly increase of 37,684 copies over the previous six months'.[49] *Melody Maker* could no longer call itself 'The World's Best Selling Music Paper', the sub-title that previously proudly emboldened its front page. Whatever the anti-commercial ramblings of certain *Melody Maker* critics, business priorities dictated that a publication that belonged to Britain's premier publishing house, International Publishing Corporation (IPC), could not allow its main outside rival, *NME*, to steal its customers. Although *Melody Maker* retained ample jazz coverage, it now had to acknowledge pop and teenage tastes or it faced losing even more circulation ground to its chief market competitor. This possibly accounts for the surprisingly positive stance of Brown's review of *King Creole*: Presley was the greatest youth icon at a time when music newspapers increasingly had to serve teenagers.

This economic necessity for the music press to cater to the preferences of their readership provided the crucial determinant in accounting for the attitudes of *NME* and *Melody Maker* towards violence. Understanding of the comparative glamorisation of the publicity material surrounding Presley's juvenile delinquent film requires some historical context. According to John Davis, around 1958, 'teenagers' became a broad classification to describe non-deviant young people, explicitly distinct from the negative connotations associated with disreputable youth subcultures such as the

Teddy Boys and the beatniks: 'As the decade drew to a close, however, these two momentarily superimposed images of youth [the Ted and the Teenager], began in many respects to distance themselves from each other, and as this occurred the Teenager came to be viewed in far less uniformly unfavourable light.'[50]

The pre-Army Presley fitted decisively into the fears concerning deviant youth: as stated earlier many critics believed that Presley and rock'n'roll threatened moral and cultural decay. Despite its violence *King Creole* received publicity that appealed to the emerging 'clean teens' constituency explained in the Introduction. To quote from the American teen idol John Saxon's contemporary comments (almost certainly ghost-written), Hollywood now possessed an obligation to 'depict teenagers as a real happy bunch who like music, parties and good clean sports' rather than presenting 'films about teenage hoodlums'.[51] Matching this new climate of teenage morality, Figure 1 presents Presley as being against delinquency. From this initial publicity material Danny Fisher not only emerges as an ordinary teenager who has unfortunately got himself caught up with a gang of Teddy Boys, but also he represents a brave character who defends the dignity of himself, his family and exploited women against violent thugs like Maxie Fields and Shark. Given the culturally specific British reference to the Teddy Boys, such language positioned the star as being against anti-social behaviour. The star's image was reconfigured to suit a British social context that feared an upsurge in juvenile crime. The film's advertising in *NME* reinforced this message, with the claim that Danny/Elvis is 'struggling to the top against gangs and hoodlums!' Such material illustrates how Presley's image as the leader of world youth culture shifted in order to strengthen the campaign against the negative images associated with rock-'n'roll, namely juvenile crime, gangland violence and moral decay.

The written material that *NME* featured around *King Creole* also emphasised this stance. In a question and answer session, the 'normally quiet and polite' Presley discussed juvenile delinquency and his alleged role in contributing to this social problem:

Q: 'Some critics say your music causes juvenile delinquency. What do you say about that?'

A: 'I don't understand it. Delinquency to me means robbing, knife fighting and things like that. I've done nothing to cause that and I'd never set up a pattern like that for others to follow.'[52]

King Creole may have featured these activities, but the star increasingly distanced himself from such trademarks of delinquency. His military service inevitably facilitated this task, but Presley's gradual shift towards becoming an icon for youth culture as a whole, a representative of the majority 'clean teen' culture, rather than a symbol of teenage revolt also helped. By 1958, Presley finally established himself as unquestionably the most popular young American singer in Britain ahead of Pat Boone; an ominous indication of his shift from rock'n'roll rebel to a widely accepted family entertainer that badly damaged his post-1960 musical and cinematic credibility.[53]

The gradual shift of Presley's image away from his pre-Army persona as a rock'n'roll icon and star of juvenile delinquent films matches other similar cases within 1950s youth culture. Both of Elvis' pre-Army rock'n'roll/crime pictures, *Jailhouse Rock* and *King Creole*, end with the rebellious young hero being reconciled to family life. The traditional values of romance and familial loyalty are upheld at the end of each movie: the young delinquent is tamed through patriarchal society reasserting itself. Similar situations also occur in *The Wild One*, *Blackboard Jungle* and *Rebel Without a Cause*. Like the Presley movies, these films are highly ambiguous with regards to their stance on juvenile delinquency. Through their 'search for authority' these films conclude with the hooligans' defeat by the forces of law and order or the regeneration of the nuclear family to protect young people.[54] In this sense, the conservative endings to *Jailhouse Rock* and *King Creole* merely corresponded to the dominant endings of films aimed at the youth market during the 1950s.

The ambiguity of the 1950s youth films resulted from the fact that their often moralistic conclusions coincided with the presence of 'an irresistible and charismatic, anti-social rebel hero' who possessed great appeal for young audiences.[55] This applied to Presley in *Jailhouse Rock* and *King Creole*, as well as the characters played by Dean and Brando. However such screen rebellion was mediated and controlled. According to Peter Guralnick, Presley's manager, Colonel Tom Parker, planned the star's move into feature films as a deliberate attempt to disassociate his protégé from images of controversy and deviancy. Family entertainment via the cinema would enable Elvis to 'build a career that would last, a career that could survive musical trends'.[56] This desire to disassociate Presley away from images of deviancy for commercial motives coincides with Heb-

dige's argument that economic and ideological pressures succeed in destroying subcultural distinctiveness. Once aimed at a mass audience, the subculture becomes 'codified, made comprehensible, rendered at once public property and profitable merchandise'. The evidence from *NME*'s coverage of *King Creole* seems to support this thesis that commercial interests only succeed in trivialising and domesticating rebellious youth cultures.[57] Yet Hebdige seriously underestimates the importance of the mediated, and thereby less deviant, image of the youth icon presented to fans. Thornton writes that the music press helps to actually 'construct' youth subcultural formations, through codifying the various discrepancies associated with teenage culture.[58] As the following information makes clear, the coverage of *King Creole* presents an exemplary case study of how the media helped to redefine the meanings associated with youth culture at a specific historical juncture.

Much of *NME*'s coverage of *King Creole* displayed an acknowledgement of the presence of the non-deviant 'clean teen' audience; the fans attracted by the mediated and commercialised vision of the star. Inevitably, this desire to reach the maximum number of Presley fans ensured a concealment of the delinquent side of Danny Fisher's character, in favour of the propagation of generational codes. Figure 1 actively stressed these points. The photographs immediately anchored Presley's latest movie with his previous films and contemporary star persona, associating *King Creole* with three central images. First, the design portrayed 'Elvis the singer', complete with guitar, confirming to fans the film's generic status as a musical. Second, the large central photo depicted 'Elvis the icon'. The picture emphasised the star's leading role in the film, essentially confirming Presley's position as the sole centre of attraction within the movie and conjuring up the various connotations associated with his image. His face looks comparatively tender and the image appears calculated to sell Elvis as a love interest to female fans. Third, in Figure 1, above the word 'RIOT', Presley clenches his fists 'against the New Orleans "Teddy-boys"'. This indicated several thematic threads of the film; specifically Elvis's heroic status in the movie, involving violent action sequences against juvenile thugs wielding guns and flick knives. It also emphasised that although Presley's role involved action sequences, his use of violence served the forces of law and order, morality and self-defence, rather than representing an attempt to cause injury and harm to others through acts of crime.

The three photographs hint at the intended intertextual framework for *King Creole*. In two of the images, Presley wears rural cowboy shirts and a necktie, while in the other picture he adopts typical teenage dress codes – jacket, shirt and casual trousers. In the latter case, this possibly strengthened identification with the fans through ensuring that Presley looked decidedly ordinary, in fact not unlike any other youngster. Similarly, these dress codes related to Presley's three earlier films: the rural cowboy feel of *Love Me Tender* and *Loving You*, together with the urban action movie *Jailhouse Rock*. Rather than being marketed as a juvenile delinquent film, the publicity for *King Creole* emphasised the increasingly significant 'clean teen' aspects of Elvis' image: a defender of justice, a dynamic singer and actor, attractive love interest and, perhaps most importantly, the representative of non-deviant youth culture. The caption line on the film's advertisement in *NME*, showing Presley kissing his sweetheart, summed up this theme best, describing the film as a romantic story with generational significance rather than as a tale of delinquency: 'It pulses with the heartbeat of the younger generation.'[59]

To what extent did the two leading music papers contribute to the glamorisation of delinquency in *King Creole*? Through their concentration upon the wider teenage audience's interest in Presley as a generational icon, it could be argued that these publications failed in their obligation to cater for the moral welfare of young people, by not emphasising explicitly the delinquent side of Danny Fisher's character. Inevitably, Elvis as a love interest possessed very different meanings to Presley the delinquent. Yet, Presley always represented the classic polysemic star, capable of inducing numerous contradictory responses, often simultaneously. Although *NME*'s Allen Evans and Brown failed to condemn the movie's violence, neither critic avoided mentioning the question of delinquency and crime. Both accounts contained evidence of an obligation to mention the tough, rebellious streak of Danny Fisher's personality, because these elements seemed ingrained within the star persona of Elvis Presley. Many of his followers undoubtedly felt attracted to Presley because of his nonconformist image. The previous Elvis movies, especially *Jailhouse Rock*, had established a dramatic formula for the star's film roles combining fights, action scenes and singing. In the earlier film, Presley played the thuggish Vince Everett, who receives a prison sentence for manslaughter after killing a man in a bar brawl. *NME*'s

review of *King Creole* by Allen Evans, significantly entitled, 'Non-Stop Action in This Film', emphasised the extent to which the film built upon the formula of rock'n'roll and action sequences found in previous Elvis movies: 'As you can see, Danny Fisher – or Elvis Presley has plenty of action in *King Creole*. He fights two hoodlums at once, during which one dies from the knife blade he tries to stick in Elvis. He beats up the Big Boss and faces bullets in reprisal. He has the moll die in his arms. He is instrumental in his father (by mistake) getting slugged and robbed.'[60]

Brown did not conceal the less glamorous elements of the plot. Indeed, he revelled in the squalid and sleazy atmosphere of the film admitting that 'Presley has increased his stature by this film' and that he 'acquits himself admirably' in the acting stakes.[61] The critic would not have allowed such explicit violence to have gone unmentioned without disapproval in his earlier reviews of *Love Me Tender* and *Loving You*:

> Presley plays the teenage rebel. His dad is a weakling whom he despises. Presley is not going to be pushed around, so he gets mixed up with a gang of hoodlums, gives forth vocally in a store to divert attention while the gang clean up.
>
> The owner of the King Creole club offers him a singing job and he becomes the rage of New Orleans. But the big shot who runs a rival concern is determined to take him over. He has the singer's father beaten up and pays hospital fees to put the screw on Presley.
>
> Presley has to battle his way out of trouble – and battle is the operative word. He thumps the boss into insensibility, has a bloody encounter with his strong-arm men and his carried away into hiding by the top gangster's moll.
>
> She is a good girl at heart, caught up in the web like Presley. There is much tidying up to be done before Presley can get back to New Orleans a free man. And it is all done in the economic fashion by killing off all the complications that beset him.[62]

Such material indicates the extent to which the music press sought to distance teenage idols from any explicit hint of delinquency. Instead of Presley the violent thug, through the publicity material for *King Creole*, we witness the early construction of Elvis the action hero, the lover and the entertainer. In this sense, Presley's image became sanitised: a wider generational significance, with which a numerically far greater age group of teenagers could associate, superseded the star's earlier subcultural identification with hard-

core rock'n'roll and juvenile deviancy. To a certain extent, this represented a glamorisation of the teenage delinquent, as played by the pop idol. Figure 1 suggested the validity of juvenile thuggery, as long as this pleased a section of fans wider than potential rebels and delinquents. Yet to attack this material for constructing an antiseptic vision of Presley seems misplaced. It ignores the historical reconfiguration of the star's image that occurred at the time; to neglect aspects of the Presley image such as his potential as a romantic hero for female fans would have been bad business for film producers and music papers alike. It is wrong to dismiss such material as a less significant component of Presley's star appeal than the rebellious and delinquent sides of his persona. By 1958 many British teenagers sought to distance themselves from being associated with delinquency, producing a situation which Presley himself and his management appeared willing to exploit. The reviews, photographs and posters offer a good indication of the vast possibilities for alternate interpretations involved with the changing Presley persona. The star still retained some of his old rebelliousness, albeit toned down so not to alienate the majority of non-deviant youth, with his singing and acting ability promoted as areas of prime importance, while the tender, romantic side of his character received more recognition than ever before. The actual music press reviews might have become less critical as Presley's persona became less rebellious, but the contemporary sources also enabled his fans to experience what they wanted, allowing them the chance to judge the film and its star for themselves.

Near the climax of his first post-Army film, *GI Blues* (1960), Presley, playing an American soldier based in Germany, entertains his fellow troops in concert. Here the star appears before a huge stars and stripes flag that covers the entire screen. The scene testifies to his transition from rebel to national hero. Given these circumstances, it seems relatively easy to negatively compare Presley's post-1960 cinematic output to the films made prior to his induction into the armed forces. The patriotic star of endless beach movies appears a very different figure from the juvenile delinquent presented by *Jailhouse Rock* and *King Creole*. This chapter suggests that Presley's pre-Army screen image contained often contradictory and competing discourses. Films such as *Love Me Tender* and *King Creole* appealed to people interested in Presley the rebel and Elvis the romantic hero. The films' publicity in Britain served as an indication of the future

direction of Presley's star persona and film career. Ironically, *King Creole*, Presley's most violent film, effectively marks the point when his iconic position as the epitome of youth rebellion became tamed in favour of the romantic idol. Considering Presley's huge cinematic success in post-Army beach movies typified by *Blue Hawaii*, it becomes easier to understand the degree of continuity within the various strands of the star's image. The non-deviant Elvis persona had already been presented to fans via the publicity material for his pre-Army films: Presley's post-1960 output merely extended the existing desires of the star's management and many fans for a non-threatening Elvis to its logical conclusion.

Presley's image was always multi-dimensional. Like other great rock'n'roll icons, from the Rolling Stones to Eminem, his significance partially resulted from the adult backlash against teenage tastes. The critics who disliked Presley not only revealed their disapproval of his music and films, but also articulated contemporary fears surrounding cultural standards, Americanisation and juvenile delinquency. The fact that *King Creole* proved capable of creating such a diverse critical response testifies to the huge range of potential readings of Elvis Presley, besides illustrating why he remains the most important figure in twentieth-century youth culture.

Notes

1 The best biographies of Presley are those of Peter Guralnick: *Last Train to Memphis: The Rise of Elvis Presley* (London: Abacus, 1994) and idem, *Careless Love: The Unmaking of Elvis Presley* (London: Little, Brown, 1999). For Elvis' status as a cultural icon see G. Rodman, *Elvis After Elvis: The Posthumous Career of a Living Legend* (London: Routledge, 1996); E. L. Doss, *Elvis Cultures* (Lawrence: University of Kansas Press, 1999); G. Marcus, *Mystery Train: Images of America in Rock-'n'Roll Music* (London: Plume, 1997); and idem, *Dead Elvis: A Chronicle of a Cultural Obsession* (Cambridge, MA: Harvard University Press, 1991).

2 Marcus, *Dead Elvis*, p. 8; Guralnick, *Last Train to Memphis*, pp. xiii–xiv.

3 Marcus, *Ded Elvis*, p. 8.

4 Guralnick, *Last Train to Memphis*, p. 394.

5 I. Chambers, *Urban Rhythms: Pop Music and Popular Culture* (London: Macmillan, 1985), p. 23.

6 *Ibid.*, p. 4; D. Hebdige, 'Towards a Cartography of Taste, 1935–1962', in idem, *Hiding in the Light* (London: Routledge, 1987), pp. 47–58; J.

Street, 'Shock Waves: The Authoritarian Response to Popular Music', in D. Strinati and S. Wagg (eds), *Come On Down? Popular Media Culture in Post-War Britain* (London: Routledge, 1992), pp. 302–8.

7 For example, S. Frith, *Sound Effects: Youth, Leisure and the Politics of Rock'n'Roll* (London: Constable, 1983), pp. 165–7.

8 S. Race, 'Rock-and-Roll', *Melody Maker* (20 October 1956), p. 5.

9 *Ibid.*, p. 6.

10 *Ibid.*

11 S. Race, *Melody Maker* (22 April 1956), p. 8.

12 D. Bradley, *Understanding Rock'n'Roll: Popular Music in Britain 1955–1964* (Milton Keynes: Open University Press, 1992), pp. 55–70.

13 Chambers, *Urban Rhythms*, p. 37.

14 M. Butcher, 'Don't Think it All Began With Presley and Haley!' – 'The New Musical Express Rock'n'Roll Supplement', *NME* (21 September 1956), p. 8; S. Race, *Melody Maker* (5 May 1956), p. 5.

15 L. Henshaw, 'Rock-'n'-Roll Swamps '56 Music Scene', *Melody Maker* (15 December 1956), p. 21.

16 Bradley, Understanding Rock'n'Roll, p. 90.

17 Race, 'Rock-and-Roll', p. 5.

18 Chambers, *Urba Rhythms*, pp. 22–5.

19 Race, *Melody Maker* (5 May 1956), p. 5.

20 T. Brown, 'Rubbish on Record', *Melody Maker* (25 May 1957), pp. 2–3.

21 Brown, 'Let's be fair to Mr. Presley', *Melody Maker* (1 December 1956), p. 8.

22 D. Marsh, *Elvis* (New York: Thunder's Mouth Press, 1992), p. 116; Guralnick, *Last Train to Memphis*, pp. 383–5.

23 J. Cutts, 'Loving You', *Monthly Film Bulletin* 24: 284 (September 1957), p. 112.

24 Brown, 'They Had a Nerve Making This Elvis Presley Film', *Melody Maker* (24 August 1957), p. 3.

25 J. Mundy, *Popular Music on Screen* (Manchester: Manchester University Press, 1999), p. 121.

26 Brown, 'They Had a Nerve', p. 3.

27 H. Jenkins, *Textual Poaching: Television Fans and Participatory Culture* (London: Routledge, 1992), pp. 12–15.

28 S. Harper and V. Porter, 'Cinema Audiences in 1950s Britain', in A. Kuhn and S. Street (eds), *Journal of British Popular Cinema: Audiences and Reception in Britain No. 2 – Audiences* (Trowbridge: Flicks Books, 1999), p. 81.

29 M. Abrams, *The Teenage Consumer* (London: The London Press Exchange, 1959), p. 16.

30 S. Hall and P. Whannel, *The Popular Arts* (London: Hutchinson, 1964), p. 194.

31 M. Hinxman, 'Love Me Tender', *Picturegoer* (22 December 1956), p. 17.
32 Hinxman, 'Can Presley Survive This Film?', *Picturegoer* (22 December 1956), p. 5.
33 Hinxman, 'YOU go for Presley', *Picturegoer* (19 January 1957), p. 11.
34 *Ibid.*, p. 13.
35 Jenkins, *Textual Poaching* pp. 277–8.
36 Hinxman, 'YOU go for Presley', pp. 12–13.
37 *Ibid.*, p. 14
38 'King Creole', *Monthly Film Bulletin* 25:296 (September 1958), p. 115.
39 D. Hebdige, *Subculture: The Meaning of Style* (London: Methuen, 1979), pp. 94–6.
40 S. Thornton, *Club Cultures: Music, Media an Subcultural Capital* (Cambridge: Polity Press, 1995), p. 160.
41 'King Creole', *Monthly Film Bulletin* 25:296 (September 1958), p. 115.
42 J. Staiger, *Interpreting Films: Studies in the Historical Reception of American Cinema* (Princeton: Princeton University Press, 1992), p. 46.
43 P. Tipthorp, 'Rock'n'Roll Terror – Where Will it End?', *Photoplay* (January 1959), p. 14.
44 T. Doherty, *Teenagers and Teenpics: The Juvenilization of American Movies in the Fifties* (Philadelphia: Temple University Press, 2002 revised edn), p. 108.
45 *NME* (19 September 1958), p. 1.
46 *Ibid.*, p. 1.
47 Brown, 'Elvis Can Act!', *Melody Maker* (23 August 1958), p. 6.
48 P. Bourdieu, *Distinction: A Social Critique of the Judgment of Taste*, trans. Richard Nice (London: Routledge, 1984), p. 234.
49 *NME* (8 August 1958), p. 6.
50 J. Davis, *Youth and the Condition of Britain: Images of Adolescent Conflict* (London: Athlone Press, 1990), pp. 164–5.
51 J. Saxon, 'The Cinema's Becoming a Teen Screen', in E. Warman (ed.), *Preview 1959 – Hollywood-London* (London: Andrew Dakers, 1958), pp. 79–80.
52 'Presley Talks About His Fans', 'The *NME* Elvis Presley Supplement', *NME* (19 September 1958), p. 7.
53 This information is based upon *NME* readers' poll results from 1956, 1957 and 1958. *NME* (23 November 1956), p. 8; *NME* (4 October 1957), pp. 10–11; *NME* (3 October 1958), p. 7. Readers voted Boone the 'World's Outstanding Singer' and 'Favourite US Male Singer' in 1957 ahead of Elvis, while he achieved a number one hit single a year before Presley.
54 G. McCann, *Rebel Males: Clift, Dean and Brando* (London: Hamish Hamilton, 1991), p. 150; J. Lewis, *The Road to Romance and*

Ruin: Teen Films and Youth Culture (London: Routledge, 1992), pp. 20–30.

55 Lewis, *The Road to Romance and Ruin*, p. 30.
56 Guralnick, *Last Train to Memphis*, p. 384.
57 Hebdige, *Subculture: The Meaning of Style*, pp. 96–7.
58 Thornton, *Club Cultures*, p. 151.
59 Advert for *King Creole* in 'The *NME* Elvis Presley Supplement', *NME* (19 September 1958), p. 10.
60 A. Evans, 'Non-Stop Action in This Film', in 'The *NME* Elvis Presley Supplement', p. 8.
61 Brown, 'Elvis Can Act!', p. 6.
62 *Ibid.*

Chapter 4

British visions of America

The headmaster of a private school in Birkenhead, Mr. A-, speaking at a prizegiving last week, viciously attacked the way teenagers dress. To quote Mr. A-, he said, 'Teenagers are becoming Americanised, and show little taste when choosing clothes. Winkle-pickers, drainpipe trousers, long Teddy-boy jackets, thin ties and suits made of brightly-coloured material, are modes of dress which I consider suitable only for those with fourth-rate minds.

All these forms of clothing ought to be publicly burnt, and teenagers should be made to dress like British ladies and gentlemen, and not like a bunch of cowboys performing at a rodeo.'[1]

Any discussion of popular culture in 1950s and 1960s Britain must address the question of Americanisation. The impact of this process, especially through its influence upon youth culture, films and popular music, remains impossible to fully quantify. The above extract, originating from a 1962 *Mersey Beat* article by Bernard Falk, indicates some of the contemporary hostility towards the burgeoning American influence upon British youth. At this juncture, this music newspaper served as a regionally based subcultural product written by, and intended to reach, young people whose lives interacted with US music, films and fashions on an everyday level. The document remarkably illustrated the consternation of authority figures regarding increasing Americanisation. A logical conclusion from the quotation would be that through embracing American consumer culture, British teenagers made a decisive break with the models of behaviour prescribed by authority figures, typified by Mr A.

This extract initiates some of the theoretical debates surrounding the subject of the Americanisation of 1950s Britain. The widely quoted works of Dick Hebdige and Jackie Stacey adapt Antonio

Gramsci's writings on American industrial and cultural production to the context of post-war Britain.[2] In his comments regarding the development of American methods of industrial production and popular culture within Europe, Gramsci concluded that hostility towards 'Americanism' by cultural and social commentators appeared symptomatic of a bourgeois elite whose economic and cultural supremacy faced destruction thanks to the emerging transatlantic influences:

> What is today called 'Americanism' is to a large extent an advance criticism of old strata which will in fact be crushed by an eventual new order and which are already in the grips of a wave of social panic, dissolution and despair. It is an unconscious attempt at reaction on the part of those who are impotent to rebuild and who are emphasising the negative aspects of the revolution.[3]

Gramsci believed that the cause of working-class revolution and political education received encouragement through industrialisation on the American model, because such a phenomenon supposedly brought about the most advanced state of capitalism. In turn, Marxist critics believed that such economic events facilitated the social-economic framework for social dislocation and the eventual rise of the revolutionary proletariat.

The influence of these Gramscian ideas has permitted some British scholars of the 1950s to claim that American popular culture, specifically films and rock'n'roll music, provided a subversive threat to the established hegemony. As detailed in chapter 2, Hebdige argues that 'the shock of the new', whether in architecture, rock-'n'roll or car designs, paved the way for a defensive hostility on behalf of those who felt threatened by change. Antagonism really disguised fears over 'their future', which faced possible elimination under Americanisation.[4] Writing about British women's adoption of American stars in the 1950s, in order to 'rebel against what they perceived as restrictive *British* norms' [italics in original], Stacey claims that: 'In rejecting the previous generation's definitions of acceptable femininities, American femininity offered the chance to rework the Hollywood images on the screen. What is repeatedly articulated is the desire to avoid the typically bourgeois image of respectability and asexuality.'[5]

At first sight, Falk's comments match Stacey's sentiments regarding the potentially radical uses of American popular culture for

British audiences. The youthful columnist satirised Mr A's speech informing his readers that, 'Like you, I am becoming fed up of these pompous, high-minded overgrown cabbages, spouting their out-dated Victorian views all over the place.'[6] The likes of Mr A consid-ered American dress codes a threat to the future development of 'British ladies and gentlemen', because such fashions symbolically questioned the values of those who sought to control and educate youth. By turning to leisure products of American origin, teenagers reinforced their cultural identity and altered the conception and material existence of British youth.

Another angle prompted by the Falk article revolves around the value of such sources to explore the consumption of American pop-ular culture. A legitimate conclusion from reading the extract would be that British teenagers actively enjoyed US cultural products. The findings of commentators such as Stacey, Paul Swann and Joanne Lacey, who describe how many British audiences could identify with American films and their stars, coincide with this claim. US products seemed more exciting to British viewers, because they offered an escapism and potential space for wish fulfilment usually absent in domestically produced films. American movies provided evidence of a luxurious, consumerist lifestyle, largely free of the class rigidity and economic hardships of contemporary Britain.[7] Such work estab-lishes a connection between British audiences and the reasons why many people looked to America for aspiration and inspiration. This creates obvious implications for an investigation into interpretations of the US made through American films and stars aimed at British teenage audiences.

While acknowledging that British audiences could read many of the American films and stars in subversive ways, this chapter argues that the position adopted by Hebdige and Stacey underestimates the diversity of readings evident within critical reviews and star profiles, stressing that no absolute or coherent critical positions regarding Americanisation existed in any publication. As Lacey argues: 'Too often we speak of the American Dream and of Americanisation in post-war Britain as a monolith . . . It is easy to forget that variations on and within the American Dream were constructed by individuals in concrete local contexts. The American Dream also played itself out differently across different cultural texts.'[8]

Although primarily concerned with her work on Liverpool audi-ences and the American Dream, Lacey's comments also indicate the

difficulty in designating Americanisation as a uniform phenomenon. Surely if interpretations regarding Americanisation differed according to social location and cultural capital, then the process did not necessarily contribute to challenging the status quo. The work of Hebdige and Stacey does not explain the discrepancies that regularly existed over opinions expressed by particular publications and individual writers, and presumably among ordinary members of the public. For instance, is it possible to reconcile the enthusiasm of *Picturegoer* for Pat Boone with their writers' distaste for most US rock-'n'roll movies?

American rock'n'roll movies and British commentators

The revolution in popular music triggered by figures like Elvis Presley, Bill Haley and Little Richard enabled Americanisation to achieve its most potent sphere of influence within British society. Through studying the reaction towards US rock'n'roll films, the cultural and political nature of the hostility towards the greatest example of 1950s youth culture becomes obvious. The new musical trends symbolised not only elite fears over declining cultural standards, but also saw a strategic opposition to the influx of American popular culture into Britain.

To what extent can the critical dislike of rock'n'roll films be attributed to their American origins? Although few of the actual film reviews involved explicitly anti-American statements many contained links to the issue of cultural taste. As illustrated in chapter 2, during the 1950s commercialism and the alleged cheapening of popular taste served as a euphemism for hostility towards American popular culture. If this diagnosis is correct then any denunciation of commercial mass culture contained an unwritten assumption that the debasement of popular taste resulted from American influences. With the arrival of rock'n'roll in the British pop charts from 1955, certain quarters began to attack the new musical trend as the epitome of cultural deterioration. The venom offered by Jack Payne, the former bandleader and BBC presenter, the original head of the Corporation's popular music unit during the 1920s offered an extreme example of this position. In a *Melody Maker* article in June 1956, entitled 'Should we surrender to the teenagers?', he connected the emergence of a distinct teenage musical taste not only to a potential fall in cultural standards, but also to the rising tide of Americanisa-

tion.[9] The article presented a war between the British musical and entertainment establishment and the youthful, American upstart through both words and symbols. On the last point, the photograph of Payne, the epitome of the British musical establishment with a career in popular music dating back to the Rethian era of the 1920s, faced the opposing visage of a surly, unsmiling Elvis Presley. Symbolically, this initiated a battle between traditional British cultural values and the youthful, commercialised United States. Payne's actual comments on the role of the disc jockey confirmed this point. The BBC and the disc jockey possessed an obligation to provide 'vast and varied' entertainment with 'good taste'. If the musical authorities 'pander to teenage tastes', they risked the emergence of 'record programmes completely devoted to the new songs and absolutely bulging with best-selling singers – most of whom would be, I'm afraid, American'.[10] By following 'the latest teen-age craze in America' (Presley) and yielding 'to those who shout the loudest' (the teenagers) British culture faced disintegration. The young evidently lacked the taste to discriminate between 'good and bad entertainment', leading to 'mob rule' and finally to the loss of cultural 'independence'.[11] Payne presented a synthesis of all the arguments against Americanisation. Considering his place at the heart of the entertainment establishment since the 1920s, Payne's comments provide a significant commentary upon British attitudes towards rock 'n'roll:

> The question of how far one should pander to teen-age tastes on the BBC is, I submit, a very knotty one. Adolescence is, we are told, a very difficult time of life, a phase, some sociologists say, of emotional unbalance.
>
> To take the matter to the extreme, are we to let young people become the sole arbiters of what constitutes good or bad entertainment? And, if we did, would standards go up or down?
>
> Are we to move towards a world in which the teen-agers, dancing hysterically to the tune of each latter-day Pied Piper, will inflict a mob rule in music?
>
> If our publishers and record men, with an eye on profits are in favour of the BBC studying the American market in order to anticipate the next teen-age craze over here, then I am against them.
>
> That would be to abdicate our musical independence, the last scrap of it – and it would completely turn Britain into a 49th state in the world of entertainment.[12]

Alongside such overt anti-Americanism, there existed a more disturbing trend within occasional reviews: racism. Little Richard received vicious diatribes from music journalists in reviews of his appearances in several rock movies, including *The Girl Can't Help It* and *Don't Knock the Rock*. The enthusiasm and brashness of his act triggered critical responses that bordered on racism. For example, during the opening credit sequence of *The Girl Can't Help It*, Little Richard's rendition of the theme tune interrupts Tom Miller's (Tom Ewell) description of modern music as dignified and gentle. Barry Keith Grant claims that this scene provides 'a comic but incisive comment on the commonly expressed concern of the day that the primitive qualities of rock'n'roll threatened to subvert more civilized values'.[13] The shock of Little Richard's musical act is compounded by his visual performance throughout the film. He stands up, rather than sits down, at his piano, while his dress and personal appearance are startling: dressed in a long draped jacket, lips adorned with mascara and possessing a large quiff for a haircut. As Donald Clarke writes, 'Little Richard was bisexual, he wore make-up, he was a tornado on stage and he passionately shouted dirty songs in a sanctified style, screams and all.'[14] In this context, it becomes easier to understand why one critic described Little Richard as 'the epitome of vocal vulgarity'.[15] *Melody Maker*, a paper that prided itself on its love of jazz, referred to Little Richard in racist terms. The paper suggested that Britain faced being invaded by a 'whirling dervish', a view that can only be interpreted as discomfort with the connection between rock'n'roll and black performers:

> In the rock-'n'-roll films, *Don't Knock the Rock* and *The Girl Can't Help It*, he proved both an eye and an ear catcher, the leading shock trooper of an absolute barrage of aural assault.
> This whirling dervish of modern entertainment is only 21, and already threatens to invade Britain in the winter.[16]

NME's review of *Don't Knock the Rock* clumsily tried to distance itself from racism, only to fall into the trap of writing about Little Richard in racialist language: 'Little Richard certainly knows how to rock. He attacks the song and his piano-playing with non-stop drive. His antics and appearance reminded me of an animated golliwog – and I don't mean that in any way disparagingly. Much of the time he plays and sings with his right leg on the piano keyboard. Don't ask me why . . . maybe he was tired.'[17]

Although, to their credit, *Melody Maker* critics later attacked the overt racism of Teddy Boys involved with the race riots in Notting Hill during 1958, as with other cultural organs the paper could not always describe black American performers in non-racialist terms.[18] Both leading music papers contained language associating Little Richard with objectionable stereotypes: 'the whirling dervish' and the 'golliwog' respectively. An arguably unconscious racism permeated these reviews, probably thanks to the legacy of British imperialism.

Another important piece of information contained within Payne's article occurred through his belief that British family entertainment faced destruction via Americanisation. Chapter 2 illustrated how light entertainment in Britain appeared synonymous with the family audience. If adult society 'pandered' and 'surrendered' to teenage preferences, broad, good taste faced possible elimination. According to Payne, high cultural standards could only be maintained if the BBC and other cultural guardians of taste and morals catered for the entire listening public, rather than those teenagers uninterested in 'the tastes of other sections of the community'.[19] His own philosophy remained distinctly conservative, owing much to the Public Service Broadcasting ethos of his former BBC boss, John Reith, 'I still believe that good entertainment – (*with something for everybody*) – should be allied to good taste' [italics in original].[20]

Of all the major film genres of the classic Hollywood cinema, the musical came closest to Payne's maxim. At its best, the musical combined charismatic stars, spectacular entertainment and memorable music with exceptional artistic skill in the fields of direction, cinematography, costume design and choreography. Rick Altman's argument that the musical epitomised the greatest virtues of the Hollywood studio system, which entered decline almost simultaneously with the gradual demise of the US film musical belongs to another debate.[21] The musical possessed a broader popular and critical appeal than any other genre, with the possible exception of the western. During the 1950s, the Hollywood musical enjoyed the attention of the entire spectrum of film criticism from *Picturegoer* to *Sight and Sound*. Of course, critical priorities differed widely according to the alternative forms of publication, but *Sight and Sound*'s appraisals of Vincente Minnelli and Gene Kelly complemented *Picturegoer*'s extensive coverage of the latest big-budget blockbuster. Despite their different critical stances, film publications

paid attention to the musical either as entertainment or cinematic art.

Rock'n'roll changed forever the shape of the film musical. As stated earlier, the developing trends in Hollywood film production saw the emergence of movies produced exclusively for the teenage constituency. Companies typified by AIP seized upon the youth market through producing films that directly appealed to young-sters' tastes. In the same way that AIP exploited Dean's legacy via derivative products such as *Dragstrip Girl*, film companies quickly noticed the financial benefits attached to appeasing the teenage taste for rock'n'roll. In the wake of the first authentic rock movie *Rock Around the Clock* emerged such titles as *Rock, Rock, Rock, Shake, Rattle and Rock* and *Rock All Night* (1957), besides films with supe-rior production values typified by Presley's output and *The Girl Can't Help It*.

Rock Around the Clock starred Bill Haley and his Comets, the original popularisers of rock'n'roll to a mainstream white audience. The film adopted the template of the backstage musical romance, which featured the love interest centred around the film's dramatic leads, alongside the rise to nationwide fame by Haley and company. Besides Haley, the film saw appearances by the Platters, Freddie Bell and the Bellboys and disc jockey Alan Freed. The *Monthly Film Bul-letin* provided a lukewarm response to the film:

> The story is pleasantly negligible, serving only as a line on which to hang a succession of band numbers. The latter consist mainly on the contemporary brand of jive known as 'rock-an-roll' [sic] (exemplified by Haley's Comets), alleviated by a few expeditions into the Afro-Cuban style (the Martinez band) and a couple of vocal-group numbers by The Platters, whose style tends towards monotony. An innocuous entertainment, designed to suit the tastes of American – or for that matter – British teenagers.[22]

Although hardly enthusiastic, the review indicates several key strands vital to understanding rock movies. First, critics adopted an ambiguous attitude to the pop film from the start; a position that remained for the next decade. Second, in terms of its structure, *Rock Around the Clock* is a revue musical, in which the narrative is sec-ondary to the visual spectacle of musical performance. Mark Ker-mode argues because 'their musical content is so quintessentially representative of a critical moment in youth history – the birth of the 'teenager' – that they have grown in stature over the years into clas-

work on the various fields of cultural production. As
[st]ated in chapter 1, a different system of cultural values
[betwe]en 'the field of restricted production' and 'the field of
[mass p]roduction':

> production *per se* owes its own structure to the opposition
> [th]e *field of restricted production* as a system producing cul-
> [ture] (and the instruments for appropriating these goods) objec-
> [tiv]ed for a public of producers of cultural goods, and the *field*
> [of larg]e cultural production, specifically organized with a view to
> [satisfac]tion of cultural goods, 'the public at large'. In contrast to
> [the] large-scale cultural production, which submits to the laws
> [of competit]ion for the conquest of the largest possible market, the field
> [of restricted] production tends to develop its own criteria for the eval-
> [uation of i]ts products, thus achieving the truly cultural recognition
> [b]y the peer group whose members are both privileged clients
> [and compet]itors. [italics in original][30]

[Bourdieu pos]sibly overstates the potential for opposition between
[com]peting fields of cultural production, but this work helps
[explor]e some aspects of *Distinction* which appear over-deter-
[mined. It i]s certainly appropriate to see the BFI publications as
['restricted production' aimed at a clientele of educated
[enthusi]asts. They possessed their 'own criteria for the evalua-
[tion of pr]oducts', with productions that did not meet the artistic
[v]alues imposed by this critical hierarchy being derided.
[F]ilm fan magazines and the music press operated as pub-
[lish]ed at 'the public at large'. They aimed to appeal to the
[who]le readership through submitting 'to the laws of com-
[petition for] the conquest of the largest possible market'. This
[is how] *Melody Maker* covered teenage pop music during the
[1]950s, despite the consternation of many of the paper's
[staff. Ho]wever, the need to appeal to the mass market did not
[mean that e]lite and popular tastes did not coincide. The quotes
[from *Ro]ck, Rock, Rock* indicate that film critics opposed the
[musicians i]n a particular movie according to the values evident
[in their] own cultural sphere. The artistic presumptions of the
[195]0s considered rock'n'roll as anathema: commentators
[the fields] of production felt that the new trend violated their cul-
[tural stan]ds. Therefore *Rock, Rock, Rock* saw film critics express-
[ing their] taste against rock'n'roll music and movies. Instead of
[this, th]at commentators from the elite film press opposed the

sic celluloid timepieces . . . All these films have gained a nostalgic
appeal as a result of their seminal pop content – they got the music
right, and that was enough.'[23] Therefore, within the revue style pop
film the music takes priority over the dramatic plot. To this end, the
rock movie belonged to the tradition of 'cinema of attractions', prin-
cipally associated with the early silent era, in which the medium's
novelty value was emphasised. In his article on the subject, Tom
Gunning writes that:

> To summarise, the cinema of attractions directly solicits spectator
> attention, inciting visual curiosity, and supplying pleasure through an
> exciting spectacle – a unique event, whether fictional or documentary,
> that is of interest in itself . . . Fictional situations tend to be restricted
> to gags, vaudeville numbers or revelations of shocking or curious inci-
> dents (executions, current events). It is the direct address of the audi-
> ence in which an attraction is offered to the spectator by a camera
> showman, that defines this approach to film making. Theatrical display
> dominates over narrative absorption, emphasising the direct stimula-
> tion of shock or surprise at the expense of unfolding a story or creat-
> ing a diegetic universe. The cinema of attractions expends little energy
> creating characters or individual personality. Making use of both fic-
> tional and non-fictional attractions, its energy moves towards an
> acknowledged spectator rather than inward towards character-based
> situations essential to classical narrative.[24]

The 1950s and 1960s rock movies were never designed to be pres-
tigious works of cinema. Their emphasis lay on the spectacle of per-
formance offered by the musical artistes on display. They were
novelties because they transplanted new recording acts to the big
screen in film productions that directly appealed to teenagers.
Equally, the pop film mirrored other forms of popular cinema, often
disregarded by critics, whose narrative was 'organised around its
various attractions'. Writing about the Gracie Fields film *Sing as we
Go* (1934), Andrew Higson writes that 'the attractions are the point
of the film, not its flaws: the pleasures of this film are less the drama
of narrative integration and more the attractions of potential disin-
tegration'.[25] The revue style format regularly featured in the 1930s
British musical comedy, as well as the pop film over twenty years
later. Fields typified the music hall tradition, which, as chapter 5
explains, the British pop film also inherited. Therefore the rock
movie originated from a form that linked performance with audi-
ence gratification rather than cinematic quality. While the BFI pub-

lications had problems embracing this tradition, commentators inclined towards commercial entertainment could offer more sympathetic accounts of films located within this paradigm. Although ambiguous towards the film's qualities, such an example emerged with *NME*'s review of *Rock Around the Clock* by Charles Govey:

> The climax of the film is a huge rock-and-roll jamboree, which is televised from coast to coast. The usual antics of the Comets during the rocking finale make the Eric Delaney Band look as sedate as a string quartet.
>
> The atmosphere gets so heated that the tenorman starts playing with his hands behind his back (work that one out!) taking his jacket off. Meanwhile, the bass player actually climbs aboard his instrument in an attempt to improve the beat, and leader Haley jerks his guitar up and down like some 'groovy' mechanical digger.
>
> As you can see, this isn't a film for the square – or the person with any degree of musical taste.
>
> . . . With the Comets performing most of their well-known titles, the Platters doing hit versions of 'Only You' and 'The Great Pretender' and Tony Martinez's band rock-and-rolling the cha-cha-cha-cha, this is a film the young ones are going to turn out in their thousands to see.
>
> 'The little people' are coming your way. Don't say you haven't been warned.[26]

Besides their obvious and occasionally risible attempts to appeal to rock'n'roll fans via the integration of musical acts into the narrative, the early American rock films possessed one thing in common: critical disapproval from the entire spectrum of British film reviewers. That various film critics differed little in their attitudes towards rock'n'roll becomes evident with the comments of *Picturegoer* and the *Monthly Film Bulletin* regarding *Rock, Rock, Rock*:

> This is a collector's item! Until you've seen thirteen-year-old Frankie Lymon sing 'No, No, No, I'm Not a Juvenile Delinquent' [sic] to a rock-'n'-roll beat, you ain't heard nothin'.
>
> Compared with this rock'n rolling jamboree *Rock Around the Clock* is just a quiet session for 'squares'.
>
> Everyone acts as though they can't wait for the next rock'n'roll number.[27]

This slim plot provides a rather ineffective link for a very large collection of Rock'n'Roll numbers, some of which are staged in poor imitation of the original *Rock Around the Clock* style. The use of gramophone records as playback discs for the shooting of exterior

song routines is very unpleasant, pr[...]
effect. The entire film appears to h[...]
maximum speed and minimum effo[...]
rent fashion for Rock'n'Roll.[28]

Application of Bourdieu's thesis r[...]
taste leads to an expectation tha[...]
adopt an opposite view to the eli[...]
tural products are deliberate, enf[...]
being selected 'because they are s[...]
tions in their respective spaces',[...]
within the critical sphere, review[...]
tives.[29] This clearly does not hold[...]
Rock. Both commentators expr[...]
ceived vulgarity and the appa[...]
nature of the film's production h[...]
script and direction all appeared[...]
'n'roll number' at the expense o[...]
tic verve. The degree of deta[...]
differed widely. The sketchy, ge[...]
within *Picturegoer* lacked detail[...]
Stoddart perceived the film as [...]
the cinematic and technical int[...]
the *Monthly Film Bulletin* conc[...]
musical performances, direction[...]

Although this offers a cruci[...]
elite film criticism, the two re[...]
than Bourdieu's thesis would [...]
instance the two critical positi[...]
tion via the habitus. Instead, e[...]
their human agency, displayi[...]
expected attitudes and behavi[...]
tion's claims regarding the fix[...]
positions fail to account for his[...]
Ironically, considering the atti[...]
musical displayed by *Picturego[...]
Rock, Rock, Rock appeared ra[...]
Rock material indicates that c[...]
trum do not necessary adopt [...]
cations disliked the new trend[...]
of the reasons for this posit[...]

Bourd[...]
briefly [...]
exists [...]
large s[...]

The [...]
betw[...]
tural [...]
tively [...]
*of lar[...]
the pr[...]
the fie[...]
of con[...]
of rest[...]
uation [...]
accord[...]
and co[...]

Bourdieu[...]
the two [...]
to recon[...]
ministic.[...]
examples[...]
film enth[...]
tion of its[...]
and socia[...]
Equally th[...]
lications a[...]
largest po[...]
petition f[...]
explains w[...]
mid-to-lat[...]
writers. H[...]
mean that [...]
regarding [...]
values wit[...]
within the[...]
mid-late 1[...]
in both fiel[...]
tural standa[...]
ing their d[...]
presuming [...]

comments of fan-orientated publications, what emerges is evidence that they comprised separate spheres of production with their own critical priorities.

Monthly Film Bulletin and rock'n'roll movies

The comments on *Rock Around the Clock* indicated that the resentment against the rock'n'roll movies from the BFI critics resulted from a critical distaste towards the music and form of such films. Further evidence of this disposition appears in the critical commentaries on other early US rock movies. The review of AIP's *Shake, Rattle and Rock* claimed that 'the film also falls into the usual error of ridiculing serious music'.[31] By 'serious music', the anonymous critic almost certainly referred to classical music. In a key scene, rock'n'roll is placed on trial for alleged musical and moral degeneracy. During this extract, the disc-jockey hero defends rock'n'roll by arguing the similarities between rock and the classical style of Beethoven and Chopin. Lindsay Anderson provided further evidence that the BFI critics did not see anything amusing in trivialising high culture at the expense of supposedly commercial trash in 1956:

> It is damaging, tolerating the shoddy and the third-rate, and muffling work of importance by a flippant or purely sentimental response. It is impossible to praise things that are bad without injuring the things that are good. By celebrating the merits of the trivial and the meretricious, or by being funny at its expense, we lower the prestige of the cinema, and, indirectly, make it difficult for anybody to make a good film.[32]

As discussed earlier with regards to *Dragstrip Girl*, the critical elite disliked the new methods of film production, synonymous with the arrival of the teen movie. The rock'n'roll films provide another chance to study their attitudes regarding the apparent decline in cinematic standards. *Sight and Sound* critics did not dislike the Hollywood musical of the 1940s and early 1950s. Yet by the mid-1950s, with the almost simultaneous development of new technology, typified by 3D, cinemascope and stereophonic sound, and the demise of the studio system, a more ambivalent attitude emerged towards the genre. Penelope Houston would have preferred the clock to stand still in 1953, before the purity of the musical had been diminished by spectacle and rock'n'roll. In 1963, bemoaning a decade of appar-

ent artistic deterioration, she complained that with the advent of the widescreen blockbusters:

> Producers had to study what would bring people into the cinema and, no less important, what would keep them out ... musicals worked, providing they originated in big stage successes. The essentially film musical, as Vincente Minnelli (*Meet Me in St. Louis, An American in Paris, The Band Wagon*) and Gene Kelly and Stanley Donen (*On the Town, Singin' in the Rain*) had been lovingly developing it, was an early casualty. Such films had relied on dancing, colour, pace, the elegance or drive of their visual style. Big screen musicals were slowed down, to look more like the original stage shows; song and dance began to count for less than 'production values' – the trappings of size. Musical stars (Judy Garland, Doris Day, Fred Astaire) turned straight, and straight actors (Deborah Kerr, Yul Brynner, Rosalind Russell) moved into the new musicals.[33]

For Houston, these changes in the production of musicals proved an unqualified disaster for the genre's artistic development. 'Spectacle' replaced 'dance', 'colour', 'pace' and 'elegance'. Worse still, such films resulted from giving the public what they wanted, rather than bringing art to the public. Although primarily directed against films such as *Oklahoma!* (1955) Houston's comments explain why the critical establishment hated rock'n'roll movies from an artistic perspective. The likes of *Rock, Rock, Rock* did not feature 'dancing', 'colour' and 'elegance' in their choreography and production design. With notable exceptions, such as *The Girl Can't Help It* and *Loving You*, most of the early rock'n'roll movies were cheaply produced monochrome productions. From the viewpoint of *Sight and Sound/Monthly Film Bulletin*, this in itself might not necessarily have been a bad thing. *Rock, Rock, Rock* received condemnation, because of its inability to overcome the obvious flaws of its stars, budget and technical designers. The early rock'n'roll movies looked cheap and amateurish, because they could not provide the dramatic and technical expertise to disguise their limitations. In Roger Corman's *Rock All Night*, described by the *Monthly Film Bulletin* as 'pure comic strip material' complete with 'uninspired wisecracks', microphones and lighting equipment are visible at various points of the film.[34]

The same applies to *Rock, Rock, Rock*. The musical scenes received derision not only for their unoriginality by imitating *Rock Around the Clock*, but also because there is no evidently cinematic

musical treatment on display. Instead of original, balletic numbers performed with wit and professionalism, *Rock, Rock, Rock* features a televisual style. Performers, such as Chuck Berry and Frankie Lymon and the Teenagers, merely stand and mime in front of the camera. The imagination and grace of the MGM musical of several years previously, with song and dance fully integrated with character and plot, does not materialise in *Rock, Rock, Rock*'s musical sequences. To this extent, the film offers a classic example of 'cinema of attractions', neglecting narrative plot and technical expertise in favour of the musical performances. The music takes priority over the acting: hence the need to build the television show into the plot, which like *Rock Around the Clock* features Alan Freed, to strengthen the film's structure. The reviewer's contempt for the movie typified the intellectual superiority possessed by the *Monthly Film Bulletin*'s contributors at the time. Critics from this elite film publication examined the movie according to their own standards about what equalled quality cinema. This ensured that their 'aesthetic disposition' to 'break off the nature and function of the object represented and exclude any "naïve" reaction' asserted itself. The 'precondition for all learning of legitimate culture' necessitated a critical concentration 'upon the mode of representation, the style, perceived and appreciated by comparison with other styles'.[35] By examining *Rock, Rock, Rock* in accordance with the best screen musicals, the critical elite inevitably found the film devoid of what they expected from a quality musical. The importance of the movie's potential entertainment value did not concern the *Monthly Film Bulletin*, because not only did this publication not cater for teenage tastes, but also due to the fact that judging a film in accordance with its commercial potential was associated with the fan publications. To adopt the latter condition would have reduced the *Monthly Film Bulletin* to the status of *Picturegoer*, something intolerable for the magazine's discerning critics and readership.

Another key reason why the critical elite hated the rock'n'roll movies lay with the spectacular and emotional functions of these films. Bourdieu explains that the desire of the ordinary public for active participation encourages them to embrace the spectacular and the sensual, because they emphasise 'more direct, more immediate satisfactions'. He writes:

> It is because, through the collective festivity they give rise to and the array of spectacular delights they offer (I am thinking also of the

music-hall light opera or the big feature film) – fabulous sets, glittering
costumes, exciting music, lively action, enthusiastic actors – they sat-
isfy for and sense of revelry, the plain speaking and hearty laughter
which liberate by setting the social world head over heels, overturning
conventions and properties.[36]

This theory enables another insight into the attitudes of the *Monthly
Film Bulletin* and *Sight and Sound* regarding what they thought the
rock'n'roll movies represented. If the 'gifted minority', typified by
the elite critics at the BFI publications, sought to distance themselves
from the most spectacular elements of modern entertainment, then
critical disapproval of the rock films became inevitable. These
movies proved spectacular, albeit in a slightly different sense to that
articulated by Bourdieu. Cheaply made productions like *Rock, Rock,
Rock* did not feature 'fabulous sets' or 'glittering costumes', but for
their target audience such films undoubtedly offered opportunities
for 'collective festivity', 'spectacular delights', 'exciting music',
'lively action' and 'enthusiastic actors'. With *Rock, Rock, Rock* and
The Girl Can't Help It it remains difficult to estimate the feelings of
excitement experienced by fans as they saw Chuck Berry or Little
Richard on the big screen. Considering that, with few exceptions,
the early rock'n'rollers failed to tour Britain, the cinema provided
the means by which the music and personalities of American per-
formers could be brought closer to the everyday experiences of
British youngsters. As demonstrated by the discussion of *Love Me
Tender* in chapter 3, the rock'n'roll films meant a cause for celebra-
tion and 'collective festivity', because by bringing American acts into
the cultural lives of many youngsters, they created entertainment,
escapism and excitement. Their significance lay as a novelty value:
they simply provided an entertainment experience otherwise
unavailable. For example, Cliff Richard described Presley with awe
in a 1959 interview: '[Elvis Presley] has grown into a terrific mythi-
cal figure for thousands of teenagers here. He's got real star status
like it used to be in the old film days – something that glittered far
off in the unattainable. Something to dream about.'[37]

These positive aspects of the spectacular coincide with other the-
ories about the appeal of popular culture. Discussing the 'Heroes of
Popular Literature', Gramsci makes similar comments to those of
Bourdieu regarding the processes of identification in popular cul-
ture. According to Gramsci, 'one of the most characteristic attitudes
of the popular public towards its literature' centres around the

assumption that 'the writer's name and personality do not matter, but the personality of the protagonist does'.[38] This presumption features heavily in Tony Bennett and Janet Woollacott's *Bond and Beyond*. They claim that popular fictional heroes can escape 'from the originating textual conditions of their existence, functioning as an established point of cultural reference' even for those consumers 'unaware of their original context of production and consumption'.[39] If these theories are extended to the rock films, then the charisma of the pop star or the leading protagonist's fictional situation possibly contained the potential for empathy, interest and identification among consumers. Although real-life rock'n'roll stars and fictional teenage stereotyped characters should not be equated with icons of the stature of James Bond or Sherlock Holmes, the images seen in the cinema could easily have enhanced the everyday culture life of young people. The likes of Presley, Little Richard and Chuck Berry not only became more than simply rock singers and film stars, but also symbolised a separate teenage cultural existence. Their screen appearances and recordings took on extra dimensions, as British teenagers adopted rock'n'roll as a means of cultural and generational expression.

The American rock'n'roll films expressed an ethos that differed from the rigidity of 1950s Britain. Character identification proved important in this sense, reinforcing the 'carnival' nature of the American rock movie. In *Rock, Rock, Rock* the devious, yet kindhearted, Dori (Tuesday Weld) schemes to obtain a strapless ballgown for the high school dance. She does not accept her place in the high school hierarchy: she sets out to achieve her objectives and will do anything (legal) to achieve them. The film applauds Dori for challenging her role in a structured system: against the odds she wins the boy and ball-gown.

At first sight, such plot details hardly seem confrontational. Despite her naïve charm, Dori is materialistic, unwittingly stealing money away from her friend Arabella (Fran Michael) in a failed scheme to establish a savings bank. However, despite this, *Rock, Rock, Rock* contains a certain carnivalesque spirit. According to the Soviet literary critic Mikhail Bakhtin, carnival in medieval and early modern Europe 'marked the [temporary] suspension of all hierarchical rank, privileges, norms and prohibitions'.[40] If the rock'n'roll movies are interpreted in this light, then their potential for dislocation becomes clearer. American rock films and music provided a

means of generational solidarity among teenagers: symbols of
repression such as from the parental home, school and, in the case
of *Rock, Rock, Rock*, bullying rich brats, could be turned into objects
of derision. Moreover, the films facilitated new, direct forms of com-
munication 'frank and free, permitting no distance between those
who came in contact with each other and liberating from norms of
etiquette and decency imposed at other times', rather in the mould
of carnival.[41] This occurred not only through identifying with the
pop performers, but also through fictional characters facing similar
experiences to those confronting their real-life audiences, typified
by Dori's plight in *Rock, Rock, Rock*.

 The actual experience of filmgoing largely exacerbated the mood
of freedom implicit within the early American rock films. The audi-
ences for the new films and music were overwhelmingly teenagers:
theatres were transformed into temporary sites of youthful solidar-
ity excluding older customers. Such festivity even resulted in further
carnivalesque acts such as dancing in the aisles or the destruction of
the cinema seats. Although these actions brought recrimination, they
illustrated the extent to which the rock musical had the potential to
turn the world upside down, providing a release from normal codes
of behaviour.

Picturegoer – rock'n'roll and Pat Boone

Although they never directed attacked rock'n'roll fans *Picturegoer*
critics possessed little sympathy for the new musical form. Referring
to the manner in which ex-gangster Fats Murdock (Edmond
O'Brien) desires a record career for his talentless girlfriend Jerri
Jordan (Jayne Mansfield) in *The Girl Can't Help It*, Margaret
Hinxman referred to the film as a 'spoof of the rock'n'roll racket'.
She described 'bringing rock'n'roll down to the level of a gangster
comedy' as 'a stroke of genius', evidence that she regarded the
music and everything it signified as representing complicity with
criminality. Stoddart began her comments on *Don't Knock the Rock*
with 'earplugs ready – here they come again. Another batch of rock-
'n'roll acts from Hollywood's assembly line'.[42] The need for
'earplugs', expressed in the form of a joke, not only indicated
Stoddart's distaste for rock'n'roll as music, but also emphasised
that she did not treat the trend seriously as a cultural or sociological
phenomenon.

sic celluloid timepieces . . . All these films have gained a nostalgic appeal as a result of their seminal pop content – they got the music right, and that was enough.'[23] Therefore, within the revue style pop film the music takes priority over the dramatic plot. To this end, the rock movie belonged to the tradition of 'cinema of attractions', principally associated with the early silent era, in which the medium's novelty value was emphasised. In his article on the subject, Tom Gunning writes that:

> To summarise, the cinema of attractions directly solicits spectator attention, inciting visual curiosity, and supplying pleasure through an exciting spectacle – a unique event, whether fictional or documentary, that is of interest in itself . . . Fictional situations tend to be restricted to gags, vaudeville numbers or revelations of shocking or curious incidents (executions, current events). It is the direct address of the audience in which an attraction is offered to the spectator by a camera showman, that defines this approach to film making. Theatrical display dominates over narrative absorption, emphasising the direct stimulation of shock or surprise at the expense of unfolding a story or creating a diegetic universe. The cinema of attractions expends little energy creating characters or individual personality. Making use of both fictional and non-fictional attractions, its energy moves towards an acknowledged spectator rather than inward towards character-based situations essential to classical narrative.[24]

The 1950s and 1960s rock movies were never designed to be prestigious works of cinema. Their emphasis lay on the spectacle of performance offered by the musical artistes on display. They were novelties because they transplanted new recording acts to the big screen in film productions that directly appealed to teenagers. Equally, the pop film mirrored other forms of popular cinema, often disregarded by critics, whose narrative was 'organised around its various attractions'. Writing about the Gracie Fields film *Sing as we Go* (1934), Andrew Higson writes that 'the attractions are the point of the film, not its flaws: the pleasures of this film are less the drama of narrative integration and more the attractions of potential disintegration'.[25] The revue style format regularly featured in the 1930s British musical comedy, as well as the pop film over twenty years later. Fields typified the music hall tradition, which, as chapter 5 explains, the British pop film also inherited. Therefore the rock movie originated from a form that linked performance with audience gratification rather than cinematic quality. While the BFI pub-

lications had problems embracing this tradition, commentators inclined towards commercial entertainment could offer more sympathetic accounts of films located within this paradigm. Although ambiguous towards the film's qualities, such an example emerged with *NME*'s review of *Rock Around the Clock* by Charles Govey:

> The climax of the film is a huge rock-and-roll jamboree, which is televised from coast to coast. The usual antics of the Comets during the rocking finale make the Eric Delaney Band look as sedate as a string quartet.
>
> The atmosphere gets so heated that the tenorman starts playing with his hands behind his back (work that one out!) taking his jacket off. Meanwhile, the bass player actually climbs aboard his instrument in an attempt to improve the beat, and leader Haley jerks his guitar up and down like some 'groovy' mechanical digger.
>
> As you can see, this isn't a film for the square – or the person with any degree of musical taste.
>
> . . . With the Comets performing most of their well-known titles, the Platters doing hit versions of 'Only You' and 'The Great Pretender' and Tony Martinez's band rock-and-rolling the cha-cha-cha-cha, this is a film the young ones are going to turn out in their thousands to see.
>
> 'The little people' are coming your way. Don't say you haven't been warned.[26]

Besides their obvious and occasionally risible attempts to appeal to rock'n'roll fans via the integration of musical acts into the narrative, the early American rock films possessed one thing in common: critical disapproval from the entire spectrum of British film reviewers. That various film critics differed little in their attitudes towards rock'n'roll becomes evident with the comments of *Picturegoer* and the *Monthly Film Bulletin* regarding *Rock, Rock, Rock*:

> This is a collector's item! Until you've seen thirteen-year-old Frankie Lymon sing 'No, No, No, I'm Not a Juvenile Delinquent' [sic] to a rock-'n'-roll beat, you ain't heard nothin'.
>
> Compared with this rock'n rolling jamboree *Rock Around the Clock* is just a quiet session for 'squares'.
>
> Everyone acts as though they can't wait for the next rock'n'roll number.[27]

This slim plot provides a rather ineffective link for a very large collection of Rock'n'Roll numbers, some of which are staged in poor imitation of the original *Rock Around the Clock* style. The use of gramophone records as playback discs for the shooting of exterior

song routines is very unpleasant, producing a singularly unconvincing effect. The entire film appears to have been hurled together with the maximum speed and minimum effort, in order to capitalise on the current fashion for Rock'n'Roll.[28]

Application of Bourdieu's thesis regarding the operation of critical taste leads to an expectation that the populist *Picturegoer* would adopt an opposite view to the elitist *Monthly Film Bulletin*. If cultural products are deliberate, enforced choices thanks to decisions being selected 'because they are studied in roughly equivalent positions in their respective spaces', then a presumption emerges that, within the critical sphere, reviews would adopt divergent perspectives.[29] This clearly does not hold with the discussions of *Rock, Rock, Rock*. Both commentators expressed disgust at rock'n'roll's perceived vulgarity and the apparent shoddiness and exploitative nature of the film's production history. To these critics, acting, plot, script and direction all appeared calculated to reach 'the next rock-'n'roll number' at the expense of cinematic entertainment and artistic verve. The degree of detail contained within these reviews differed widely. The sketchy, generalised tone of writing contained within *Picturegoer* lacked detailed examination of why critic Sarah Stoddart perceived the film as a bad musical, while demonstrating the cinematic and technical interests of its cine-literate readership, the *Monthly Film Bulletin* concentrated on the style of the picture's musical performances, direction and choreography.

Although this offers a crucial distinction between popular and elite film criticism, the two reviewers possessed more in common than Bourdieu's thesis would bring us to expect. Certainly, in this instance the two critical positions did not operate in direct opposition via the habitus. Instead, each commentator actually expressed their human agency, displaying a capability for deviating from expected attitudes and behaviour. Or did they? In reality, *Distinction*'s claims regarding the fixed and pre-destined nature of critical positions fail to account for historically specific events and attitudes. Ironically, considering the attitudes towards rock'n'roll and the film musical displayed by *Picturegoer* critics, the paper's distaste towards *Rock, Rock, Rock* appeared rather pre-determined. The *Rock, Rock, Rock* material indicates that critics from opposite ends of the spectrum do not necessary adopt contrasting opinions: both film publications disliked the new trends in popular music. An understanding of the reasons for this position emerges from the application of

Bourdieu's work on the various fields of cultural production. As briefly indicated in chapter 1, a different system of cultural values exists between 'the field of restricted production' and 'the field of large scale production':

> The field of production *per se* owes its own structure to the opposition between the *field of restricted production* as a system producing cultural goods (and the instruments for appropriating these goods) objectively destined for a public of producers of cultural goods, and the *field of large-scale cultural production*, specifically organized with a view to the production of cultural goods, 'the public at large'. In contrast to the field of large-scale cultural production, which submits to the laws of competition for the conquest of the largest possible market, the field of restricted production tends to develop its own criteria for the evaluation of its products, thus achieving the truly cultural recognition accorded by the peer group whose members are both privileged clients and competitors. [italics in original][30]

Bourdieu possibly overstates the potential for opposition between the two competing fields of cultural production, but this work helps to reconfigure some aspects of *Distinction* which appear over-deterministic. It is certainly appropriate to see the BFI publications as examples of 'restricted production' aimed at a clientele of educated film enthusiasts. They possessed their 'own criteria for the evaluation of its products', with productions that did not meet the artistic and social values imposed by this critical hierarchy being derided. Equally the film fan magazines and the music press operated as publications aimed at 'the public at large'. They aimed to appeal to the largest possible readership through submitting 'to the laws of competition for the conquest of the largest possible market'. This explains why *Melody Maker* covered teenage pop music during the mid-to-late 1950s, despite the consternation of many of the paper's writers. However, the need to appeal to the mass market did not mean that elite and popular tastes did not coincide. The quotes regarding *Rock, Rock, Rock* indicate that film critics opposed the values within a particular movie according to the values evident within their own cultural sphere. The artistic presumptions of the mid-late 1950s considered rock'n'roll as anathema: commentators in both fields of production felt that the new trend violated their cultural standards. Therefore *Rock, Rock, Rock* saw film critics expressing their distaste against rock'n'roll music and movies. Instead of presuming that commentators from the elite film press opposed the

comments of fan-orientated publications, what emerges is evidence that they comprised separate spheres of production with their own critical priorities.

Monthly Film Bulletin and rock'n'roll movies

The comments on *Rock Around the Clock* indicated that the resentment against the rock'n'roll movies from the BFI critics resulted from a critical distaste towards the music and form of such films. Further evidence of this disposition appears in the critical commentaries on other early US rock movies. The review of AIP's *Shake, Rattle and Rock* claimed that 'the film also falls into the usual error of ridiculing serious music'.[31] By 'serious music', the anonymous critic almost certainly referred to classical music. In a key scene, rock'n'roll is placed on trial for alleged musical and moral degeneracy. During this extract, the disc-jockey hero defends rock'n'roll by arguing the similarities between rock and the classical style of Beethoven and Chopin. Lindsay Anderson provided further evidence that the BFI critics did not see anything amusing in trivialising high culture at the expense of supposedly commercial trash in 1956:

> It is damaging, tolerating the shoddy and the third-rate, and muffling work of importance by a flippant or purely sentimental response. It is impossible to praise things that are bad without injuring the things that are good. By celebrating the merits of the trivial and the meretricious, or by being funny at its expense, we lower the prestige of the cinema, and, indirectly, make it difficult for anybody to make a good film.[32]

As discussed earlier with regards to *Dragstrip Girl*, the critical elite disliked the new methods of film production, synonymous with the arrival of the teen movie. The rock'n'roll films provide another chance to study their attitudes regarding the apparent decline in cinematic standards. *Sight and Sound* critics did not dislike the Hollywood musical of the 1940s and early 1950s. Yet by the mid-1950s, with the almost simultaneous development of new technology, typified by 3D, cinemascope and stereophonic sound, and the demise of the studio system, a more ambivalent attitude emerged towards the genre. Penelope Houston would have preferred the clock to stand still in 1953, before the purity of the musical had been diminished by spectacle and rock'n'roll. In 1963, bemoaning a decade of appar-

ent artistic deterioration, she complained that with the advent of the widescreen blockbusters:

> Producers had to study what would bring people into the cinema and, no less important, what would keep them out . . . musicals worked, providing they originated in big stage successes. The essentially film musical, as Vincente Minnelli (*Meet Me in St. Louis, An American in Paris, The Band Wagon*) and Gene Kelly and Stanley Donen (*On the Town, Singin' in the Rain*) had been lovingly developing it, was an early casualty. Such films had relied on dancing, colour, pace, the elegance or drive of their visual style. Big screen musicals were slowed down, to look more like the original stage shows; song and dance began to count for less than 'production values' – the trappings of size. Musical stars (Judy Garland, Doris Day, Fred Astaire) turned straight, and straight actors (Deborah Kerr, Yul Brynner, Rosalind Russell) moved into the new musicals.[33]

For Houston, these changes in the production of musicals proved an unqualified disaster for the genre's artistic development. 'Spectacle' replaced 'dance', 'colour', 'pace' and 'elegance'. Worse still, such films resulted from giving the public what they wanted, rather than bringing art to the public. Although primarily directed against films such as *Oklahoma!* (1955) Houston's comments explain why the critical establishment hated rock'n'roll movies from an artistic perspective. The likes of *Rock, Rock, Rock* did not feature 'dancing', 'colour' and 'elegance' in their choreography and production design. With notable exceptions, such as *The Girl Can't Help It* and *Loving You*, most of the early rock'n'roll movies were cheaply produced monochrome productions. From the viewpoint of *Sight and Sound/Monthly Film Bulletin*, this in itself might not necessarily have been a bad thing. *Rock, Rock, Rock* received condemnation, because of its inability to overcome the obvious flaws of its stars, budget and technical designers. The early rock'n'roll movies looked cheap and amateurish, because they could not provide the dramatic and technical expertise to disguise their limitations. In Roger Corman's *Rock All Night*, described by the *Monthly Film Bulletin* as 'pure comic strip material' complete with 'uninspired wisecracks', microphones and lighting equipment are visible at various points of the film.[34]

The same applies to *Rock, Rock, Rock*. The musical scenes received derision not only for their unoriginality by imitating *Rock Around the Clock*, but also because there is no evidently cinematic

musical treatment on display. Instead of original, balletic numbers performed with wit and professionalism, *Rock, Rock, Rock* features a televisual style. Perfomers, such as Chuck Berry and Frankie Lymon and the Teenagers, merely stand and mime in front of the camera. The imagination and grace of the MGM musical of several years previously, with song and dance fully integrated with character and plot, does not materialise in *Rock, Rock, Rock*'s musical sequences. To this extent, the film offers a classic example of 'cinema of attractions', neglecting narrative plot and technical expertise in favour of the musical performances. The music takes priority over the acting: hence the need to build the television show into the plot, which like *Rock Around the Clock* features Alan Freed, to strengthen the film's structure. The reviewer's contempt for the movie typified the intellectual superiority possessed by the *Monthly Film Bulletin*'s contributors at the time. Critics from this elite film publication examined the movie according to their own standards about what equalled quality cinema. This ensured that their 'aesthetic disposition' to 'break off the nature and function of the object represented and exclude any "naïve" reaction' asserted itself. The 'precondition for all learning of legitimate culture' necessitated a critical concentration 'upon the mode of representation, the style, perceived and appreciated by comparison with other styles'.[35] By examining *Rock, Rock, Rock* in accordance with the best screen musicals, the critical elite inevitably found the film devoid of what they expected from a quality musical. The importance of the movie's potential entertainment value did not concern the *Monthly Film Bulletin*, because not only did this publication not cater for teenage tastes, but also due to the fact that judging a film in accordance with its commercial potential was associated with the fan publications. To adopt the latter condition would have reduced the *Monthly Film Bulletin* to the status of *Picturegoer*, something intolerable for the magazine's discerning critics and readership.

Another key reason why the critical elite hated the rock'n'roll movies lay with the spectacular and emotional functions of these films. Bourdieu explains that the desire of the ordinary public for active participation encourages them to embrace the spectacular and the sensual, because they emphasise 'more direct, more immediate satisfactions'. He writes:

> It is because, through the collective festivity they give rise to and the array of spectacular delights they offer (I am thinking also of the

music-hall light opera or the big feature film) – fabulous sets, glittering costumes, exciting music, lively action, enthusiastic actors – they satisfy for and sense of revelry, the plain speaking and hearty laughter which liberate by setting the social world head over heels, overturning conventions and properties.[36]

This theory enables another insight into the attitudes of the *Monthly Film Bulletin* and *Sight and Sound* regarding what they thought the rock'n'roll movies represented. If the 'gifted minority', typified by the elite critics at the BFI publications, sought to distance themselves from the most spectacular elements of modern entertainment, then critical disapproval of the rock films became inevitable. These movies proved spectacular, albeit in a slightly different sense to that articulated by Bourdieu. Cheaply made productions like *Rock, Rock, Rock* did not feature 'fabulous sets' or 'glittering costumes', but for their target audience such films undoubtedly offered opportunities for 'collective festivity', 'spectacular delights', 'exciting music', 'lively action' and 'enthusiastic actors'. With *Rock, Rock, Rock* and *The Girl Can't Help It* it remains difficult to estimate the feelings of excitement experienced by fans as they saw Chuck Berry or Little Richard on the big screen. Considering that, with few exceptions, the early rock'n'rollers failed to tour Britain, the cinema provided the means by which the music and personalities of American performers could be brought closer to the everyday experiences of British youngsters. As demonstrated by the discussion of *Love Me Tender* in chapter 3, the rock'n'roll films meant a cause for celebration and 'collective festivity', because by bringing American acts into the cultural lives of many youngsters, they created entertainment, escapism and excitement. Their significance lay as a novelty value: they simply provided an entertainment experience otherwise unavailable. For example, Cliff Richard described Presley with awe in a 1959 interview: '[Elvis Presley] has grown into a terrific mythical figure for thousands of teenagers here. He's got real star status like it used to be in the old film days – something that glittered far off in the unattainable. Something to dream about.'[37]

These positive aspects of the spectacular coincide with other theories about the appeal of popular culture. Discussing the 'Heroes of Popular Literature', Gramsci makes similar comments to those of Bourdieu regarding the processes of identification in popular culture. According to Gramsci, 'one of the most characteristic attitudes of the popular public towards its literature' centres around the

assumption that 'the writer's name and personality do not matter, but the personality of the protagonist does'.[38] This presumption features heavily in Tony Bennett and Janet Woollacott's *Bond and Beyond*. They claim that popular fictional heroes can escape 'from the originating textual conditions of their existence, functioning as an established point of cultural reference' even for those consumers 'unaware of their original context of production and consumption'.[39] If these theories are extended to the rock films, then the charisma of the pop star or the leading protagonist's fictional situation possibly contained the potential for empathy, interest and identification among consumers. Although real-life rock'n'roll stars and fictional teenage stereotyped characters should not be equated with icons of the stature of James Bond or Sherlock Holmes, the images seen in the cinema could easily have enhanced the everyday culture life of young people. The likes of Presley, Little Richard and Chuck Berry not only became more than simply rock singers and film stars, but also symbolised a separate teenage cultural existence. Their screen appearances and recordings took on extra dimensions, as British teenagers adopted rock'n'roll as a means of cultural and generational expression.

The American rock'n'roll films expressed an ethos that differed from the rigidity of 1950s Britain. Character identification proved important in this sense, reinforcing the 'carnival' nature of the American rock movie. In *Rock, Rock, Rock* the devious, yet kind-hearted, Dori (Tuesday Weld) schemes to obtain a strapless ball-gown for the high school dance. She does not accept her place in the high school hierarchy: she sets out to achieve her objectives and will do anything (legal) to achieve them. The film applauds Dori for challenging her role in a structured system: against the odds she wins the boy and ball-gown.

At first sight, such plot details hardly seem confrontational. Despite her naïve charm, Dori is materialistic, unwittingly stealing money away from her friend Arabella (Fran Michael) in a failed scheme to establish a savings bank. However, despite this, *Rock, Rock, Rock* contains a certain carnivalesque spirit. According to the Soviet literary critic Mikhail Bakhtin, carnival in medieval and early modern Europe 'marked the [temporary] suspension of all hierarchical rank, privileges, norms and prohibitions'.[40] If the rock'n'roll movies are interpreted in this light, then their potential for dislocation becomes clearer. American rock films and music provided a

means of generational solidarity among teenagers: symbols of
repression such as from the parental home, school and, in the case
of *Rock, Rock, Rock*, bullying rich brats, could be turned into objects
of derision. Moreover, the films facilitated new, direct forms of com-
munication 'frank and free, permitting no distance between those
who came in contact with each other and liberating from norms of
etiquette and decency imposed at other times', rather in the mould
of carnival.[41] This occurred not only through identifying with the
pop performers, but also through fictional characters facing similar
experiences to those confronting their real-life audiences, typified
by Dori's plight in *Rock, Rock, Rock*.

The actual experience of filmgoing largely exacerbated the mood
of freedom implicit within the early American rock films. The audi-
ences for the new films and music were overwhelmingly teenagers:
theatres were transformed into temporary sites of youthful solidar-
ity excluding older customers. Such festivity even resulted in further
carnivalesque acts such as dancing in the aisles or the destruction of
the cinema seats. Although these actions brought recrimination, they
illustrated the extent to which the rock musical had the potential to
turn the world upside down, providing a release from normal codes
of behaviour.

Picturegoer – rock'n'roll and Pat Boone

Although they never directed attacked rock'n'roll fans *Picturegoer*
critics possessed little sympathy for the new musical form. Referring
to the manner in which ex-gangster Fats Murdock (Edmond
O'Brien) desires a record career for his talentless girlfriend Jerri
Jordan (Jayne Mansfield) in *The Girl Can't Help It*, Margaret
Hinxman referred to the film as a 'spoof of the rock'n'roll racket'.
She described 'bringing rock'n'roll down to the level of a gangster
comedy' as 'a stroke of genius', evidence that she regarded the
music and everything it signified as representing complicity with
criminality. Stoddart began her comments on *Don't Knock the Rock*
with 'earplugs ready – here they come again. Another batch of rock-
'n'roll acts from Hollywood's assembly line'.[42] The need for
'earplugs', expressed in the form of a joke, not only indicated
Stoddart's distaste for rock'n'roll as music, but also emphasised
that she did not treat the trend seriously as a cultural or sociological
phenomenon.

The big-budget, family entertainment film provided *Picturegoer*'s idea of a quality musical. Ernie Player sadly acknowledged that by 1958 'it's the teenagers who provide filmland with its bread and butter. The cinema men will ignore them at their peril'.[43] Listing the leading box-office successes of the previous year, Player delighted at the popularity of old-fashioned, expensive musicals such as *Oklahoma!* and *The King and I* (1956). Applause greeted these films not only for maintaining the artistic standards of the Hollywood musical, but also for reinvigorating the genre as a family medium: 'TRUE that the non-regular picturegoer added the gilt to the gingerbread of *The King and I*, etc. TRUE it will be a good thing for cinema if they can get Mum and Dad paying their whack at the box-office more often.' [capitals in original][44]

Obviously *Picturegoer* wanted more musicals in the mould of *The King and I*. 'Songs' meant ballads and lullabies unlike those offerings performed by 'rock'n'rollers [who] make every song sound alike'.[45] Orchestration rather than loud electronic instruments formed the primary mode of musical instrumentation. *Picturegoer*'s Elizabeth Forrest, in a condemnation of rock'n'roll movies, praised young entertainers working within the traditional screen musical rather than rock'n'roll. She hoped that the likes of Eddie Fisher, Pat Boone and Shirley Jones provided the means to 'get the screen musical out of the worst clutches of rock'n'roll' and the 'gyrating madmen'. Forrest questioned whether the rock acts even possessed artistic ability with her phrase, 'if you can call it that', referring to what she perceived as their lack of musical talent.[46] Evidently she did not consider rock'n'roll as proper music or rock musicians as capable of operating within the 'shape' and 'style of a decent screen musical'. This compared greatly with Fisher, Boone and Jones, figures that could act, 'sing' and fit comfortably within the parameters of the Hollywood musical. Around such performers the possibility for romance, old-fashioned musical entertainment and some semblance of a story remained, something unlikely to happen with the majority of rock-'n'roll stars. Aimed at the teenage market, featuring a despised form of music and little more than a series of rock'n'roll acts operating around often ultra thin plots, the rock movies stood as the antithesis of the productions desired by popular critics in Britain accustomed to traditional, blockbuster musicals.

One of the leading young American stars of the mid-to-late 1950s, Pat Boone provided excellent ammunition for commentators hostile

towards rock'n'roll. He initially rose to fame through cleaned-up versions of rock'n'roll classics, such as 'Tutti Frutti', yet differed greatly from his contemporaries by possessing a clean-cut image that appeared 'almost too good to be true'.[47] Boone summed up his own philosophy – 'I refuse to offend anybody.'[48] For opponents of rock-'n'roll, this devout Christian, staunchly moralistic, family entertainer presented a vision of young America which they could embrace as recognisably originating from a long-established Hollywood tradition of stage and screen performers.

Boone's popularity in Britain between 1956 and 1958 should not be doubted. Apart from Presley no other young American singer/actor remotely matched his all-round appeal. Voted the 'World's Outstanding Singer' and 'Favourite US Male Singer' by *NME* readers in 1957, he achieved a number one hit single an entire year before his nearest rival, Presley.[49] Although contemporaries in terms of age and their association with rock'n'roll, albeit tentative in Boone's case, the performers differed hugely in their treatment from British music journalists and popular film critics. Presley represented a major threat to the social and cultural fabric of Britain, but Boone and his early films, especially *April Love* (1957), articulated an idealised and conservative message to young people at a time of social unrest. Confirmation of the British preference for Boone occurred with *Picturegoer*'s decision in 1958 to grant him the front cover of their latest annual along with his *April Love* co-star Shirley Jones. This portrait, reproduced as Figure 2, depicted the stars enjoying the film's rural environment, which resembles a scene from a fairy story up-dated to the 1950s. Such calculated wholesomeness ensured that neither star became associated with deviance. Boone and Jones resembled polite, well dressed, clean-cut normal youngsters. Old-fashioned romance took precedence over violent juvenile crime or confronting parent culture. Boone received the treatment justifying *Picturegoer*'s opinion that he was the major star of his generation; something that contrasted greatly with Presley who obtained only a half-hearted token article near the end of the annual. Granting Boone the accolade of the cover for Britain's leading film annual signified that *Picturegoer* placed great trust in his abilities as a future giant of stage and screen.[50]

The musical and dramatic conservatism of Boone's music and films played a crucial role in facilitating his critical acceptance. Thomas Doherty argues that Boone represented 'a traditional show

business type whose white bucks were firmly planted on familiar ground'.[51] The traditionalism and familiarity within Boone's act is demonstrated by *April Love*. This film casts him as a young car thief, Nick Conover, who is sent to his Uncle Jed's (Arthur O'Connell) farm on probation. Hard work, discipline and the love of local

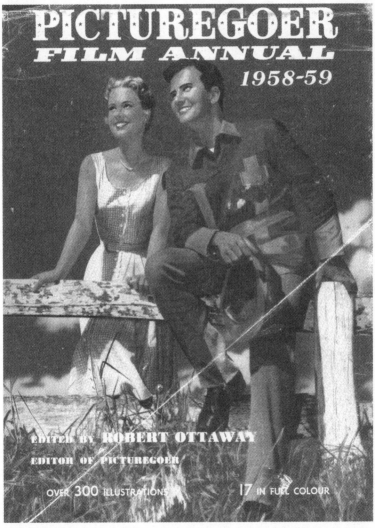

2 The fan publications and rock'n'roll: *Picturegoer* and Pat Boone (R. Ottoway (ed.)), *Picturegoer Film Annual 1958–59*

tomboy, Liz Templeton (Jones) brings the would-be delinquent into line. A constructive outlet for his energy occurs via learning to race Uncle Jed's previously uncontrollable stallion, Tugfire. Although Nick still manages to get into trouble through driving while disqualified, the problem is happily overcome at the end. Nick and Tugfire win the big race at the local fair, with the romance between the hero and Liz being cemented.

The film possibly represents the most successful attempt to incorporate a contemporary pop singer into the structures of the traditional Hollywood musical. From a musical perspective, Boone's screen role and record releases involved continuity with the dominant Tin Pan Alley tradition of American show business. *April Love* does not contain a single rock'n'roll number: most of the tunes are orchestral ballads written by distinguished songwriters including Cyril J. Mockbridge, Paul Francis Webster and Sammy Fain. On several occasions during 1957 and 1958, *Picturegoer* significantly compared his personality to a young Frank Sinatra or Bing Crosby.[52] Boone might have sung diluted rock'n'roll, but he declared that: 'I definitely do not want to be known as a rock'n'roll singer . . . *I want to be known as a fellow who can sing songs*' [italics in from original].[53] He publicly distanced himself from the 'smutty lyrics' that damaged rock'n'roll's reputation with the moral guardians, instead claiming that a young entertainer had the obligation to positively influence the attitudes and actions of their fans.[54]

April Love is a very recognisable 1950s musical not only through its musical score but also through its emphasis on family entertainment. This ensured that any glamorisation of delinquency did not occur. Even at a local dance/talent contest the local kids are dressed in ball-gowns and smart suits dancing gently to big band music and traditional jazz. Nick begins the film as a delinquent, but he is morally redeemable: beneath the tough exterior, he is a well-behaved, caring and sensitive young man who got involved with the wrong crowd. *April Love* contained nothing to encourage delinquency or moral degeneracy. *Picturegoer*'s Sarah Stoddart declared that regardless of Nick's previous criminal history 'you can't help liking the lad, *Boone sees to that*' and that the character is 'no teenage lout' [italics in original].[55] Her colleague, Hinxman, enthusiastically celebrated the musical as exemplifying the old-fashioned family romance that existed prior to the advent of rock'n'roll: 'it is a charming reminder of the days when Hollywood

made musicals about nice young people to whom a kiss was as bind-ing as an engagement ring and any misunderstandings were strictly unintentional'.[56]

As discussed earlier, much of the critical hostility directed against rock'n'roll resulted from the belief that the new musical form was exclusively a teenage preserve. *April Love* reversed this trend, as shown by the quotation featured in the *Photoplay* advert for the film. The comments of the veteran critic Jympson Harman of the *Evening News* described *April Love* as 'a very attractive "family" picture of a kind we should see more frequently'.[57] This applause for Boone signified critical statements not only against rock'n'roll, but also in favour of an old-fashioned familiarity. Apart from the youngster's cars, *April Love* contained nothing that could not have featured in a film made decades earlier: indeed it was a remake of *A Home in Indiana* (1944).[58] No concession to 1950s youth culture existed in the film. The codes of behaviour and the styles of popular music present within *April Love* met with critical approval, because the values evident in the movie matched the critics' own cultural conservatism. They had no idea that styles that had constituted popular music and modes of teenage behaviour for decades faced imminent destruction. Boone provided security and reassurance as a musical and moral figure; a comfort in an age of anxiety and change. He represented a transitional figure: the last of the crooners who was a contemporary of the early rock'n'rollers. *Picturegoer* critics lacked the foresight to realise that Presley was one of the greatest entertainers of the century; instead they opted to actively endorse Boone despite doubts about his 'dull' personality.[59] Their adherence to the ethos of the family entertainment musical blinded *Picturegoer* writers to the talent and artistry of rock'n'roll per-formers unable to fit snugly within the confines of conservative show business. Above all, this accounted for the positive acceptance of Boone as the perceived future of the musical. Although *Picture-goer*'s desire never reached fruition, their comments retain value as an explanation for the initial British preference of Boone over Presley:

> In *Bernadine*, he turned in a deft and witty performance, skirting most of the pitfalls of the beginner. His sincerity was unforced, he did his meagre stint of acting with ease and he showed that the odds were odds on his becoming a full-blown personality.

Then came *April Love* and, for my money, Pat Boone existed as a human being – unlike the eye-rolling, hip-wiggling school of rock-'n'rollers, who will lurch out of existence, as far as movies are concerned, as soon as the fashion is stone dead.[60]

Why did the AIP beach movies fail in Britain?

The void created by Presley's departure for the US Army in 1958 created a gap within American pop music that was filled by a succession of clean-cut teen idols. Typified by the likes of Fabian, Frankie Avalon and Annette Funicello, these acts have received a bad press from rock and film historians. For Nik Cohn, the early 1960s marked 'the worst period pop has been through', while Donald Clarke writes that the arrival of the likes of Funicello and Avalon saw the dilution of classic 1950s rock'n'roll rebellion into bland conformity and a shift to 'irritatingly monotonous . . . saccharine [and] banal' music.[61] Thomas Doherty adds that 'the clean teens may have taken their look from Presley, but their image was cast from Boone's model'. Certainly, the Boone persona, able to switch between various media forms, was copied by such acts: for example, both Ricky Nelson and Annette Funicello went from television shows to pop and film success.[62]

Presley not only influenced the look of such manufactured teen stars as Fabian and Avalon. His most lucrative series of movies appeared after 1960 with a succession of glossy, relatively expensive musicals. Epitomised by the likes of *Blue Hawaii* and *Girls! Girls! Girls!* (1962) this type of production proved highly influential upon the American pop film in the early-to-mid 1960s. Although Presley did not invent the beach movie, he certainly was its most popular exponent.[63] Apart from the likes of *Blue Hawaii*, the beach movie is now primarily associated with the teenage pop musicals produced by AIP during the mid-1960s, most of which starred Avalon and Funicello. A succession of titles appeared including *Beach Party* (1963), *Muscle Beach Party, Bikini Beach, Pajama Party* (all 1964) and *Beach Blanket Bingo* (1965). The importance of these pictures lies with their romanticised vision of Californian youth culture, particularly via their mixture of sun, sea, sand, surf and sex. A definition of the series' intentions emerges with *Record Mail*'s review of 'Annette's Beach Party', the soundtrack album to *Beach Party* featuring music by Funicello: 'I suppose that American teenagers do

have things like homework, and do get bored, but they are always singing about such wonderful activities as surfing, hot-rodding, holidays in the sun, the pleasures of going steady and the reflection of the moon on the tranquil waters of the Pacific.'[64]

However, what makes the AIP beach movies interesting for the purposes of this book is their failure to achieve success in Britain. The studio attempted to launch the films in Britain via a 'Starburst of Youth' publicity campaign at the end of 1965. Accompanying this publicity was an article in *Photoplay*, which sought to reveal the attractions of the series to British audiences by stressing the cycle's idyllic vision of American youth culture. Two aspects featured heavily within beach movie iconography and the article: the sport of surfing and the bikini. The would-be-stars' hobbies and physiques subscribed to the myths and stereotypes associated with Californian youth culture. Nearly every participant involved with the AIP promotional venture was described as enjoying surfing or other healthy outdoor sports, such as waterskiing, tennis and swimming. For example, Patti Chandler was 'always a sun-worshipper and a water sports enthusiast', while 'attractive Susan Hart' was reported as 'essentially an out-doors girl, she excels in ski-ing, surfing and horseback riding'.[65] The article suggested that sporting and physical prowess, together with actual career success were available to those whose personalities and attributes matched the myths of surfing culture.

Confirmation of this occurred through the presentation of the female hopefuls in the article. This fully elucidated the connections between physical appearance and dress conformity via Iain McAsh's descriptions of the 'starlets' involved with the 'Starburst of Youth' tour and their supporting photographs. As *Record Mail*'s review of 'Annette's Beach Party' illustrated earlier, the American Dream as filtered through the AIP movies offered a correlation between sporting aptitude and physical attractiveness. In the words of beach movie director, William Asher, 'our audiences welcome clean sex . . . They're bored with juvenile delinquents'.[66] The photography featured in the article exacerbated this sexualisation of the female hopefuls involved in the 'Starburst of Youth'. Of the five actresses only Luree Holmes failed to wear the bikini, the stereotypical costume of Californian women at the time. Therefore, it is not altogether surprising that all of the women featured in the written part of the article were connected with beauty contests, modelling or

surfing. Comments such as 'a vivacious 22-year old blond with the eye-popping measurements of 38"-22"-35"' and 'a vivacious 22-year-old beauty who won a bikini contest conducted for AIP's *Bikini Beach*' described Bobbi Shaw and Patti Chandler. 'A successful modelling career' provided the passport to fame for Mary Hughes, Salli Sachse, Jo Collins and Sue Hamilton.[67]

Despite such publicity the series failed commercially and critically in Britain at the time of their release and the 'Starburst of Youth' hopefuls soon returned to obscurity. However, it needs to be established that the beach movies failed in Britain. Crucially, during the mid-1960s, the commercial viability of the films was hindered by five factors:

First, like other AIP products in Britain, the beach movies were restricted to supporting features/double bills with other pop films. For example, *Bikini Beach* was teamed with the Dave Clark Five vehicle *Catch Us If You Can* (1965).[68] This confirmed their position as minor films that could easily pass unnoticed by British audiences. Moreover, the films were poorly distributed in Britain: *Beach Party* arrived a year after its American release, while *Muscle Beach Party* and *Pajama Party* (1964) emerged two years later across the Atlantic. The later parts of the series, including *Beach Blanket Bingo* and *How the Stuff a Wild Bikini* (1965) failed to obtain British cinema releases, testifying to the films' inability to reach a British audience.

Second, the beach movies attracted negative critical comments from the outset. This disapproval for the films coincided with the prevailing critical discourses at the time in Britain outlined earlier. Considering this context, it becomes easier to account for the initial critical disdain for the beach movies. Although *Beach Party* received unexpected praise from the *Monthly Film Bulletin* for 'its attractive visual sheen' and friendly, lightly satirical tone', this acclaim proved short-lived.[69] Many reviewers in the mid-1960s regarded the films as examples of bad movies. A revealing insight into such disapproval for the beach movies occurred through the *Monthly Film Bulletin*'s comments on *Pajama Party*:

> Possibly there is a big gap between American and British teenagers, but it is hard to visualise the latter appreciating any of the deliberately disparate elements in this painful film. The pop songs are feeble, the black-leather-gang parody is too completely divorced from reality, the Sci-Fi element doesn't get off the ground, and the numerous near-nude

teenage parties are utterly synthetic in their exuberance. [Director] Don Weis has a smooth way with action, but can make nothing of the chaotic narrative, the lethally unfunny running gags, and the insipid love scenes. It is sad to see the still-glamorous Dorothy Lamour warbling a burlesque of her own type of singing, and Buster Keaton labouring nobly and at length with the ghastly role of a moronic Red Indian. Still, he appears to be enjoying a Keystone Cops chase, even if Sennett would have done it ten times better.[70]

Given the canonical disposition of many British film critics, the AIP beach movies faced problems from the start. In the case of the beach movies, the presence of performers, such as Buster Keaton, merely confirmed the distaste for such pop films as musical comedies. Other veterans, such as Vincent Price and Peter Lorre, appeared in the films. To a certain extent, what emerged with the negative reaction towards the beach movies was consternation that the legacies of *The General* (1926) or *M* (1931) had been diminished, thanks to their stars being forced into such teenage trash during their declining years.

In this sense, pop films were taken to represent a form of 'dumbing down' of the artistic potential of the cinema. *Films and Filming*'s Robin Bean believed that the 'churning out [of] formula pictures till they reach the point of diminishing returns' appeared symptomatic of the desperation of producers to attract young people to the cinema at a time of falling audiences.[71] Reviewing *Beach Party*, Bean commented that 'somewhere a teenage romance of sorts (which seems to be more like a feud) is being carried on by Frankie Avalon and Annette Funicello which no doubt will last for many movies to come'.[72] His prediction proved correct, as the Avalon/Funicello on/off romance lasted for the series' entire duration. For several years, the *Beach Party* formula was repeated until diminishing returns set in, and AIP turned their attention to counter-culture rebellion films such as *The Wild Angels* (1966) and *The Trip* (1967).

Third, the AIP beach movies failed commercially in Britain because UK teenagers did not require their idyllic vision of American life. The mid-1960s arguably marked the apogee of British popular music through the 'beat boom', headed by artists such as the Beatles and the Rolling Stones. Why would British pop fans have any need to see Funicello and Avalon, neither of whom had achieved significant chart success in Britain, in *Beach Party* during August 1964, when they possessed the opportunities to experience both *A Hard*

Day's Night and Cliff Richard in *Wonderful Life* (both 1964)? Cliff is the crucial figure in explaining the AIP films' failure in Britain, and, along with Presley, the prime exponent of the beach movie to British audiences. Not only did he occupy a similar boy-next-door teen idol role to that held by Avalon in America from c. 1958/59, but also Cliff starred in glossy, escapist, musical comedies not a million miles away from the AIP formula. *Summer Holiday* and *Wonderful Life* are British beach movies designed for domestic consumption, while similar glossy travelogues featured not only in the Beatles' *Help!*, but also through that agent of 'swinging sixties' Britishness James Bond. In these circumstances, it does not appear surprising that the music paper, *Music Echo* boasted in 1965 'that British pop films have the edge over the American'.[73] Ultimately, perhaps the reason why British critics often treat the beach movies as kitsch nonsense results from the fact that they resembled obscure curiosities from the moment of their initial release in Britain. During the mid-1960s, the AIP beach movies were irrelevant in Britain: if Cliff Richard famously failed in America, Annette Funicello and Frankie Avalon failed in Britain, as neither country wanted or required the other nation's chief representatives of non-deviant teenage culture.[74]

Fourth, Presley had already firmly established himself as the prime American exponent of the beach movie over two years before the release of *Beach Party* thanks to *Blue Hawaii*. This film was the third and fourth highest-grossing film of 1962 in Britain and America respectively.[75] He repeated this formula on several occasions: for instance, his next beach movie, *Girls!, Girls!, Girls!* also set in Hawaii virtually remade the earlier film. Inevitably, this brought complaints about the star's roles, as shown by *Melody Maker*'s comments about *Girls!, Girls!, Girls!*:

> It is no longer headline news when Elvis Presley makes a film – it just happens regularly like Bank Holidays and bank-raids.
> It WOULD be news if he made a film where (a.) he didn't sing a note or so much as slide towards a guitar (b.) didn't appear with girls washing round him like the waves of the tropical paradise his latest films have been made in, and (C.) ACTED.
> This doesn't mean that he can't sing, is precocious, or can't act.
> But his latest film *Girls! Girls! Girls!* is following much of the same pattern of one before and one before that – the kind of fairytale life many people would like to lead [sic].
> . . . Good, escapist cinema. But is it broadening Presley's reputation among the cinemagoers as opposed to the fans. [emphasis in original][76]

This critical disapproval also spread to the fans. By the mid-1960s Presley resembled a 'falling star', waning in popularity.[77] This partly occurred due to the British 'beat' boom, but also due to the rather tired nature of his films and music. *Fun in Acapulco* (1963) and *Girl Happy* (1965) simply remade the *Blue Hawaii/Girls! Girls! Girls!* formula, but without their hit songs such as the number one singles 'Can't Help Falling In Love' and 'Return to Sender'. Too many of Presley's film songs were lightweight, and some possessed ridiculous titles like 'The Fort Lauderdale Chamber of Commerce' and 'The Bullfighter was a Lady'. This greatly damaged Presley's chart performances. Between November 1960 and August 1963, Presley dominated the British hit parade: ten out his thirteen singles chart entries reached number one. In the two subsequent years of chart entries, October 1963 to November 1965, only two out of ten Presley singles even reached the top ten.[78]

After such a remarkable period of dominance, this marked an unmistakable decline in popularity, which had implications for the AIP beach movies. The Avalon/Funicello films were not only released at a time when the American pop film had already peaked in Britain, but also the main star associated with this cycle had declined in popularity. Given this situation and the fact that Avalon and Funicello were never major artists in Britain, the commercial failure of their beach movies was inevitable.

Finally, the AIP films did not translate to Britain because they were too American. Youth subcultures have traditionally been represented as being 'identifiably different' from parental culture. According to Clarke *et al.*, such socio-cultural movements 'must be focused around certain activities, values, certain uses of material artefacts, territorial spaces etc. which significantly differentiate them from the wider culture'.[79] Although this interpretation of British post-war youth subcultures over-emphasised the degree of deviance within many youth movements, its claims on the importance of separate teenage cultural codes contains relevance to this study. The Californian surfing craze, presented and popularised by the AIP films, depicted subcultural activities through language and customs that could only have been appreciated by people aware of these cultural codes. This distinction ensures that the films' surfers employ a certain subcultural language that is unintelligible to those unaware of their culture. For example, Dick Dale and the Del-Tones' 'Secret Surfin' Spot' from *Beach Party* refers to 'hot-dogging on my board

until the sun goes down', while this secluded surfing paradise remains unique because it is situated where 'the gremmies and the hooters never go'. The beach serves the classic location for exercising subcultural difference. Surf culture is presented as being unavailable to 'gremmies', motor cyclists such as the buffoon-like Eric Von Zipper (Harvey Lembeck) the surfers' bumbling enemy in numerous AIP films, and 'hooters' defined by *Record Mail* as kids under fifteen who are 'looked upon with amusement, and are definitely not allowed in with the surf'.[80] Other films are full of surfing terminology such as 'waxing our boards', 'cowabunga', 'jazz the glass', 'real hotdogger' and to 'catch/shoot/sneak a wave'. Besides this, real-life surfing locations are explicitly alluded to in songs: Balboa, in *Beach Party*'s theme tune, and Muscle Beach through the very title of *Muscle Beach Party*. These references were intended to increase the subcultural capital of viewers interested in surfing. Yet, by acknowledging the surfing subculture, they effectively disenfranchised audiences unacquainted with such specialised knowledge.

The very American nature of the AIP beach movies simply made them irrelevant and inaccessible to most British pop fans. Their failure not only demonstrates how US teen culture did not necessarily translate to Britain, but also highlights the importance of favourable historical circumstances as a reason for the success of the early rock-'n'roll films. In 1956–57, British teenagers desired American music and films, yet this situation no longer existed by the mid-1960s. To investigate how this scenario materialised, it becomes necessary to discuss the British pop film in the next two chapters.

Notes

1 B. Falk, 'The Moving Finger', *Mersey Beat* (26 July–9 August 1962), p. 7.
2 D. Hebdige, 'Towards a Cartography of Taste 1935–1962', in idem, *Hiding in the Light* (London: Routledge, 1988), pp. 45–76; J. Stacey, *Star Gazing: Hollywood Cinema and Female Spectatorship* (London: Routledge, 1994); A. Gramsci, *Selections From the Prison Notebooks*, ed. and trans. Quentin Hoare and Geoffrey Nowell-Smith (London: Lawrence and Wishart, 1971), pp. 277–320.
3 Gramsci, *Prison Notebooks*, p. 317.
4 Hebdige, 'Cartography of Taste', pp. 70–3.
5 Stacey, *Star Gazing*, p. 238.
6 Falk, 'The Moving Finger', p. 5.

7 Stacey, *Star Gazing*, pp. 80–223; P. Swann, *The Hollywood Feature Film in Postwar Britain* (London: Croon Helm, 1987), pp. 1–79; J. Lacey, 'Seeing Through Happiness: Hollywood Musicals and the Construction of the American Dream in the 1950s', in A. Kuhn and S. Street (eds), *Journal of Popular British Cinema 2 – Audiences* (Trowbridge: Flicks Books, 1999), pp. 54–65.
8 Lacey, 'Seeing Through Happiness', p. 56.
9 J. Payne, 'Should we Surrender to the Teenagers?', *Melody Maker* (23 June 1956), p. 5.
10 *Ibid.*
11 *Ibid.*
12 *Ibid.*
13 B. K. Grant, 'The Classic Hollywood Musical and the "Problem" of Rock'n'Roll', *Journal of Popular Film and Television* 13:14 (1986), p. 198.
14 D. Clarke, *The Rise and Fall of Popular Music* (London: Penguin, 1995), p. 377.
15 L. Henshaw, *Melody Maker* (13 July 1957), p. 11.
16 *Melody Maker* (13 April 1957), p. 10.
17 R. Morton, 'Haley's New Film, *Don't Knock the Rock*, Brings More Rock and Roll Talent to the Screens', *NME* (18 January 1957), p. 10.
18 'Race Riots', *Melody Maker* (6 September 1958), pp. 1, 16.
19 Payne, 'Should we Surrender to the Teenagers?', p. 5.
20 *Ibid.*
21 R. Altman, *The American Film Musical* (London: BFI Publishing, 1989), p. 199.
22 'Rock Around the Clock', *Monthly Film Bulletin* 271:23 (August 1957), p. 107.
23 M. Kermode, 'Twisting the Knife', in J. Romney and A. Wootton (eds), *Celluloid Jukebox: Popular Music and the Movies Since the Fifties* (London: BFI Publishing), p. 9.
24 T. Gunning [1986], 'The Cinema of Attractions', in J. Hollows, P. Hutchings and M. Jancovich (eds), *The Film Studies Reader* (London: Arnold, 2000), p. 163.
25 A. Higson, *Waving the Flag: Constructing a National Cinema in Britain* (Oxford: Clarendon Press, 1995), p. 146.
26 C. Govey, 'New Bill Haley Film Even Rock-and-Rolls the Cha-cha-cha!', *NME* (20 July 1956), p. 6. The Eric Delaney Band were a British jazz/swing band renowned for their extrovert performance style.
27 S. Stoddart, 'Rock, Rock, Rock', *Picturegoer* (12 January 1957), p. 16.
28 'Rock, Rock, Rock', *Monthly Film Bulletin* 24:277 (February 1957), p. 20.

29 P. Bourdieu, *Distinction: A Social Critique of the Judgement of Taste*, trans. Richard Nice (London: Routledge, 1984), p. 232.

30 Bourdieu, *The Field of Cultural Production: Essays on Art and Literature*, edited and introduced by Randal Johnson (Cambridge: Polity Press, 1993) p. 115.

31 'Shake, Rattle and Rock', *Monthly Film Bulletin* 24: 276 (January 1957), p. 9.

32 L. Anderson, 'Stand Up! Stand Up!', *Sight and Sound* 26:1 (Summer 1956), p. 66.

33 P. Houston, *The Contemporary Cinema* (London: Pelican, 1963), p. 57.

34 'Rock All Night', *Monthly Film Bulletin*, 24:281 (June 1957), 75.

35 Bourdieu, *Distinction*, p. 54.

36 *Ibid.*, p. 32.

37 K. Cooper, 'The Terrors of Stardom', *Melody Maker* (26 September 1959), p. 8.

38 A. Gramsci, *Selections From Cultural Writings*, ed. D. Forgacs and G. Nowell-Smith (London: Lawrence and Wishart, 1987), p. 350.

39 T. Bennett and J. Woollacott, *Bond and Beyond: The Political Career of a Popular Hero* (New York: Methuen, 1987), p. 14.

40 M. Bakhtin, *Rabelais and His World*, trans. Hélène Iswolsky (Bloomington: Indiana University Press, 1984), p. 10.

41 *Ibid.*

42 M. Hinxman, 'The Girl Can't Help It', *Picturegoer* (9 February 1957), p. 17; S. Stoddart, 'Don't Knock the Rock', *Picturegoer* (16 February 1957), p. 16.

43 E. Player, 'Should Filmland Ignore the Teenagers?', *Picturegoer* (25 January 1958), p. 13.

44 *Ibid.*

45 E. Forrest, 'Can Fisher Stop the Rock'n'Rollers?', *Picturegoer* (23 February 1957), p. 7.

46 *Ibid.*

47 D. Walker, 'Is Pat Boone Too Good to Be True?', *Picturegoer* (6 April 1957), p. 7.

48 P. Boone as told to P. Hill, 'I Refuse to Offend Anybody', *Melody Maker* (22 December 1956), p. 3.

49 *NME* (4 October 1957), pp. 10–11; K. O'Brien (ed.), *Guinness Book of British Hit Singles* (London: Guinness Publishing, 1999, 12th edn), p. 44.

50 R. Ottaway (ed.), *Picturegoer Film Annual, 1958–59* (London: Odhams, 1958), front cover.

51 T. Doherty, *Teenagers and Teenpics: The Juvenilization of American Movies in the 1950s* (Philadelphia: Temple University Press, 2002 revised edn), p. 167.

52 J. Stevens, 'Boone Can Learn From Sinatra', in Ottaway (ed.), *Picture-goer Film Annual*, pp. 31–5; S. Stoddart, 'Boone Latches on to that Sinatra Gimmick', *Picturegoer* (22 February 1958), p. 12.

53 'No Wonder they Swoon over Boone', *Photoplay* (March 1957), p. 24.

54 Boone, 'I Refuse to Offend Anybody', p. 3.

55 S. Stoddart, 'Boone Latches on to that Sinatra Gimmick', p. 12.

56 Hinxman, 'April Love', *Picturegoer* (1 March 1958), n.p.

57 *April Love* advert, *Photoplay* (May 1958), p. 10.

58 P. Davis, *Pat Boone: The Authorized Biography* (London: HarperCollins, 2001), p. 96.

59 Stevens, 'Boone Can Learn From Sinatra', pp. 32–3.

60 *Ibid.*, p. 32.

61 N. Cohn, *Awopbopaloobop Alopbamboom: Pop From the Beginning* (London: Minerva, 1996 [1969]), p. 73; Clarke, *The Rise and Fall of Popular Music*, p. 426.

62 Doherty, *Teenagers and Teenpics*, p. 167.

63 The first beach movie was *Gidget* (1959), starring Sandra Dee and featuring music from the Four Freshman.

64 R. Attenborough, 'Annette's Beach Party', *Record Mail* (October 1964), p. 4.

65 I. McAsh, 'The Treatment', *Photoplay* (December 1965), p. 52.

66 Quoted in B. Hoskyns, *Waiting for the Sun: Strange Days, Weird Scenes of Los Angeles* (London: Bloomsbury, 1996), p. 59.

67 McAsh, 'The Treatment', pp. 52–3.

68 Advert for *Bikini Beach* and *Catch Us If You Can*, NME (23 July 1965), p. 4.

69 'Beach Party', *Monthly Film Bulletin* 32:368 (September 1964), p. 133.

70 'Pajama Party', *Monthly Film Bulletin* 33:387 (April 1966), pp. 62–3.

71 R. Bean, 'Keeping Up With the Beatles', *Films and Filming* 10:6 (February 1964), p. 12.

72 R. Bean, 'Beach Party', *Films and Filming* 11:1 (September 1964), p. 22.

73 B. Harry, 'Elvis – Still Busy Filming', *Music Echo* (26 June 1965), p. 9.

74 O'Brien (ed.), *The Guinness Book of British Hit Singles*, pp. 96, 188. Funicello never actually charted in Britain, while neither Fabian or Avalon obtained a British hit single after 1960.

75 R. Bean, 'Girls! Girls! Girls', *Films and Filming* 9:5 (January 1963), p. 38; P. Guralnick, *Careless Love: The Unmaking of Elvis Presley* (London: Little, Brown, 1999), p. 122.

76 C. Roberts, 'Will Elvis Ever Emerge as a Film Actor?', *Melody Maker* (26 January 1963), p. 6.

77 R. Coleman, 'Catch a Falling Star', *Melody Maker* (21 September 1963), p. 9.

78 O'Brien (ed.), *The Guiness Book of British Hit Singles*, pp. 327–8.
79 J. Clarke, S. Hall, T. Jefferson and B. Roberts, 'Subcultures, Cultures and Class: A Theoretical Overview', in S. Hall and T. Jefferson (eds), *Resistance Through Rituals: Youth Subcultures in Post-War Britain* (London: Hutchinson, 1976), pp. 13–14.
80 'Surfin'', *Record Mail* (October 1963), p. 6.

Chapter 5

The rise of the British pop film

Modern British pop dates back to the years between 1956 and 1962. This period saw the emergence of the first homegrown teen idols; authentic representatives of youth culture who primarily appealed to young people. Within popular music and film, the likes of Tommy Steele, Cliff Richard and Adam Faith illustrated the increasing importance of British youth culture. Each of these pop stars attempted a film career, albeit with contrasting success. The actual quality of their music and films is less significant than the social-cultural changes they personified. Without Steele and Cliff, British youth culture might have turned out very differently. Steele initiated the trend of British pop musicals made quickly and cheaply in order to capitalise upon an act's initial success. The first British manufactured pop star established a pattern for a countless succession of 'puppets', whose popularity owed more to expert management than discernible talent, Steele's path to fame remains a potent recipe for success in the age of *Pop Idol*. Cliff Richard arguably represents the definitive British teen idol. He was much more of a traditional romantic interest than the Beatles, while his image epitomised a greater range of socio-cultural discourses than most subsequent teen idols.[1]

'The symbol of the teenagers of Britain' – Tommy Steele and 1950s British youth culture[2]

Tommy Steele emerged as the first British teen idol who could match the Americans for charisma, if not through his talent. Although the skiffle craze headed by Lonnie Donegan had a considerable impact upon the future direction of British pop, Steele possessed a youthful

energy that the experienced traditional jazz musician Donegan lacked. In the words of George Melly, 'Steele was the first British performer to receive the true pop accolade, the pubescent shriek.'[3] Until Steele Britain lacked a young working-class musical and film personality able to match the popularity of American artists. As Steele's co-manager Larry Parnes commented during the 1980s, earlier 'excellent dance band singers like Dickie Valentine, Dennis Lotis, David Whitfield . . . never really captured a teenage audience'.[4] British cinema also neglected the youth constituency. While James Dean typified the US teen revolt of the mid-1950s, *Picturegoer* ludicrously placed their hopes for a British equivalent on the upper-class-accented Jeremy Spenser, the obnoxious young king from *The Prince and the Showgirl* (1957).[5] In this context, Steele's symbolic importance as a working class youngster, at the top of his profession in both film and pop music should not be underestimated.

Steele's rapid ascent to the top of British entertainment provided the model for subsequent acts to capitalise upon. First, to many critics, Steele's rise typified the importance of PR and shrewd management in determining an artist's success. Second, his fast absorption, via film and variety, into the structures of family entertainment served as the effective career paradigm for British pop performers until the mid-1960s. Third, Steele's Britishness, or more specifically his undisguised Cockney working class roots, featured prominently in his star persona. Critics seized upon the perceived naturalism of movies such as *The Tommy Steele Story* (1957), together with the wider implications of his image, as representing the continuity of British popular culture against US influences. The actual quality of Steele's music and films does not concern this discussion: whether *The Duke Wore Jeans* (1958) justifies Andy Medhurst's censure for being 'frankly, almost unwatchably bad' requires another debate.[6] Rather, it locates Steele in 1957, the year of his greatest recording and film success, examining his significance through a consideration of contemporary discourses surrounding the star.

Throughout the initial period of Steele's fame (late 1956/early 1957), his almost unbelievable ascent to stardom featured prominently in press reports. A simplified version of real events featured in his first starring vehicle *The Tommy Steele Story*, as indicated by the *Monthly Film Bulletin*'s synopsis:[7] 'Having learnt to play guitar while in hospital, Tommy Steele discovers his ability as a performer while working as a ship's steward. Returning to London with diffi-

culty reassuring his parents, he is given an engagement in the Two I's coffee Bar. He is asked to make a gramophone record, and, subsequent to its issue, becomes a teenage rock'n'roll idol.'[8]

No other British teenage idol has ever quite matched Steele's neat compliance with the Cinderella myth. Tommy Hicks, a merchant seaman on leave from his maritime duties, was discovered by manager/PR agent John Kennedy, while performing at a London coffee house, the Two I's. Within six months, the renamed Tommy Steele had won a recording contract and gained significant musical popularity, appeared at prestigious cabaret venues, such as the Stork Club and the Café de Paris, and starred in his own film biopic.[9] His success prompted a merchandising frenzy complete with 'Tommy Steele shoes, Tommy Steele shirts, blouses, panties, skirts, ear-rings, bracelets, pullovers and sweaters'.[10] By the end of 1957, he was 'probably the biggest attraction in British show business today', earning an estimated £60,000 per year and £20,000 plus per centage profits for the forthcoming *The Duke Wore Jeans*.[11]

Kennedy and Parnes used their connections with PR and music journalism to maximise their protégé's commercial potential. This strategy involved fabricating information to achieve publicity: apparently Kennedy 'faked' images of debutantes and the Duke of Kent enjoying Steele's act.[12] Their 'get-rich-quick' mentality accounted for the plethora of merchandising items, while the actual production of *The Tommy Steele Story* typified the exploitation of youth by svengali managers. The film was announced in January 1957 and released in June 1957, costing an inexpensive £15,000.[13] Indirectly, the movie emphasised the cross-media relationship between the press and the pop industry through featuring shots of actual positive articles such as Charles Govey's glowing *NME* piece 'Six Weeks to Stardom!'.

Commentating on the strategy for musical success established by Steele, Parnes and Kennedy, Stuart Hall and Paddy Whannel claimed that 'teenage culture is a contradictory mixture of the authentic and the manufactured':

> [the pop star] is usually a teenager, springing from the familiar adolescent world, and making a whole set of common feelings with his audience. But once he is successful, he is transformed into a commercial entertainer by the pop-music business. Yet in style, presentation and the material he performs, he must maintain his close involvement with the teenage world, or he will lose his popularity. The record compa-

nies see him as a means of marketing their products – he is a living, animated, commercial image.[14]

Following Steele, Parnes orchestrated the fortunes of other pre-Beatles pop singers, such as Billy Fury and Marty Wilde, providing lessons in singing and stage technique before launching his rechristened protégés on the path to success. He admitted that pop provided opportunities to exploit teenage tastes. In a 1959 interview, when asked about whether young peoples' tastes had changed since the advent of rock'n'roll, Parnes declared that 'they have not so much changed as had their tastes changed for them'.[15] Considering this context it is easier to understand why Parnes served as the chief inspiration behind the insincere pop manager, Johnny Jackson, in the play/film *Expresso Bongo* (1959).

Yet it is over simplistic to equate Steele's success with the machinations of his managerial team. A successful teen idol has to operate as a symbol of youth identity without appearing as the artificially constructed puppet of his/her publicists. Steele's transformation from supposed rock'n'roll rebel to family entertainer has generally attracted negative criticism, but proved beneficial to his career. Melly claimed that the move into films and variety achieved Steele's 'castration' as a musician and his 'consequent alienation of his first public, the teenage rebels', while Medhurst similarly attributes the 'bad' artistic quality of Steele's movies to the ethos of family entertainment.[16]

Despite these claims, *The Tommy Steele Story* cannot be considered outside contemporary discourses surrounding British light entertainment. From the start, Parnes and Kennedy connected their artist within the wider spectrum of show business than rock'n'roll. Steele's management declared in a February 1957 *Photoplay* article that: 'We're not exploiting Tommy as a rock'n'roller. True he's a product of the new craze, but if you take a look at these packed houses Tommy's been getting, you'll agree that he's sure to continue to be a great favourite.'[17] Long-term career progression could only exist for pop performers if they also proved adept at theatre and films. Steele's film career provided the next step in this process after his achievements in the pop charts and variety. This route from pop performer to light entertainer was considered unavoidable for British pop stars until the mid-1960s: it is often forgotten that even *A Hard Day's Night* features such British showbiz stalwarts as Derek Nimmo and Lionel Blair alongside the Beatles. The structure of British show business during the 1950s and early 1960s necessitated

a shift from pop performer to family entertainment. Unless chart artists developed into clean cut acts able to diversify between pop, film, theatre and pantomime, they would fail to gain access to the most lucrative concert venues and television shows. Particularly powerful in this field of light entertainment were the Grade brothers who, according to Shadows drummer Tony Meehan, 'really monopolised British showbusiness' throughout this period, thanks to their extensive interests in television companies, agencies and concert venues.[18] The Grades preferred acts whose talents fitted neatly into their own diverse interests: i.e. artists able to perform regularly on television programmes such as *Sunday Night at the London Palladium*, and with the ability to perform concerts and summer seasons/pantomine. Acts who successfully made this transition from teen pop idols to family entertainers and film stars, such as Steele and Cliff Richard, therefore had a much greater chance of career longevity than performers, like Johnny Kidd, who failed to adapt to this system.

This context explains why Steele received critical plaudits for his move into light entertainment. For example, *Picturegoer*'s Ernie Player provided a glowing tribute to *The Tommy Steele Story*:

YES, sir, *The Tommy Steele Story* is rattling good propaganda. A ridiculous way to describe Britain's first screen try at putting over an Elvis Presley-type personality? No. Propaganda for teenagers is exactly how I rate it.

For it DOESN'T show youngsters with a taste for rock'n'roll and kindred capers as hysterical curiosities.

It DOESN'T make them out to be ridiculous, weirdly garbed morons.

It DOESN'T present them as crazy mixed-up kids who have to find abandoned release in zany dancing and screaming hero-worship.

It mirrors young people as they more generally are: normal characters ready to enjoy and express themselves, responding healthily to Steele's personality and performance.

And Steele himself is represented as no frenzied freak, but as an eager and honest fellow who makes a career from playing a guitar and singing.

IN OTHER WORDS, IT DOES RIGHT BY THE UNDER-TWENTIES. THAT'S WHAT I MEAN WHEN I CALL IT GOOD PROPAGANDA.

For let's be honest, some of the things Hollywood has done in its rock-around-the-projector presentations need to be counter-balanced.

Rock, Rock, Rock and *Rock, Pretty Baby* and the rest have done little to demolish the school of thought that holds that all teenagers to be irresponsible and hysterical.

Some of the virtues of *The Tommy Steele Story* were doubtless dictated by its unpretentiousness. The budget wouldn't stand huge crowds of howling extras.

Nevertheless, the credit goes to the makers for their basic approach – 'Keep it simple and don't exaggerate. [emphasis in original][19]

Picturegoer's description of *The Tommy Steele Story*'s positive attributes barely masked a diatribe against American cultural influences, indicating hostility towards the connotations associated with rock'n'roll. British teenagers were positioned in opposition to US rock'n'roll movies and unworthy icons like Elvis Presley. Instead the film presented an appropriately British vision of teenage life with energetic, well-behaved youngsters typified by Steele. Under these circumstances, the original posters for *The Tommy Steele Story* boasted that the movie represented 'GRAND ENTERTAINMENT THE WHOLE FAMILY WILL ENJOY' (emphasis in original).[20]

Beyond this emphasis on family entertainment, *The Tommy Steele Story* positions its star as a personality capable of uniting people regardless of class and age. To achieve this task, the film adopts two notable strategies. First, the music is not solely teenage-orientated; Steele significantly performs ballads and rock numbers. Besides Steele's act, viewers hear renditions from trad jazz trumpeter Humphrey Lyttleton, the skiffle/folk artists Chas McDevitt and Nancy Whiskey and two calypso groups, Chris O'Brien's Caribbeans and Tommy Eytle's Calypso Band. Second, the film is in resolutely good taste. It seeks to bring respectability to teenage pop by emphasising Steele's appeal to people from a higher social class. At the start of the film, we see Steele performing at the top London 'Dining', 'Dancing' and 'Cabaret' venue, the Café de Paris. Unlike the US rock movies, these British audiences are not jiving teenagers frantically dancing to the music. Rather this location provides dignified entertainment for debutantes, the middle class and the middle-aged: the dress code is ball-gowns and ties, not jeans. Interestingly, even in the scenes where Steele performs to teenagers in the Two I's coffee bar and Bermondsey Town Hall, the youngsters are polite, well dressed; they behave with appropriately British restraint. Although dancing does occur we mostly witness gentle swaying from side to side. No wild screaming occurs: the star's act

is well received with applause at the end of each song – he is not interrupted. The impression at the end of the film is that Steele represents the ideal figure for an era of affluence and consensus politics. Youthful and working-class, yet able to appeal to older generations and agnostics towards rock'n'roll by the force of his personality, Steele unites the nation at a time of social and cultural upheaval. Interestingly, Peter Leslie comments that Steele's popularity primarily lay with 'the 5–12 age group [rather] than the 12–15 bracket as had been thought'. This link to the children's market was seen to enhance his career 'beyond the still narrow confines of "the big beat"', indicating the centrality of family entertainment to contemporary debates over rock'n'roll and its place within the wider framework of British showbusiness.[21]

Picturegoer's disdain for American culture coincided with the views of other commentators writing about Steele's films and personality. Ironically, considering the movie's exploitation origins, Tony Brown's *Melody Maker* review of *The Tommy Steele Story* featured a notable observation: 'This unlike some of those rock-'n-'roll efforts is no "quickie' on a shoe-string and pushed out to cash in on Steele's popularity. It is a competent, professional production.'[22] As with Player's comments, a distance between Steele and 'those rock-'n'-roll efforts' emerged within Brown's review. The American rock-'n'roll movies represented shoddy 'quickie' presentations. *NME*'s Charles Govey offered two similar conclusions:

> That although the British film studios were pretty late climbing aboard the rock'n'roll bandwagon, they have produced something far better than any of those Hollywood epics.
> That Tommy himself emerges as a sincere actor and a fine all-round performer, and the cynics who said he would fade out with the end of rock'n'roll can get ready to eat their hats.[23]

However, the key reason why Steele's movies did not receive the same condemnation as US pop musicals lay with his nationality. In a January 1958 comparative examination of Steele and Presley, *NME*'s Derek Johnson declared that in spite of the American's considerable British popularity, 'it was only natural that we in this country, although perfectly willing to recognise the achievements of Presley should want to boost a star of our own'.[24]

Britain during the 1950s still lived under the shadow of Empire and the Second World War. Events such as the 1953 Coronation con-

firmed British patriotism despite the nation's decreasing status as a world superpower. Patriotism figured in the national psyche through such occurrences as the playing of the national anthem at cinemas. Interestingly, Steele's rise to fame coincided with the Suez Crisis in late 1956, the international humiliation that proved the hollowness of British claims to world power status. Steele's rise presents a case of youthful Britain fighting back against the upstart Americans, offering resistance to US domination. Certainly, the nation's youth was seen not only as the epitome of current social problems, but also teenagers represented an optimistic future. For example, 1960's Albemarle Report stated that teenagers and adolescents represented 'the litmus paper of a society'.[25] Under these circumstances youth, through figures such as Steele, could reinvigorate the nation's esteem after the turmoil of the previous two decades. His nationality certainly proved beneficial for obtaining the allegiance of British teenagers. Culturally, geographically and, crucially, on a personal level, Steele appealed as a more realistic and recognisable personality than Presley. The American seemed a distant, mythical figure, while the Cockney resembled a friendly face, someone not unlike other British youngsters, notwithstanding his regular appearances on television and record. An insight into the respective qualities of Steele and Presley featured in the comments of a London secretary:

> Well, they're supposed to represent the youth of two countries. I suppose that's why the girls like them – because we can dream about them being the men in our lives. But although Elvis is an ideal screen hero, he's only in the land of make-believe to us. And I'm sure that when it really comes to the point, most girls would prefer a down-to-earth character like Tommy.[26]

The peculiarly English characteristics of Steele's personality and act received scrutiny from the novelist and critic Colin MacInnes. He described Steele, even during his rock'n'roll phase, as 'resoundingly, so irreversibly English'. MacInnes suspected that many of the star's fans shared his ambivalence towards American culture. In this sense, Steele represented a source of Britishness, a recognisable symbol for a society that felt threatened by Americanisation. Commenting upon the differences between English and American teenagers, he provided an acute observation of the star's appeal:

> Put an English teenager beside an American and you'll see the difference: our version is less streamlined, less pattern-perfect, and more

knobbly, homely, self-possessed. The last word on this was said by Tommy Steele himself. When asked by an interviewer, if he was going to the States, he said (in characteristically transatlantic idiom): 'I don't dig America'. And whatever they may take from there, I think that goes for his admirers, too.[27]

This situation largely resulted from the extent to which Steele's image appeared located inside traditional working class culture. A critical romanticism towards music hall facilitated Steele's acceptance as a star of major promise. Again, MacInnes serves as an excellent starting point for analysing Steele's importance. Discussing the cultural significance of popular music for young people, he wrote that Steele stood in 'complete contrast' to Presley, belonging as much to the music hall tradition as to rock'n'roll:

> His tunes, originally derived from 'rock', but increasingly melodious and even, on occasions tender, are an invitation to the forest to the haywain, to the misty reaches of the Thames at Bermondsey from whence he comes. Not that Tommy cannot 'send' the kids with agitated, blue-jeaned leaps and caperings, and golliwog mop-shakes of his golden hair. But the whole effect, to use a silly word, is much *nicer*. His voice and cavortings are sensual, certainly, but in a strange way innocent, even pure. His speaking voice is that of a descendant of a long line of Cockney singers – Elen, Kate Carney, Chevalier – sardonic and sentimental. But when he sings, it's as if he spoke another language: for though the teenagers may accept a thoroughly English *singer,* they are indifferent to a contemporary English *song.* Indeed – except for old-style sentimental ballads – no such thing may yet be said to exist in early 1958. [italics in original][28]

The 'sincerity' of Steele's act mentioned by Player and Govey received detailed elaboration via *Sight and Sound*'s David Robinson. Here the perceived naturalism and realism of the star's performance in *The Tommy Steele Story* obtained unexpected praise:

> *The Tommy Steele Story* (Anglo-Amalgamated) is an inexpensive and unpretentious film; but it is notable for brief glimpses of a reality rare in British cinema. The smoke-worn bricks of Frearn [sic] Street;[29] the Steeles' Bermondsey living-room with its cheap ornaments, gaudy crockery and sauce-bottle on the tea-table; above all the easy, grinning pocky-face figure of Tommy Steele himself – beside these the loyal old English character parts (Cockney mum and dad, ancient, eccentric junk-dealer, sweeper-philosopher) appear impossibly unreal. Tommy Steele lives out his part with an ease and freedom from affectation

which make you despair of the politer conventions of film acting. It is the sort of performance which a few documentary directors have managed to win from non-actors; but here – one must assume from the inadequacy of the other performances – the credit is due not so much to the director (Gerald Bryant) as to an individual quality in Steele himself. Fortunately he entirely dominates the film, laughing and stomping his way through a dozen or more rock'n'roll numbers with absolute assurance in his skill.[30]

Robinson congratulated Steele upon the realistic nature of his performance. *The Tommy Steele Story* not only obtained the largely unique feat of a review in the most highbrow of the film journals, but also, for the critic, the movie partially rectified one of the glaring failures of 1950s British cinema, i.e. the retreat from realism. Interestingly Robinson never provided any criticism about the standard of the film's script, direction and musical integration. Instead he discussed minute details regarding 'the brief glimpses of reality rare in British cinema'. Another BFI-affiliated reviewer, this time at the *Monthly Film Bulletin*, singled out Steele for the individual quality of his performance and his emergence as 'a completely real person with an ability to project his reality with wholly unaffected ease'.[31]

At first sight this applause originating from the bastion of the critical establishment seems astonishing, considering the venom that the *Monthly Film Bulletin* and *Sight and Sound* inflicted upon Presley and US rock'n'roll movies during the late 1950s. In reality, given the historical context of the reviews, this position seems less surprising. Just as the BFI publications appreciated James Dean for reacquainting 1950s audiences to the pleasures of socio-realism in popular American cinema, Tommy Steele benefited from a critical desire for British films to contain elements of real life. As Robinson's review makes clear, *The Tommy Steele Story* apparently had achieved this feat. Both *Sight and Sound* and the *Monthly Film Bulletin*, not accidentally, noticed the film's 'documentary' qualities. The mid-to-late 1950s marked the apogee of the Free Cinema movement featuring documentary films originating from *Sight and Sound* alumni including Lindsay Anderson, Karel Reisz and Tony Richardson. Not only did the experience obtained through this enterprise enable these directors to obtain valuable experience that would reach fruition with the British New Wave, but also, at the time, *Sight and Sound* critics believed that this reinvigoration of the documentary realist

tradition offered the Promised Land for British cinema.[32] Although alien from the Free Cinema movement, *The Tommy Steele Story* illustrated the realistic characteristics of working class life, largely missing in 1950s British popular cinema.

As hinted earlier, much of this realism resulted from Steele's perceived links with a music hall heritage. This connection between Steele's supposed music hall influences links to Hall and Whannel's discussion of traditional 'folk' and 'popular' art. 'Folk art' constituted a rural, pre-industrial tradition containing 'communal ways of life' or 'organic communities' central to each locality's popular entertainment. This not only involved rural songs being performed in a way that linked closely to the 'common situations within familiar patterns of life', but also embraced a form of communal participation that diminished the borderline between performer and audience.[33] Although 'folk art' became obsolete with industrialisation, Hall and Whannel claim that much of its popular appeal with working class communities, 'framed by common references and attitudes', could be located within the music hall tradition of popular art. They claim that 'the source of its peculiar strength – and the case of the 'act' of its most distinguished performers – remained the closeness of audience and artist to shared experiences and moral attitudes, and a shared quality of humour and pathos'.[34]

The key connections with Steele's personality lay with the assumption that he represented continuity with the music hall tradition. His carefully constructed image placed a premium upon his working class London origins: in interviews Steele continually stressed his appreciation for his parents and local community, emphasising that he remained the same as before his fame.[35] His declaration near the end of *The Tommy Steele Story* provided a rare glimpse in British 1950s cinema of working-class community spirit: 'I don't know how long it will last, but while it does I know who I have to thank for it – the thousands of people living in the thousands of streets like Frean Street Bermondsey, all over the place. I'm not just going to take it for granted, I'm going to say thanks, especially to the kids like myself'.

Given these conditions, Robinson's observations regarding the realistic recreation of Steele's family home in the film mirrored the comments of Hall and Whannel and MacInnes. Steele received applause as a figure who reflected the interests and spirit of his community. *The Tommy Steele Story* indicates that while Steele achieves

social mobility and acceptance from his social superiors, he remains essentially the same person. The class system is not threatened, but rather the film supports existing power structures by indicating the flexibility of the elites to embrace the latest working-class tastes. Steele reinvigorated old-fashioned, British working-class culture at the time when it faced destruction in an age of Americanisation and mass consumption. Interestingly, on the same page as his review of *The Tommy Steele Story*, Robinson denounced ITV quiz shows for offering 'prizes of up to £3,000 for feats of idiocy . . . or general knowledge that should be at any fool's command'.[36] The difference between Steele and Presley is that the Cockney symbolised a recognisable and romanticised British working class culture, while Elvis represented a largely unknown, and therefore dangerous, American variant upon popular music and cinema.

'The best teenage romp ever!' – Cliff Richard and the construction of a British teenage identity, 1959–64[37]

Besides being Britain's leading pre-Beatles pop performer, Cliff Richard was the most commercially successful British film star of the early 1960s, achieving four significant box-office hits with *Expresso Bongo*, *The Young Ones*, *Summer Holiday* and *Wonderful Life*. Despite this popular success, Cliff has been treated badly by commentators on the 1960s pop film, partly resulting from distaste for his music, light entertainment and right-wing Christianity. For example, John Hill claims that *The Young Ones* refuses to confront class and generational conflict, ignoring the fact that the movie was one of the most commercially successful British films of the decade.[38] Bob Neaverson states that by the mid-1960s Cliff's music and films seemed 'hopelessly naïve and outdated', while K. J. Donnelly remains convinced that that the star's career trajectory is symptomatic of attempts to facilitate 'the entry of rock'n'roll performers to more adult, traditional modes of entertainment, specifically to the lucrative cabaret and variety circuits'.[39]

Derision of Cliff's transition into a family entertainer features in several influential works of rock criticism. Nik Cohn describes the star as 'insipid and syrupy', while George Melly partially blames Cliff for 'the castration of the first British pop explosion'.[40] This kind of 'hip' dismissal of the performer dates back to the original discourses surrounding his films. Raymond Durgnat critiqued *Summer*

Holiday, its star, and its place within the British light entertainment tradition in his review for *Films and Filming*:

> *Summer Holiday* is a musical comedy in the Associated British tradition – that is, the limp dialogue is sent whizzing along by the pep and jollity of the actors, the incoherent choreography is cleverly camoflaged by quick cutting, and those stars who can't dance very well (which is most of them) jump around cheerfully instead.
>
> . . . At heart these teenage ravers are as square as the Huggetts and wouldn't have minded having Her Glorious Majesty Anna Neagle coming along to chaperone. It's what they call a happy film, with Cliff and his chums clowning agreeably (some of the scenes seem almost improvised) while the director concentrates on keeping up a spanking pace so that the audience doesn't mind whether the jokes are good or bad.[41]

Perhaps more damaging to Cliff's long-term reputation among future rock and film scholars were John Lennon's comments dating from 1963. Expressing sentiments that have been echoed since, he claimed that 'We've always *hated* him. He was everything we hated in pop', taking delight in *Summer Holiday*'s failure in America [italics in original].[42] The distaste for the light entertainment tradition among critics and musicians has undoubtedly contributed to Cliff's unfashionable status as a cultural icon. Yet his role within the development of not only the British pop film, but also the actual construction of teenage identity in Britain deserves reconsideration.

Given the nature of the British entertainment industry in the early 1960s, the music press' applause for Cliff's development from rock-'n'roll to family entertainer seems unsurprising. For example, *NME*'s 'Alley Cat' column had originally described Cliff's early television appearances in 1958 as 'revolting', a 'form of indecency', 'vulgar' and 'disgraceful', because of his employment of Presley-style gyrations.[43] However, the paper soon became one of Cliff's staunchest supporters. On the occasion of his twenty-first birthday in October 1961, Johnson published a 'Tribute to a Nice Guy', in which he praised Cliff as 'one of Britain's top show business personalities'.[44] This extract concerning the star's career development is worth quoting at length, not only because it reveals much about the nature of Cliff's progression as an entertainer, but also because Johnson articulated many of the personal biases of music and entertainment journalists of the day:

Perhaps the most outstanding factor to Cliff's everlasting credit; is to be found in his effective graduation from the role of teenage idol to that of genuine all-round entertainer. There can be no denying that his appeal to the youngsters is still tremendous, and the fact that he continues to give them priority is of immense benefit to his popularity.

But when Cliff first came into the public eye he was purely and simply a rock'n'roller. Now, by way of his films and TV appearances and a general toning down of his approach and style, he is appreciated by all age groups. He has acquired a sophistication, a polish and a maturity which normally come only after years and years of experience.

And today, although his status as Britain's foremost youthful performer remains unchallenged, he has also proved his worth as a competent family entertainer.

Like the true artist he is, Cliff is never satisfied – he is always anxious to widen his scope by exploring new media and accepting fresh challenges. And in his quest to improve more, he is currently taking dancing lessons and striving to develop his acting ability. He is, in every way, a sincere artist who has reached the very top by way of sheer hardwork, teeth-gritting determination and utter dedication to show business.

This is the stuff of which big stars are made. And Cliff has shown that he is endowed with star quality from the top of his head to the tips of his toes.[45]

Similar comments greeted Cliff's films. *Melody Maker* had a three page special 'tribute' to *Summer Holiday*, a film that 'brings to the screen a professionalism, polish and flair all too rare in home-made musicals'.[46] *NME* was even more glowing in Johnson's review of *Summer Holiday*: 'The essence of the whole film is escapism. It's intended as light-hearted entertainment, and it fulfils its function admirably. A couple of years ago, I wouldn't have believed that such a first class musical could be made in this country. Now Cliff and his team of fellow performers and backroom boys have two to their credit.'[47]

The obvious question that arises from such pro-show business statements is whether the entertainment press, particularly the music papers, really appreciated teenage pop music. Simon Frith has commented that the music press of the 1950s and early 1960s was inclined towards the music industry's own self-interest, resulting in the emergence of largely uncritical attitudes towards pop:

Such publications provided no perspective on the music they covered; they had no developed critical position (except that what was popular

music must be good); they showed no curiosity about where records came from or where they went. The music papers presented the industry's own view of itself, and were written, accordingly, in a breathy, adman's prose.[48]

Until around 1962 it is arguable that many music press commentators had very little empathy with teenage pop music. For example, *NME* editor Andy Gray's career in entertainment journalism dated back to before the Second World War.[49] Keith Altham, a contributor to the paper in the 1960s later remarked that Gray was more interested in golf than music.[50] The confession of *Record Mail*'s Peter Haigh, during his review of *Expresso Bongo*, indicates that many of the British entertainment critics ultimately had little sympathy with teenage cultural tastes: 'I come from a long line of squares. By that I mean that I love traditional jazz, dixie, boogie, Basin Street, symphonies, musical comedies, operas and concertos and I don't like rock and roll.'[51]

This information provides an essential background for any understanding of the music press' attitudes towards pop musicals, especially those films that clearly operated within the light entertainment tradition. This particularly applies to *The Young Ones* and *Summer Holiday*. Gray's enthusiasm for the earlier film should be read as delight with the belief that Britain had at last produced a pop performer seemingly capable of continuing the tradition of British musical comedies. The established career path for pop stars was successfully being implemented: unusually for British performers, Cliff had proved a great success on the big screen. The film represented good, clean, old-fashioned family entertainment, rather than one of those squalid, nasty 'B'-movies like Adam Faith's *Beat Girl* that revelled in filth rather than the variety tradition:

> Let's face it – British pop music stars aren't too well served by film industry. More retard their career than advance them on the big screen.
>
> So I went to see Cliff Richard's first top starring film *The Young Ones* . . . with some misgiving. But I'm delighted to say I came away very happy.
>
> Cliff is excellent, and the whole Kenneth Harper-Sidney Furie picture adds up to the best musical Britain has ever made and the best teenage screen entertainment produced for a long time – *anywhere*! [emphasis in original][52]

Johnson confirmed Gray's glee at Cliff's successful conversion from pop idol to movie star in his discussion of *Summer Holiday*'s musical interludes. He lavished attention on the more traditional elements of the film soundtrack, clearly derived from the format of the Hollywood musical rather than rock'n'roll:

> Highlights I recall are 'Seven Days To A Holiday' performed in the bus depot while the vehicle is being made serviceable for its trip abroad; 'Let Us Take You For A Ride' sung and danced by Cliff and the team in the team in the middle of a French highway; and 'Really Waltzing' in which the company entertains on the dance floor of an Austrian beer house in true 'White Horse Inn' tradition![53]

It is these parts of the film that Donnelly claims help to explain 'the process of Cliff's transplantation into more traditional popular music'.[54] He rightly illustrates the comparative 'marginalization' of beat music songs within the film, a position reflected by Johnson's review. The journalist described the title song 'Summer Holiday', written by Shadows members Bruce Welch and Brian Bennett, in a dismissive manner that resembled a footnote positioned at the end of the article. Even the pop critic considered 'Summer Holiday', the song, as commercial pop fodder, failing to treat it seriously compared to the routines deriving from the Hollywood musical: 'By the way, watch out for the title song. It's very catchy indeed – and if Columbia sees fit to release it as Cliff's next single, it could provide him with another No.1'.[55]

If his transition from rock'n'roller to clean-cut family entertainer and matinee idol was essential for the long-term survival of Cliff's career, then the star also required disassociation from the more negative connotations featured in *Expresso Bongo*. This indictment against the shadier side of the London entertainment industry originated from a stage play by Wolf Mankowitz before being transferred to the screen. A useful plot synopsis of the film comes from the *Monthly Film Bulletin*'s Brenda Davies:

> Johnny Jackson, a dance band drummer, dreams of getting into big money as an agent. He and his girl, Maisie, a strip tease soubrette, witness the hysteria induced by a young beat singer in a teenager's coffee bar. Convinced that this boy, Bert Rudge, has great possibilities, Johnny talks him into signing away half his earnings. Johnny's unscrupulous methods soon make Bert, now rechristened Bongo Herbert, a big success and Johnny is in clover. But Bongo meets a fading

American musical star, Dixie Collins, who is attracted by his innocence and enraged by the way Johnny is exploiting him. When she learns that Bongo is under twenty-one, she succeeds in having his contract nullified. Johnny takes this setback philosophically and starts looking round for a new client.[56]

Considering the degree of critical divergence between Durgnat and *NME* over *Summer Holiday*, it might seem surprising that a similar gulf did not exist around *Expresso Bongo*. The film received positive reviews from publications as diverse as the *Monthly Film Bulletin*, *Films and Filming*, *Melody Maker* and *Record Mail*. Critical plaudits included such comments as: 'witty, amusing, and well worth your time and money'[57]; 'in its own way [it] beats anything that Hollywood has done'[58] and 'well above the average of British comedies with music . . . good for an evening's entertainment'.[59]

Bourdieu's theories of taste, as outlined in earlier chapters, contain implications for this survey of critical opinions regarding *Expresso Bongo*. He states that tastes are 'asserted purely negatively, by the refusal of other tastes'.[60] Critics from differing fields of production could appreciate a particular film providing that movie upheld their own cultural and social values. Most crucially, how did existing attitudes towards pop music and teenage culture influence the film's reception? The likes of Haigh, Peter G. Baker at *Films and Filming* and Brown were hardly sympathetic to rock'n'roll. Brown's attitude featured in chapter 3, while Baker described rock'n'roll as 'savage "mindless"' music.[61] In this light, the enthusiasm of these individuals for *Expresso Bongo* seems much less surprising. If as Bourdieu argues, social and cultural tastes are predetermined, then the film's anti-rock'n'roll satire could emerge as distinctly appealing. It is noticeable that the scene most singled out for praise by both Davies and Baker, the 'Nausea' sketch whereby an ageing record company executive displays his disgust at Bongo's act and teenage culture, provides a savage critique of rock'n'roll. For Baker, Meier Tzelniker's performance equalled 'a wonderful piece of characterisation', while Davies pointed out the 'wit and verve' contained within his acting.[62] Brown congratulated Mankowitz upon his denunciation of rock'n'roll:

On the way, Johnny snaps up young Bert Rudge, promotes him by various strokes into the big-time as Bongo Herbert, much the same as has been done in life.

The situation is so monstrous that no words could be too strong. That Mankowitz went beyond scathing contempt into impolite language indicates that he also saw it in those terms.[63]

In each case, the satirical content of *Expresso Bongo* matched the cultural prejudices of the critics. Their own views on teenagers and rock'n'roll did not differ drastically from the savage opinions expressed on screen: they too believed that young people were 'eight million telly-hugging imbeciles' and 'grimy yobs'. The film offered easy gratification for critics hostile to rock'n'roll and attacked an obvious target: young people lacking the cultural capital and facility to answer back their accusers with the same degree of sophistication. Beneath the endorsements for *Expresso Bongo*, there lurked an extremely contemptuous attitude towards young people.

A comparison of Brown and Baker's attitudes to Cliff's role as Bongo Herbert illustrates this point. Both commentators expressed apprehension at the changing nature of teenage culture in late 1950s Britain:

> The screen version of the stage show has added lots of new ingredients . . . and lost the stark cynicism of the original. No longer is this a bitter revelation of hollow talentless youth, for unlike the play, Bongo finishes up with a contract for New York! In other words, the producers having signed latest idol Cliff Richards [sic] for the lad are going to take the mickey out of everyone except Cliff boy . . . who rather pathetically sings such original numbers that remain (notably 'Shrine on the Second Floor') as though he meant them.[64]

> Cliff Richard . . . the latest teenage wonder [is miscast]. He says his piece nicely enough – too nicely, probably.
> The role is that of a moronic Cockney, whereas the well-modulated tones and essentially quiet charm of Richard contradict that and evokes too much sympathy.[65]

Both critics suggested that rock'n'roll performers were idiotic and 'moronic'. Baker presumed that Cliff's unawareness at the exploitative and satirical element contained within the religious pastiche, 'Shrine on the Second Floor', indicated the stupidity of real-life pop idols. Brown implied that rock'n'roll was music performed by a certain type of person, namely 'moronic', working-class Cockneys patterned on Tommy Steele. Cliff's 'quiet charm' faced attack, because it did not match his belief that rock'n'roll constituted music played by, and for, teenagers lacking in cultural taste and moral values. Through the reviews of Brown and Baker, the star's performance

attracted consternation, because it legitimised a culture that these critics considered aesthetically degenerate.

Does this degree of similarity between ideas expressed in the music and film press indicate that minimal difference existed between criticism published in each sector? Certainly the reviews regarding *Expresso Bongo* hint that the actual critical opinions did not differ widely: commentators originating from conflicting fields of production reached similar conclusions. Yet this disguises several crucial points. First, as a screen version of a prominent stage play, *Expresso Bongo* was an exceptionally distinguished pop film: the degree of critical consensus inevitably did not apply to each new release. Second, as Bourdieu argues, writers and editors need to ensure that the content of their publication reaches the largest possible readership, without alienating its existing clientele. He comments upon the 'functional and structural homology' connecting production and distribution:

> The correspondence which is thereby objectively established between the classes of products and the classes of consumers is realized in acts of consumption only through the meditation of that sense of homology between goods and groups which defines tastes. Choosing according to one's tastes is a matter of identifying goods that are objectively attuned to one's position and which 'go together' because they are situated in roughly equivalent spaces, be they films or plays, cartoons or novels, clothes or furniture; this choice is assisted by institutions – shops, theatres, . . . critics, newspapers, magazines – which are themselves defined by their position in a field and which are chosen on the same principles.[66]

Despite their similar views concerning *Expresso Bongo*, *Films and Filming* and the *Monthly Film Bulletin* did not enjoy the same readership as *Melody Maker* and *Record Mail*. The film publications did not have to appease Cliff's fans and promoters in the same way that *Melody Maker* did. The strategy of Brown's article succeeded: the film received praise, alongside a denunciation of rock'n'roll to appease the paper's jazz enthusiasts, hostile towards teenage pop. In this way, it also retained the crucial advertising space from Cliff's record company, Columbia: related adverts and the film's cinema poster appeared on the same page as Brown's review.[67] Unlike the film press, *Melody Maker* could not antagonise the record company promoters – especially as such advertisers comprised a large chunk of the music press' revenue. Middlebrow film publications like the

Monthly Film Bulletin and *Films and Filming* did not have to cater for the cultural needs of the teenage market to anything like the extent of the music press. For information about the latest pop musicals, British teenagers during the late 1950s and early 1960s probably turned to the music press. Between 1958 and 1964 *NME*'s average weekly circulation doubled from 143,259 to over 300,000 with an estimated total readership of over a million.[68] This widespread distribution throughout the teenage public almost certainly meant that *NME*'s comments had more influence upon Cliff's core audience than the film magazines. The interests of cinemagoers and pop fans did not necessarily coincide: separate publications existed for these alternate forms of leisure consumption.

Interestingly, as with *The Tommy Steele Story*, the music press itself serves a function within *Expresso Bongo*. Although, unlike the earlier film, actual articles are not utilised for plot emphasis, fictional headlines from *Melody Maker* and another music paper, *Disc*, can be glimpsed. In a brief montage scene, actual photographs of Bongo Herbert stand alongside imaginary news concerning his progress. Both the pictures and the articles exactly resemble the kind of material the music press would have published on Cliff Richard. Therefore this use of headlines from the music press blurred fact from fiction, something exacerbated by the presence of an actual pop star within a film about rock'n'roll.

The case of *Record Mail* illustrates this point even better. This was a publication funded by EMI records to publicise the latest news and photographs about their artists: the paper itself was an advertisement. It sought to promote in-house acts, which meant that criticism attacking EMI stars was extremely unlikely, as such a course of action could damage potential profits. The 'Alley Cat' incident could have harmed Cliff's image: it required repairing if only to improve his chances of a long-term career as a family entertainer. *Expresso Bongo* marked the first step in this process of reclaiming Cliff as a morally upright symbol of British youth.

Haigh's review of *Expresso Bongo* illustrated the conflicting interests at stake among critics regarding teen movies. The actual filmic text, and even the review, might adopt a hostile attitude towards youth culture, but rarely could a teenage-orientated publication directly attack the star involved due to a commercial imperative not to alienate the target audience. The teen idol offered a sacred object of adulation for many readers, or at least a figure that many people

could acknowledge as a symbol of generational identification. Teenagers would not have spent their money on publications that attacked their favourite stars. In 1957 teenagers spent £25 million or 11.4 per cent of all magazine spending that year. Two years later the total amount of consumption on all magazines totalled £26 million per annum, which comprised 10.9 per cent of the purchases for that year.[69] By the late 1950s, distinct patterns and particular niche markets began to emerge, reflecting the developing teenage consumer market. For example, in 1959 British teenagers accounted for 42.5 per cent and 28.2 per cent of all consumer spending concerning record purchases and cinema attendances.[70] The attitudes of the fan magazines and the music press during this era should be seen in this context. As one picture book, aimed largely at the youth market, emphasised in 1960, 'entertainment for the teen-ager is indeed today big business'.[71]

The gearing of the fan magazines and the music press largely towards working-class teenagers, especially girls, had several implications.[72] According to Abrams, the most popular forms of cultural newspaper and magazines with young people were publications which devoted a lot of attention towards the latest teen idols and/or love comics.[73] As the case of Cliff reveals, these areas were very often combined. In terms of avoiding overt criticism of the film/pop star and their latest cinematic and musical offerings, deviance constituted an area, which many fans wanted to actively avoid confronting. Partly, this was a result of changes within British teenage life, namely the progression away from an automatic assumption that youth culture meant deviance and generational conflict. Rather, there emerged an acknowledgement of teenage cultural distinctiveness within the wider parameters imposed by parent culture and adult society. To a certain extent this can be seen as the development of a non-deviant youth consumer identity, dominated by girls. According to Peter Laurie, teenage publications such as the girls' comic strip/romance weekly and the pop newspapers contained 'a tone [which] is almost dauntingly wholesome':

> The most likely explanation is that this is what the majority of young readers want – an image of a fond, friendly world, where characters get their just desserts, and there are no villains; where the sexes are tender towards each other rather than lustful and predatory. If grown-ups will not sing any more of golden lads and girls, the young must do it for themselves, as best they can.[74]

In 1959 Cliff made his first film . . . Serious Charge. And it was something to boast about to the seven sheen.

CLIFF RICHARD

It was a nippy day in September, 1958. I was sitting in an office just off Piccadilly. Staring at me was a young, dark-haired man. He was Cliff. He had just made his first record, and was called 'Move it'. To an established oldie like myself at number 27. By the time I had had my interview, which I published in PICTURE SHOW, the disc had zoomed to second place in the charts. It was one of the most fantastic successes in British show business. The name was, in future, to be— Cliff Richard.

Here, to keep Cliff's many fans happy, are a few facts about the golden boy of British discs.

REAL NAME: Harry Webb. When Cliff started in the business, his agent, Franklyn Boyd, got together to pick a suitable name for him. Several were suggested, Russ, Richards, Richards, until, by a process of elimination, they decided on "Cliff" and then, "Cliff" decided to knock an "s" off the surname to make it more distinctive. "The name 'Cliff Richards' is only discovered lately.

HEIGHT: I could only discover from his agent that he is "about 5 ft. 10 ins." Apparently he hasn't had himself measured lately.

HAIR: Dark brown.

EYES: Very dark brown, almost black, and quite hypnotic. "It's the people I can't see," he says of my eyes on the audience. "That gets them going."

BORN: (Reluctantly) in India, at Lucknow.

PARENTS: Dorothy and Roger Webb.

GOLDEN DISCS: Livin' Doll is the only one so far. But there's 'Voice in the Wilderness,' Livin' Year. The funny thing about Livin' Doll is— Cliff hated it! He didn't want to record it. When it was cut in his first place recorded, he looked at his face. After it had sold a million, he described the song as "hardly a million, a million, yet with the LP of songs from Express Songs, either. After hearing it for the first time, one recording company and sold them he thought the recording wasn't good.

GIRL FRIENDS: Poor old Cliff. He can't have any. Says he has too many to choose from.

L.S.D.: He earns plenty, but gives himself only £15 a week. "Why should I go out with girls," he asks, "I don't drink, and I can't to go with girls. So what is there to spend it on?" I'm sure I don't know.

FANS: They've persuaded themselves up and sent chocolates to him, hoping his wardrobe and nearly suffocated, nearly fallen under the wheels of his car and have shown their affection, and showered him with presents. It's nice to be loved.

It is certainly appropriate to see Cliff as the prime British exponent of the non-deviant, but generationally aware, group of teenagers that existed in the early 1960s.

Record Mail's photo extracts from behind the scenes of *Expresso Bongo* demonstrated the occasional necessity for an uncritical attitude. This resulted from a desire to appease the teenage consumers, besides illustrating EMI's own self-interest in the most positive light. There was no attempt to confront Cliff's fans with an insight into the sleazier elements of the plot, nor did it emphasise the anti-rock-'n'roll themes of the film. Instead, Cliff chatted with his co-star Laurence Harvey, while anything related to *Expresso Bongo*'s strip-club scenes was strictly taboo in this morally uplifting, EMI sanctioned photo-shoot. The largest photograph, set in a coffee bar, reinforced the star's teenage credentials. In a still directly taken from the movie, Cliff played the bongos surrounded by the Shadows, his actual backing group, and an appreciative adolescent audience.[75]

This scene forms one of the most crucial moments of the film, as it coincides with Johnny Jackson witnessing Bongo's popularity for the first time, an event that eventually leads to the youngster's rise to fame. Significantly Bongo's first appearance shows him seated and chatting quietly to other customers; he remains relatively nondescript. He only performs after encouragement from his friends, thereby revealing his shyness and passivity. This side of his character not only makes Bongo less threatening to teenagers, but also makes him vulnerable to Johnny's opportunism. For example, later in the film, Bongo proves his sincerity, and Johnny's manipulative nature, by performing the religious song 'Shrine on the Second Floor' on national television in an attempt to win over previously hostile parents.

Other photographs from the coffee bar scene featured in another photo-spread on *Expresso Bongo*. Published in the 1960 Christmas Special, *Picture Show – All Star Special 1961*, and reproduced as Figure 3, these film stills again emphasised Cliff's centrality with late 1950s teenage culture.[76] The most significant aspect of the photographs is their emphasis of the boy-next-door teen idol; the image of Cliff mutually desired by his female fans and his business promoters. For example, the three largest photographs featured in Figure 3 are very much in the mould of the tender handsome pop

3 facing Cliff Richard and British teenage identity: stills from *Expresso Bongo* (1959)

star/movie star depicted in the teenage romantic magazines. This comparison becomes evident with an examination of Figure 4, which originated from the 1959 *Valentine Pop Special*, the parent publication of which, *Valentine*, was one of the leading romantic comic strip/pop crossover magazines for girls during the late 1950s and early 1960s.[77] Special emphasis lay with Cliff's appearance; his lips being particularly prominent. The *Valentine* photograph contained a close-up of these attributes, together with the caption, 'THE LIPS SPELL FIRE' [capitals in original]. This fire metaphor hinted at the explosive and passionate side of Cliff's personality, directly appealing to the romantic interest of the readership. Yet, particularly in the coffee bar photographs from Figure 3 photoshoot, the real complexity of love and romance is relegated to a secondary level, behind issues such as having fun and the construction of a clean-cut teenage identity. The crowd appears rather anonymous: their actual faces seem virtually illegible. The pictures highlight Cliff's star status, yet also his typicality. His dress code and haircut are no different to those possessed of other teenagers in the photograph. In the two pictures from the 'Shrine on the Second Floor' segment, he adopts different stances for two distinct sections of the audience. In the central photograph, he merely stands singing in the mould of a family entertainer, while in the far-right still, the star clutches his arms and legs through adopting rock'n'roll-style gyrations. The result of this material must be that Cliff Richard/Bongo Herbert became a kind of representative symbol of all teenagers who enjoyed the same pursuits as his peers – singing, music, dancing and having fun. The photographs sought to separate the star from any hint of immorality and deviancy contained within his film vehicle. If the star seemed virtually identical in character and appearance to figures recognisable in the daily life of fans, then the physical and psychological gap between Cliff and his audience disappeared, making him a more suitable romantic idol. The absence of any deviance within these photographs should not be considered as a weakening of *Expresso Bongo*'s satirical tirade against entertainment, evident in other reviews. Rather these photographs complemented other material on the film by presenting the side of Cliff's image most desired by his fans and record company. Figure 3 worked because it located Cliff as an everyday teenager and potential romantic hero. This receives confirmation by the trivia section, almost certainly record company approved, appearing alongside the

stills. Together the final product created the appropriate amalgamation of teenage love interest and generational iconography that proved so beneficial to Cliff's career.

The above information concerning the generational significance of *Expresso Bongo*'s publicity leads to discussion of Cliff's other

4 Cliff's image in girls' magazines (*Valentine Pop Special*)

important historical function. No other British star possessed a screen persona that was so connected with the two leading discourses of the late 1950s and early 1960s, namely the simultaneous emergence of 'the age of affluence' and the development of a teenage cultural identity.[78]

Both *Summer Holiday* and *Wonderful Life* indicate how Cliff's star persona related prominently to one area of youthful prosperity, overseas travel. It has been estimated that the number of foreign holidays doubled from 2 million in 1951 to 4 million in 1961.[79] In *Summer Holiday* Cliff and his pals take a double-decker London bus on a tour across Europe before reaching their final destination of Athens. The Mediterranean theme continued in *Wonderful Life*, set in Spain, where Cliff and friends find themselves employed on a film set after being stranded at sea. These colour musical associate foreign travel with sunny, exotic places, such as Greece and Spain. Therefore Cliff's film image offers an insight into the promotion of foreign travel as a desirable leisure activity for young people.

Record Mail featured several instances of this kind of publicity. The paper produced front covers for both *Summer Holiday* and *Wonderful Life* which provided information about Cliff's latest film adventures. With regard to *Summer Holiday*, Cliff appeared in a T-shirt surrounded by Athens' historic city centre including the Acropolis. For the release of *Wonderful Life*, Cliff adopted typical Presley-style beachwear in the shape of Hawaiian shirts. He appeared 'sunburned . . . in the Canary Islands', surrounded by palm trees, beach and sand. In each case, the still corresponded directly with exotic, sunny scenes from the movie, hinting at the kind of visual spectacle awaiting potential viewers.[80] For example, the Acropolis scene serves as not only as the location for *Summer Holiday*'s key ballad and number one hit single, 'The Next Time', but also performs a key narrative role in explaining the growing love interest between the main protagonists.

The photographs from *Record Mail* were published in black and white, which meant that their potential to highlight the glamorous lifestyle depicted in Cliff's movies might have been more limited than the actual films being publicised. The full impact of this material occurred in conjunction with the actual cinematic texts that they promoted. In this context, Hall and Whannel's comments concerning the 'contrived intimacy' of Cliff's movies, and the wider world of teenage magazines, appear excessively harsh.[81] Their condemna-

tion of this culture, as overtly commercial, escapist and superficial, comments upon Cliff's escapist films, particularly *Summer Holiday*, echoing Durgnat's condemnation of the film. Such remarks are worth quoting, because they hint at the extent to which academic commentators misunderstood the long-term historical importance of the films:

> These films are composed to catch the more superficial values in the culture, but to anyone outside the cult circle they irritate by their gloss, their forced light-heartedness and their embarrassing 'tenderness' (one remembers the moon-struck Richard delivering a love-sick ballad amidst the Acropolis ruins). They derive in the style straight from the colour advertising travelogues – the continuity is between *Summer Holiday* and the more inane Look at Life short features.[82]

The escapist elements of *Summer Holiday* and *Wonderful Life* featured prominently in contemporary music press accounts of the films. Reviewers anchored these cinematic fantasies to an affluent lifestyle, which few Cliff fans could attain. As *Record Mail* wrote about *Wonderful Life*:

> Cliff and the Boys are cast in the parts of carefree youngsters who are more intent on having fun than worrying about tomorrow, and their adventures will be the envy of every teenager in the world.
>
> Cliff and his pals suddenly find themselves on the sunny Canary Islands without work, but with an abundance of high spirits, they eventually become film extras; and they top all this by making their own film. If that's not a wonderful life, what is?[83]

Such documents constructed Cliff as the very essence of teenage culture. Teenage leisure of this variety implied financial independence, the lack of parental constraints, an opportunity to travel, and, presumably, the stereotyped holiday behaviour associated with sun, sea and romance. *Summer Holiday* and *Wonderful Life* projected these images. These two overseas-based movies might appear as ideologically objectionable, because they ignore the fact that many youngsters could have never afforded such a lifestyle. They suggest that the world's problems can be solved simply via Cliff and the presence of attractive scenery, but such images contained generational significance for British youth. The films supported the dominant ideology of affluence, yet, this precisely indicates their importance. The majority of British teenagers in the early 1960s did not belong to the mod, rocker, or beatnik subcultures, but rather they lived within the

confines of parent culture. Cliff's star persona, both on-screen and through the pages of fan-orientated publications, created an image of youth lifestyle and culture that many could either directly imitate (*The Young Ones*), or dream of experiencing (*Summer Holiday* and *Wonderful Life*). As the star himself claimed in a 1963 *Photoplay* interview on being asked the reason for the success of *The Young Ones* and *Summer Holiday*:

> I don't know why they flocked to see *The Young Ones,* but they went to see *Summer Holiday* because they'd seen *The Young Ones* and liked it. I think the secret is to keep the film simple, so the public can imagine themselves doing the things we do. It's not impossible to form a club, and put on an old bus and travel across the Continent – as in *Summer Holiday*.[84]

At first sight it would appear that the very existence of Cliff Richard indicated the Americanisation of British society during the 1950s and 1960s. His own personal musical tastes – Presley, Ricky Nelson and Connie Francis – originated from across the Atlantic, while his glossy musicals of the early 1960s operated in the tradition of the Hollywood musical.[85] Yet Cliff's success coincided with outbursts of British national pride, with his nationality being frequently mentioned in discussions of his career achievements.

The American rock critic Dave Marsh writes that, in the early 1960s, 'it was especially important to have a major home-grown talent in a country that was beginning to feel overwhelmed in too many ways by American popular culture'.[86] Cliff's Britishness undoubtedly made him a figure of identification for UK audiences. For psychological and logistical reasons, it seemed inevitable that a domestically based star, particularly one whose image was loaded with generational significance, would provide an attractive symbol to British youth in an age of strong patriotism. In this context, the appeal of a British teen idol who could seemingly match any American star, except Presley, for charisma and talent should not be underestimated. Cliff's presence in Britain meant that the music press and fan magazines had potentially much greater access to the star than they would have done to his US equivalents. The same situation affected his television appearances and tours: Cliff's nationality gave him a natural advantage over his American rivals, such as Frankie Avalon, when it came to the British teenage market.

Critics frequently described Cliff's success in terms of national pride, as shown by Brown and Gray's commentaries on *Expresso*

Bongo. Johnson referred to Cliff as 'Britain's biggest box-office attraction' and to his emergence as a 'world-class film star'.[87] Through such language, Johnson converted the performer into a national hero. While *Sight and Sound* ignored Cliff's films, publications such as *NME* promoted him as the saviour of British cinema:

> [The] most startling aspect of Cliff's evolvement as an international force has unquestionably been his emergence as a world-class film star . . . [*The Young Ones* and *Summer Holiday*] not only led to his acclamation as 'Show Business Personality of the Year' and leading box-office attraction in Britain, but easily broke attendance records throughout the country – at a time when the film industry was sagging.
>
> These two films are now having a similar shattering effect in other countries the world over – and there is little doubt that his next movie, which goes into production in the autumn, will complete a hat-trick of box-office sensations.[88]

However, Cliff's success also highlighted the positive future for British youth. Youth embodied not only the nation's current predicament, but also its optimistic future. There might have fears over juvenile delinquency and immorality, but the teenagers supplied the means by which the country could revive and prosper. As the leading cultural representative of British youth on the world stage, Cliff presented the public face of his nation's future. He gathered applause because his success implied that Britain could once again assert a world role, albeit this time as the leader of world youth culture. Johnson even described Cliff as 'one of the greatest ambassadors to represent Britain abroad', whose music, films and personality 'has done more to cement a better understanding between the people's of the world than the empty words of many a politician'.[89] If youth culture could assert such a positive impact upon Britain, then the country's future looked assured.

To this extent, the deployment of Cliff's image emerged as explicitly political. He personified the ideal, non-deviant role model for British youth. National pride figured prominently in Johnson's celebration of his achievements at the time of his twenty-first birthday. To claim that Cliff reinforced the hegemony of the Tory ruling class seems far-fetched, particularly as such an interpretation takes no account of the potential for the star's fans to dissent from the dominant consensus. However, Cliff typified the key hegemonic ideas of the era, particularly youth affluence and patriotism, demonstrating that teenagers did not deserve condemnation as a delinquent generation:

We're Proud.

We in Britain have every reason to be proud of, and thankful for, Cliff Richard. Proud, because he has brought new glory to British show business, besides proving to the elder generation that teenage entertainment need not necessarily be sordid and unsavoury. And, thankful, in that he has been the source of so much pleasure and relief in this tension filled world.[90]

Adam Faith – *Beat Girl* and sensationalism

Beat Girl starring Adam Faith presents a slightly different case from the Cliff and Steele vehicles in that the movie was not rooted in light entertainment. At the start of the 1960s, the film's major selling point, Faith, briefly threatened Cliff Richard's supremacy as the leading young British singing idol. Although promoted by his record company as a smart and decent, blond-haired, blue-eyed teenager, Faith's image always contained greater deviance than his rival. In three of his films, *Beat Girl, Never Let Go* (1960) and *Mix Me A Person* (1962), Faith played characters involved with crime or beatnik activity. After *Mix Me A Person,* in which Faith's character is (wrongly) sentenced to death for the murder of a policeman, *Photoplay* complained about the star being typecast in juvenile delinquent film roles.[91] On a sociological point, he achieved a footnote in British cultural history as the first pop singer to publicly confess to pre-marital sexual intercourse. Significantly, little attention regarding *Beat Girl*, a film made before Faith's nationwide success as a pop star, featured in the music press and film fan magazines after its release in autumn 1960. As the issue of protecting teenagers from the negative connotations of youth culture appeared in earlier discussions concerning Presley and Cliff, this consideration of *Beat Girl* adopts another approach. Better than any other pop film, British or American, *Beat Girl* typified one trend in contemporary cinema that the critical establishment despised – sordid sensationalism. As indicated by the *Monthly Film Bulletin*'s reference to the film's 'comic scenes of adolescent self-pity', it remains improbable that this publication approved of lines such as 'Wow daddy-o, I'm over and out', unconvincingly spoken by Faith and others. The journal's account makes it clear why the movie received the dreaded 'III' rating, providing a perfect indication of *Beat Girl*'s content:

> Art student Jennifer Linden, neglected by her architect father Paul and jealous of his new French wife Nichole, spends her time in coffee bars

with her friends Dave, Tony and Dodo. She repulses Nichole's friendly overtures, then sees her snub Greta, a strip-dancer who evidently knows her. After visiting the Soho club where Greta works, run by her lover Kenny, Jennifer warns Nichole that if she is not left alone she will tell Paul that his wife was once a Paris dancer. Kenny also makes this threat when Nichole begs him not to touch Jennifer. A teenage party given by Jennifer at home without adult permission ends with her doing a strip-tease just as Nichole and Paul appear. She tells all about Nichole, then flees into the night. Paul assures Nichole that he still loves her and they rush into Soho, arriving in time to comfort Jennifer after the shock of seeing Greta stab Kenny for making a pass at her.

With Soho strip-tease, Teddy-boys, 'pop' songs, jiving in Chislehurst caves, a sports car chicken run, stepmother trouble, a wife with a past, teenage tantrums, and a race to save a Bardot-like heroine from the clutches of a rogue with two 'plane tickets to Paris' this film is nothing but eclectic. Yet the scenes with the youngsters somehow achieve a certain liveliness. Pop singer, Adam Faith, when he abandons his mobile invisible echo chamber and troubles to articulate, has an attractively sad and world-weary air and combines well with Peter McEnery and Shirley Ann Field in comic sessions of adolescent self pity. Walter Lassally's photography occasionally gives the general farrago, with its confusing time continuity a distinction it hardly deserves.[92]

Describing the cinematic events of 1960, *Sight and Sound* condemned the trend towards 'sensationalism' in popular cinema. Although *Beat Girl* was not singled out for attention, another British film that offered a sleazy evocation of late 1950s London, *Peeping Tom* (1960), stood guilty of crimes against taste and decency:

> From the commercial cinema and spilling over into the clubs, come the out and out appeals to sensationalism ranging from Britain's *Peeping Tom* to Japan's lubricious *The Joyhouse of Yokohama*. It is a pattern which cannot be viewed without a certain uneasiness. Admirable though it is that the audience for serious cinema is growing, it is equally important that the boundary lines between so to speak, Academy and Odeon films should remain fluid.[93]

Combined with this 'uneasiness' at the appeal towards 'sensationalism' there co-existed a fear of the future for cinema in Britain. The late 1950s and early 1960s saw a drastic fall in cinema attendances. For example, the yearly total of box-office admissions declined from 1,365,000 to 925,000 in 1957.[94] This trend continued into the early 1960s. *Sight and Sound* reported about the 'gloomy box-office

statistics for 1961, revealing an 11 per cent drop in UK cinema admissions compared with 1960'.[95] The reasons for this decline are explained elsewhere, but the emergence of television as a mass medium had consequences for the type of film that producers used to attract people back to the cinema.[96] Penelope Houston believed that television had caused a detrimental effect upon film via the implementation of changing production policies. For *Sight and Sound*'s editor, television provided 'one of the greatest incentives to mediocrity' through programmes pandering to popular taste: its influence allegedly contributed to a failure among consumers to distinguish between good and bad culture.[97] This coincided with three shifting trends in film production, none of which possessed the approval of the critical establishment. Obviously a low-budget 'B'-movie like *Beat Girl* hardly deserves classification as a De Mille style 'blockbuster', but it certainly did epitomise the trend towards 'films made specifically and deliberately for a teenage public' with its portrayal of intergenerational strife and the presence of Faith. As the subsequent discussion reveals, *Beat Girl* also signified a move towards 'sensationalism', as filmmakers began to exploit the cinema as a means for expressing risqué subjects unsuitable for family television viewing, through its explicit scenes depicting striptease and juvenile delinquency.[98]

Beat Girl represents a British reconfiguration of the AIP delinquent films (it shares numerous similarities with *Dragstrip Girl*), mixed with the influences of European sex and sensationalism associated particularly with stars like Brigitte Bardot. Like *Dragstrip Girl*, *Beat Girl* delights in the illicit, offering an occasionally sympathetic insight into deviance, while also condemning non-conformity. The film's sensationalist slant is easily identifiable from the *Monthly Film Bulletin*'s synopsis of the movie's plot as 'Soho strip-tease', 'Teddy-boys', 'a sports car chicken run', 'a wife with a past', 'teenage tantrums' and 'a race to save a Bardot-like heroine from the clutches of a rogue'. In this sense like *Dragstrip Girl*, *Beat Girl* contains images that might easily have been interpreted as threatening to public safety and moral values, especially considering the fact that the film centres on a teenage girl. Jennifer Linden presented a potentially dangerous role model in a society where the leisure activities for young women were distinctly conservative. As late as the mid-1960s, British annuals aimed at teenage girls largely revolved around knitting, cooking, cosmetics and romance. At this time

young women apparently represented 'the enforcers of purity within teen society'.[99] An indication of British social attitudes towards young women originates from two ephemeral sources from 1962/63, which illustrate why *Beat Girl* appeared so threatening upon its release. Annuals and periodicals presented a narrow, often domesticated environment that even female pop stars could not escape. *Helen Shapiro's Own Book for Girls* (1962), an annual partially built upon the personality of the schoolgirl star, who at fifteen was Britain's top female pop performer, featured a cover in which 'behind a lacquered Helen, girls are drawn, knitting while watching TV, cooking, and . . . making up dresses'.[100] According to such materials, marriage remained the ultimate aspiration, something discussed by pop star Susan Maughan in 1963:

> Like most girls, I want to get married. But marriage is a difficult step for a girl in show business to take. It is the woman who makes the home. And what boy will stand for a wife who is out most of the time entertaining other people? You don't know where you'll be from one minute to the next in this business. It's a hectic life. Marriage is a full-time occupation. And I know that right now I couldn't give all my time to it.[101]

Throughout *Beat Girl*, the youngsters display little respect for parental and adult customs and behaviour. Actions that appear as irresponsible and dangerous, most notably the chicken run sequence that culminates in the fearless teenagers placing their heads on the railway track while a train approaches, show the youngsters obviously enjoying the thrill and danger of their hazardous behaviour. At least temporarily, they are rewarded for their daring, but potentially fatal pastimes. As Hill argues, the world of the Soho beatnik cellars and strip clubs contains a vitality and passion absent in the parental home. Despite the final reconciliation between Jennifer (Gillian Hills) and her father, Paul (David Farrar), 'the energy and vitality of the world of the beatniks survives; the home remains the source of repression'.[102] The cold, unfeeling atmosphere of her father's designer home contrasts with the vibrant hedonism of the beatnik café and cellar. The scenes of the teenagers jiving in the cave sequences show Jennifer and her companions attempting some form of release, both physical and emotional, from the stern authoritarianism of the adult world. The drinking, dancing and beatnik language hints at the existence of a separate underground teenage existence, providing a location that the older generation can not

understand or reach. The generational conflict and the appeal of the teenage subculture is articulated in an acrimonious discussion between Jennifer and her father following her return from Soho at 3 a.m. with 'these clothes and all this muck on your face':

> PAUL: 'Jennifer, I'm trying so hard to understand you, but we seem to be out of touch with each other.'
>
> JENNIFER: 'That's no news to me.'
>
> PAUL: 'But you're my daughter, my own flesh and blood. I do really love you, you know.'
>
> JENNIFER: 'You don't love me, you think you do. You really don't ever look at me, not really, none of you squares ever do. You see what you want to see, a bunch of teenagers lumped together under one name but who are nothing to do with our parents. I'm me, Jennifer Linden, a complete whole independent person.'
>
> PAUL: 'This language, these words what does it mean?'
>
> JENNIFER: 'You are a real square aren't you? It means us, something that's ours. We didn't get it from our parents. We can express ourselves and they don't know what we're talking about.'

Besides displaying sympathy for teenage rebellion, *Beat Girl* adopts a very sensationalist and explicit attitude towards sex for its time. Indeed, a year's release delay materialised because of censor objections to its scenes of nudity from inside a Soho strip-club.[103] Besides this situation Nichole's past in Paris as a striptease dancer and prostitute becomes the main force behind Jennifer's attempts to blackmail her stepmother. For moralists, this delight in squalor received confirmation through the film's attempts to connect female sexuality, moral deviance and excitement. This sensationalism also possessed an inter-textual connection. Contemporary material seized upon Gillian Hills's discovery by Roger Vadim; she shared some physical similarity with the director's most famous protégé Bardot.[104] Such similarities anchored *Beat Girl* within a particular type of cinema: the pouting blonde stereotype, plus a thematic connection between sexual desire as providing excitement away from the repression of the family home. Faith's own simplistic description of the movie's plot hints at the vital importance of this connection: 'The story's about a girl whose widower father marries again, and brings home his young bride from France. His daughter finds out that her step-mother was once a strip-tease dancer in Paris, and

thinks that if mummy had a wild youth in Paris, she is quite entitled to one in London.'[105]

This content helped to establish sex, along with the presence of Adam Faith, as the major selling point of the film. *Beat Girl* offered the sensation not only of a pop star attempting to act, but also attempted to provide another attribute that could not appear on television in 1959/1960 via the strip-club scenes. Interestingly the *Monthly Film Bulletin*'s review never actually bothered to critically analyse *Beat Girl*. The list of events contained in the movie, combined with the dislike of elite critics towards sensationalism, pop music and films thought to influence teenage behaviour, proved enough to dismiss 'the general farrago' without any serious justification being offered for the 'III' grade rating. The *Monthly Film* Bulletin's account of *Beat Girl* proved as uncritical and evasive as anything written by the popular film press: it never becomes clear why the publication classified the movie as the worst type of production available at the time. The only element of praise lies with 'Walter Lassally's photography', but considering the cinematographer's close connection with Free Cinema this acclaim seems self-congratulatory and predicable. The critical elite discussed what they believed represented the main virtues of *Beat Girl*, i.e. the cinematography, while their failure to sufficiently analyse the film merely indicated their disgust and contempt.

Unlike Steele and Cliff, Faith never became a major film star, although his television acting career lasted until his death in 2003. His initial failure to convert into the all-round celebrity along the lines of Steele and Cliff indicated that the family entertainment model did not necessarily suit pop performers. Despite its late 1950s mix of beatniks and Soho sleaze, *Beat Girl* was arguably ahead of its time, especially for a film aimed at the pop market. The movie's cocktail of sex, deviance and crime arguably has more similarities with *Performance* than with *Expresso Bongo*, despite the latter's strip-club scenes. Leon Hunt even argues that the film represents a precursor of 1970s sexploitation films.[106] In contrast, both Steele and Cliff became leading musical stars during the 1960s, largely because their films successfully attracted all ages. Unlike Faith they made family entertainment films whose prime emphasis lay with unpretentious escapism. As Johnson wrote in his review of *Wonderful Life*: 'The film is jam-packed with honest-to-goodness entertainment from the word go. It's not intended to be educational, nor is it

one of those squalid, thought-provoking epics. It doesn't even have a message . . . unless it's forget your troubles and have a ball!'[107]

Notes

1 This partly resulted from an age factor: Cliff was seventeen at the time of his first hit, *Move It* in 1958, and younger than John Lennon and Ringo Starr.

2 J. Lawton, 'The Real Tommy Steele Story', *Picturegoer* (21 June 1958), p. 11.

3 G. Melly, *Revolt into Style* (London: Penguin, 1970), p. 49.

4 Quoted in J. Savage, 'The Simple Things You See Are All Complicated', in H. Kureishi and J. Savage (eds), *The Faber Book of Pop* (London: Faber and Faber), p. xxi.

5 T. Blanchard, 'Jeremy Spenser – A Veteran Youngster', in R. Ottoway (ed.), *Picturegoer Annual 1957–58* (London: Odhams Press, 1957), pp. 24–5.

6 A. Medhurst, 'It Sort of Happened Here: The Strange Brief Life of the British Pop Film', in J. Romney and A. Wootton (eds), *Celluloid Jukebox: Popular Music and the Movies since the 50s* (London: BFI Publishing, 1995), p. 64.

7 Steele's film debut actually occurred in *Kill Me Tomorrow* (1957), in which he performed a song without appearing in a central dramatic role.

8 'The Tommy Steele Story', *Monthly Film Bulletin* 24:282 (July 1957), p. 91.

9 C. Govey, 'Six weeks to Stardom!', *NME* (2 November 1956), p. 3.

10 T. Philpot, 'Bermondsey Miracle', *Picture Post* (25 February 1957), reprinted in Kureshi and Savage (eds), *The Faber Book of Pop*, p. 65.

11 F. Cross, 'A Telling Pen Portrait', *NME* (9 August 1957), pp. 2–3.

12 S. Hall and P. Whannel, *The Popular Arts* (London: Macmillan, 1964), pp. 289–90.

13 *NME* (15 March 1957), p. 10; J. Lawton, 'Steele at the Crossroads', *Picturegoer* (28 June 1958), p. 16.

14 Hall and Whannel, *The Popular Arts*, p. 276.

15 B. Dawbarn, 'The Man Behind Britain's Big Beat', *Melody Maker* (29 August 1959), pp. 2–3.

16 Melly, *Revolt into Style*, p. 50; Medhurst, 'It Sort of Happened Here', p. 64.

17 K. Ferguson, 'The ABC of Mr Steele', *Photoplay* (February 1957), p. 38.

18 A. Loog Oldham, *Stoned* (London, Vintage, 2000), pp. 87–8; Meehan quote from *ibid.*, p. 163.

19 E. Player, 'This film plays fair by the teen set', *Picturegoer* (22 June 1957), p. 5.

20 *NME* (21 June 1957), n.p.

21 P. Leslie, *Fab:The Anatomy of a Phenomenon* (London: McGibbon and Kee, 1965), p. 77.

22 T. Brown, 'Tommy? He's a Natural', *Melody Maker* (25 May 1957), p. 10.

23 C. Govey, 'Tommy Steele Triumphs on Screen', *NME* (24 May 1957), p. 10.

24 D. Johnson, 'Tommy Steele is no Carbon Copy of Elvis Presley', *NME* (31 January 1958), p. 3.

25 Ministry of Education, *The Youth Services in England and Wales* (The Albermarle Report), Cmnd. 929 (London: HMSO, 1960), p. 29.

26 Johnson, 'Tommy Steele is no Carbon Copy', p. 3.

27 C. MacInnes, 'Pop Stars and Teenagers', *The Twentieth Century* (February 1958), reprinted in Kureishi and Savage (eds), *The Faber Book of Pop*, p. 89.

28 *Ibid.*

29 The street named in the film and in contemporary literature was Frean Street, not Frearn Street as listed in Robinson's review.

30 D. Robinson, 'The Tommy Steele Story', *Sight and Sound* 27:1 (Summer 1957), p. 43.

31 'The Tommy Steele Story', *Monthly Film Bulletin* 24:282 (July 1957), p. 91.

32 For material relating to Free Cinema see G. Lambert, 'Free Cinema', *Sight and Sound* 25:4 (Spring 1956), pp. 173–7.

33 Hall and Whannel, *The Popular Arts*, pp. 52–4.

34 *Ibid.*, p. 56.

35 T. Brown, 'I'm Not Afraid of Fame', *Melody Maker* (14 December 1957), p. 3.

36 D. Robinson, 'Television', *Sight and Sound* 27:1 (Summer 1957), p. 43.

37 A. Gray, 'Cliff's Film is the Best Teenage Romp Ever!', *NME* (8 December 1961), p. 3.

38 J. Hill, *Sex, Class and Realism: British Cinema 1956–1963* (London: BFI Publishing, 1986), p. 123.

39 B. Neaverson, *The Beatles'* Movies (London: Cassell: 1997), p. 15; K. J. Donnelly, 'The Perpetual Busman's Holiday: Sir Cliff Richard and British Pop Musicals', *Journal of Popular Film & Television* 25:4 (Winter 1998), p. 148.

40 N. Cohn, *Awopbopaloobop Alopbamboom: Pop From the Beginning* (London: Minerva, 1997 [1969]), p. 65; Melly, *Revolt into Style*, p. 55.

41 R. Durgnat, 'Summer Holiday', *Films and Filming*, 9:6 (March 1963) p. 37.

42 M. Braun, *'Love Me Do!' – The Beatles' Progress* (London: Penguin, 1995 [1964]), pp. 28, 34.

43 'Tail-Pieces by The Alley Cat', *NME* (19 December 1958), p. 12.

44 Johnson, 'Tribute to a Nice Guy' – *New Musical Express* Cliff Richard 21st Birthday Supplement, *NME* (13 October 1961), p. 7.

45 *Ibid.*, p. 7.

46 *Melody Maker* (19 January 1963), p. 13.

47 D. Johnson, 'Cliff's "Summer Holiday" is Great', *NME* (11 January 1963), p. 3.

48 S. Frith, *Sound Effects: Youth, Leisure, and the Politics of Rock'n'Roll* (London: Constable, 1983), pp. 166–7.

49 'Introducing *NME*'s New Editor – Andy Gray', *NME* (31 May 1957), p. 6. This informs us that Gray was already forty in 1957, with over twenty years' experience in music journalism.

50 P. Gorman, *In Their Own Write: Adventures in the Music Press* (London: Sanctuary Publishing, 2001), p. 34.

51 P. Haigh, 'Witty, Amusing – Worth Your Time and Money', *Record Mail* 3:1 (January 1960), p. 2.

52 Gray, 'Cliff's Film', p. 3.

53 Johnson, 'Cliff's *Summer Holiday* is Great', *NME* (11 January 1963), p. 3.

54 Donnelly, 'The Perpetual Busman's Holiday', p. 152.

55 Johnson, 'Cliff's *Summer Holiday* is Great', p. 3.

56 B. Davies, 'Expresso Bongo', *Monthly Film Bulletin*, 27:312 (January 1960), p. 3.

57 Haigh, 'Witty, Amusing', p. 2.

58 T. Brown, '"Bongo" Offers a Laugh a Minute', *Melody Maker* (28 November 1959), p. 8.

59 P. G. Baker, 'Expresso Bongo', *Films and Filming* 9:4 (January 1960), p. 25.

60 P. Bourdieu, *Distinction: A Social Critique of the Judgement of Taste*, trans. Richard Nice (London: Routledge, 1984), p. 56.

61 P. G. Baker, 'High School Confidential', *Films and Filming* 5:7 (April 1959), p. 22.

62 Baker, 'Expresso Bongo', p. 25; Davies, 'Expresso Bongo', p. 3.

63 Brown, '"Bongo" offers', p. 8.

64 Baker, 'Expresso Bongo', p. 32.

65 Brown, '"Bongo" offers', p. 8.

66 Bourdieu, *Distinction*, p. 232.

67 The EMI Columbia label should not be confused with the American Columbia label which operated as CBS in Britain during the 1960s.

68 *NME* (8 August 1958), p. 6; 'You're One in a Million', *NME* (6 November 1964), p. 8.
69 M. Abrams, *The Teenage Consumer* (London: The London Press Exchange, 1959), p. 10; idem, *Teenage Consumer Spending in 1959* (London: The London Press Exchange, 1961), p. 4.
70 Abrams, *Teenage Consumer Spending in 1959*, p. 4.
71 J. Oliver (ed.), *Top Numbers' Book of the Stars* (London: Tolgate Press, 1960), p. 3.
72 Abrams, *Teenage Consumer Spending in 1959*, p. 10.
73 *Ibid*.
74 P. Laurie, *The Teenage Revolution* (London: Anthony Blond, 1965), p. 67.
75 *Record Mail* (October 1959), pp. 8–9.
76 'Cliff Richard', *Picture Show: All Star Special 1961* (London: Fleetway Publications, 1960), pp. 46–7.
77 *Valentine Pop Special* (London: The Amalgamated Press, 1959), n.p.
78 V. Bogdanor and R. Skidelsy (eds), *The Age of Affluence 1951–1964* (London: Macmillan, 1970).
79 A. Marwick, *British Society Since 1945* (London: Penguin, 1996), p. 248.
80 *Record Mail* (January 1963), p. 1; *Record Mail* (July 1964), p. 1.
81 Hall and Whannel, *The Popular Arts*, p. 281.
82 *Ibid*.
83 P. Wainwright, 'Colour, Comedy and Stacked with Songs', *Record Mail* (August 1964), p. 2.
84 K. Ferguson, 'Cliff – Will His Next Film Be the Greatest of Them All?', *Photoplay* (July 1963), p. 11.
85 S. Turner, *Cliff Richard: The Biography* (London: Lion Press), p. 156.
86 D. Marsh, *Before I Get Old: The Story of the Who* (London: Plexus, 1983), p. 27.
87 D. Johnson, 'Tribute to Cliff and the Shadows on their Fifth Anniversary in Show Business', *NME* (30 August 1963), p. 2.
88 *Ibid*.
89 Johnson, 'Tribute to a Nice Guy', p. 7.
90 *Ibid*.
91 Ferguson, 'Adam Mustn't Flop Again', *Photoplay* (November 1962), pp. 30–1.
92 'Beat Girl',
93 P. Houston, 'The Front Page', *Sight and Sound* 30:1 (Winter 1960–61), p. 3.
94 P. Houston, 'Time of Crisis', *Sight and Sound* 27:1 (Spring 1958), p. 167.

95 P. Houston, 'The Front Page', *Sight and Sound* 32:1 (Winter 1962–63), p. 3.
96 R. Murphy, *Sixties British Cinema* (London: BFI Publishing, 1992), pp. 102–14; Hill, *Sex, Class and Realism*, pp. 35–52.
97 Houston, 'Time of Crisis', p. 168.
98 *Ibid.*, pp. 168–9.
99 B. Ehrenreich, E. Hess and G. Jacobs, 'Beatlemania: A Sexually Defiant Consumer Subculture?', in K. Gelder and S. Thornton (eds), *The Subcultures Reader* (London: Routledge, 1997), pp. 523–4.
100 J. Savage, 'Pulp! The History of Fan Magazines', *Sounds* (20 August 1977), reprinted in *Time Travel – From the Sex Pistols to Nirvana: Pop, Media and Sexuality, 1977–96* (London: Vintage, 1996), p. 20.
101 Ferguson, 'Marriage and Me', *Photoplay* (August 1963), p. 14.
102 Hill, Sex, *Class and Realism*, p. 119.
103 *NME* (4 August 1960), p. 7. The film had to wait until October 1960 to obtain a full national release having been filmed over a year previously.
104 Ferguson, 'Sixteen and Sexy', *Photoplay* (June 1960), pp. 21, 42; T. Keniston, 'Adam Faith – From "Drumbeat" to "Beat Girl"', *NME* (28 August 1959), p. 10.
105 Keniston, 'Adam Faith', p. 10.
106 L. Hunt, *British Low Culture* (London: Routledge, 1998), p. 94.
107 D. Johnson, 'Cliff's Pic Packed With *Wonderful Life*', *NME* (3 July 1964), p. 4.

Chapter 6

Critics, fan culture and the British pop film

'I do feel the film was reviewed by the wrong people. It was aimed at the pop market, but they sent the sort of people to it who would go to see "Henry VIII" . . . I'm not a professional actor and neither are the boys.'[1]

Accounting for the disappointing critical reaction to *Catch Us If You Can*, its pop star lead actor Dave Clark attributed this situation to the type of critic reviewing the movie. Even *Melody Maker* largely ignored the film, while one newspaper negatively compared Clark's acting to Laurence Olivier.[2] The star himself assumed that commentators interested in Shakespeare and high culture would be unsympathetic towards a film primarily aimed at teenagers.

Clark was wrong: *Catch Us If You Can* retains interest as one of the key documents of Swinging London. Like the Beatles' debut film, *A Hard Day's Night*, the movie is a fascinating attempt to capture 'the shiny plastic immediacy' of mid-1960s youth culture.[3] Moreover both films illuminate changing attitudes to youth culture among the critical elite. Rather than being derided as teenage trash by discerning critics, the movies marked a rare moment when diverse commentators openly welcomed the British pop film.

This latter point forms the main basis for this chapter, which details why a succession of publications, ranging from the *Monthly Film Bulletin* to *NME*, praised the movie. However, rather than representing a new critical consensus, the material on *A Hard Day's Night* and *Catch Us If You Can* remained ingrained within the prevailing hierarchies of taste. To contextualise the critical reaction to these films, two further points require brief consideration. First, I will discuss the wider trends within filmgoing during the mid-1960s. Second, examples of the 'bad' British pop films responsible

for the poor critical standing of the sub-genre receive acknowledgement.

The tastes of British filmgoers in the mid-1960s

The task of discovering the differences among British cinemagoers is facilitated by a survey into current audience trends published by *Films and Filming* in June 1965. Organised in conjunction with the BBC, the survey sought to extract information from a 'listening panel' of 831 people about 'the extent and nature of listeners' interest in films and filmmaking'.[4] The relatively small number of informants means that the findings should receive some scepticism, although important socio-cultural trends were illuminated. The survey confirmed the presence of 'the interested third', those minority of cineastes who claimed 'some interest in the technical side of filmmaking', rather than the majority of respondents who frequented the cinema 'for entertainment only'.[5] The report's authors, Robert Silvey and Judy Keynon, noted that this 'interested third' comprised of people 'of a rather higher level of education than the rest and also included a higher proportion of men rather than of the women'. This educational capital involved the 'interested third' demonstrating their passion for the cinema through such activities as membership of film-societies, amateur filmmaking and reading elite film publications.[6]

The gulf between those interested in the technical side of filmmaking and the 'rest' becomes evident in the table below. While the difference between those interested in acting appeared relatively slight (73 per cent of the 'interested third' compared to 66 per cent of the 'rest'), a crucial divergence occurred with such pivotal areas of filmmaking as direction and scripting. Only 17 per cent and 23 per cent of ordinary film viewers claimed an interest in scriptwriting and direction, compared to 44 per cent and 40 per cent of the 'interested third' with an enthusiasm for these categories.[7] The survey also listed in order the five major points that influenced individuals' film-viewing habits:

> The film with an appealing story.
> The film of a favourite type.
> The film with a favourite star.
> The film praised by the critics.
> The film with a good producer/director.[8]

Aspects of interest in the film most recently seen – 1965

	The 'interested third' (%)	The rest (%)
Acting	73	66
Photography	66	41
Direction	44	17
Scripting	40	23
Colour	34	27
Lighting	13	3

Source: R. Silvey and J. Keynon, 'Why You Go To The Pictures', *Films and Filming*, 11:9 (June 1965), p. 5.

This table offers statistical information that correlates with the findings of Bourdieu on film audience preferences outlined in chapter 1. Although writing primarily about painting, he states that among the cultural elite, the presence of 'an aesthetic disposition' exemplifies 'the *absolute primacy of form over function* of the mode of representation over the object represented, [which] *categorically* demands a purely aesthetic disposition, which earlier art demanded only conditionally' (italics in original).[9] This results in the cultural elite being more interested in the form of a cultural product; the construction of the artefact contains more significance for 'the interested third' than the pleasures that it offers for the majority of consumers. This theory contains much benefit for analysing the operation of film criticism. Inevitably, granted their high knowledge of film from historical, technical and theoretical angles, critics belong in the 'interested third', meaning that they are perhaps more interested in the 'form' than the 'function' of the cinema. Their concern lies with such aspects as scripting, direction, cinematography and lighting, rather than the star system. The remainder of this chapter details how this difference between 'form' and 'function' influenced how particular films were received and publicised by various sectors of the music and film press.

'The era of poor pop films' – British pop musicals in the early 1960s[10]

When referring to the forthcoming release of Billy Fury's *I've Gotta Horse* (1965), *NME* invoked the star's previous film, *Play It Cool* (1962), as a typical product 'from the era of poor pop films'.[11]

Although this period coincided with the apogee of Cliff Richard's cinematic career, from the standpoint of the post-*A Hard Day's Night* era, earlier British pop movies did appear to critics as cinematically impoverished, lacking the musical, dramatic and technical innovations of the Beatles' film. In order to discover why critics acclaimed *A Hard Day's Night* and *Catch Us If You Can* as breakthroughs for the pop musical, consideration of the type of film responsible for the sub-genre obtaining a dire critical reputation becomes necessary.

In many ways, the British pop film of the early 1960s mirrored the American rock'n'roll film from several years earlier. The British versions of *Rock, Rock, Rock* and *Shake, Rattle and Rock* were such films as *Just For Fun* (1963), *Play It Cool* and *What a Crazy World* (1963). Indeed *Rock, Rock, Rock*'s American scriptwriter/producer, Milton Subotsky, was the brains behind the likes of *It's Trad, Dad* (1962) and *Just For Fun*, which adopted the same televisual, performance revue style evident in *Rock, Rock, Rock*. K. J. Donnelly writes that this kind of film 'was premised upon the appearance of a succession of acts almost always using the performance mode, much as did stage and television pop shows at the time, while on some occasions the film would have a minimal unifying narrative'.[12]

Like their US equivalents, the British versions were generally cheaply produced revue style films, featuring a host of pop acts alongside the de facto stars. For example, *What a Crazy World*, a pop musical starring Joe Brown and Marty Wilde, two prominent figures in pre-Beatles British pop circle, also featured one-hit-wonder Susan Maughan as Brown's on-off girlfriend. Besides musical performances from these three acts, there was a guest slot for Freddie and the Dreamers. Neither Maughan or Freddie Garrity were established stars at the time of the film's release (Christmas 1963), yet their initial success was enough to secure their places in the production. To this end, the British pop film continued along the lines established by *The Tommy Steele Story*: in the age of the pop revue, any degree of chart success ensured an appearance in a feature film.

Thanks to this revue-style format, the British pop musical often suffered from poor narrative construction. This overdose of performances and silly storylines created ammunition for hostile critics. Ridiculous plots, such as that featured in *Just For You* (1964), in which disc jockey Sam Costa introduced over twenty performances in only sixty-four minutes from his bed, met inevitable disapproval.

The *Monthly Film Bulletin* showed no mercy in attacking the film and patronising its audience:

> At a touch of a switch, Sam Costa summons a parade of pop singers to entertain him as he reclines in his electronic push-button bed.
> Blaring and vulgarly over-decorated musical fantasia, strung together by a moronic commentary from Sam Costa; plotless, and altogether charmless, though pop fans doubtless won't mind.[13]

Even the more interesting films, such as the Theatre Workshop-derived *What a Crazy World*, faced condemnation from the *Monthly Film Bulletin* for 'the dullness of the musical numbers and the tedium of the romantic interest'. This anonymous reviewer disliked these elements synonymous with the teenage movie dramas/comedies. Rather, the film was 'tasteless and charmless entertainment' that 'might just possibly appeal to those "bleedin' kids" so constantly apostrophised throughout the film'.[14]

The characteristics of *Play It Cool* singled out for abuse – script, direction, acting and thematic depth – directly contrasted with those attributes of *A Hard Day's Night* and *Catch Us If You Can* that obtained praise from elite critics. *Play It Cool* also originated from the same studio and producer as the Dave Clark Five venture (David Deutsch at Anglo Amalgamated), and contains some thematic similarities, thereby linking the critically approved and despised types of British pop film.

Play It Cool provides an opportunity to examine the implication of the critical preference for 'form' over 'function' described earlier. The first cinematic venture for Billy Fury, one of the leading pre-Beatles British pop performers, the film told the tale of a pop group, Billy Universe and the Satellites, who meet Ann (Anna Palk), a rich heiress, at the airport. After a curtailed flight to Brussels, the group escort the young lady around a succession of London nightclubs, where Billy and pals perform a batch of songs and witness numerous other pop stars in action before helping to rescue Ann from the clutches of a devious singer. This thin plot encapsulated one reason for the film's critical failure. With its perceived lack of cinematic class, *Play It Cool* illustrated why elite commentators, such as Raymond Durgnat in *Films and Filming,* invariably treated the British pop musical with disdain:

> It's surprising how solemnly people disapprove of rock-'n'-roll, and pops generally; Richard Hoggart's censorious, though well-meant

analysis of songs in *The Uses of Literacy* is nonsense from beginning to end and I'm still hoping for a film to treat the whole business of teenagers, leisure and the mass-media in a sympathetic way. Failing that, the next best thing is something as glossily absurd as *The Girl Can't Help It*.

By comparison with Tashlin's film, *Play It Cool* has an amateurish and tatty air. Billy Fury and his teenage combo rush from club to club and song to song while helping a runaway heiress to miss her date at Gretna Green with a no-good pop singer. Its London nightlife is a hectic mishmash of the palais, the plush and the pad, and its cornball set-up is just a pretext for a series of song-numbers and exploiting every absurdity in the plot as a bit of a giggle. It has what it needs to please the teenagers, a sort of idiotic verve and good humour which carries the whole caboodle along, while Mums and Dads will chuckle at its high spirits.

. . . I didn't much fancy the floppy way Billy Fury jerks his hands, even though little clumsinesses like this help endear a teenage idol to his fans, with whom they establish a band of sympathy, so that his inexperience, by its success, vindicates their own. As Billy Fury can't act he sensibly Acts Natural instead, while his musical-saw accent is left unblunted – a good touch. . . .In comparison with the recent Anglo-French twist contest, the standard of twisting here touches (so to speak) rock-bottom. The film is jolly enough in its unabashedly absurd way, but if you want wit, gloss, invention and all the other garments with which Hollywood so expertly garnishes its nonsense, then, there's no doubt about this film, It's Bad Dad.[15]

If Durgnat's review is examined with awareness of the critical preference for 'form' over 'function', then the reasons for his disapproval become obvious. Despite his superficially sympathetic attitude to popular culture, he contradicted this stance through his denunciation of Fury's performance. The star's songs 'all sound alike to me', his fans were passive, while Durgnat condescendingly described 'the floppy way Billy Fury jerks his hands'. His opinions reflected his own privileged position as a commentator on popular culture, rather than the values of the intended audience for *Play It Cool* or even *The Girl Can't Help It*.

This becomes clearer with his description of *Play It Cool*'s 'amateur and tatty air'. The accusation is particularly relevant for the film's plot, décor, script and means of production, which lacked the quality associated with the best Hollywood musicals. Durgnat had justification for denouncing the 'cornball set-up' that served as 'just a pretext for a series of song-numbers and exploiting every absurdity

in the plot as a bit of a giggle'. The era of 'bad' British pop films obtained a poor critical reputation, partly because producers, script-writers and directors made little attempt to conceal the commercial motivations behind a particular cinematic venture. Besides Fury, *Play It Cool* features pop figures including Helen Shapiro, Bobby Vee and Danny Williams as guest stars. In itself this situation need not necessarily have proved disastrous, but with *Play It Cool*, the presence of a host of pop stars merely complemented a wafer-thin plot with songs. For example on arrival at the Lotus Rooms, two members of Fury's backing group coincidently see Shapiro walking past a sign advertising her evening's performance at the club. Cue several gormless comments and, of course, a singing display from Shapiro:

ALVIN: 'There's Helen Shapiro.'
RING-A-DING: 'Didn't know she was Chinese.'

The entire scenario becomes acutely embarrassing, especially as maximum opportunities occur for songs to stem a tedious plot. It seems too much of a coincidence that, whenever the protagonists visit a club, a mystery celebrity emerges from thin air in order to per-form. To quote from the *Monthly Film Bulletin*'s review of the film, despite its 'youthfully spirited treatment', *Play It Cool* still made 'use of the usual silly romantic complications as an excuse to introduce a collection of frantic musical acts'.[16] For the critics, this sin escalated through the obvious exploitation element of the film. As the *Monthly Film Bulletin* rather disdainfully remarked, '"The Twist" also figures largely, with particular and inevitable emphasis on large figures'.[17] This jibe referred to the popular association between the dance and its leading exponent, the corpulent US singer Chubby Checker. As the latest teenage dance craze around 1962, perhaps predictably film producers sought to feature 'the twist' in the latest pop musicals. To the critical establishment such a move could easily appear suspect. First, the presence of 'the twist' on film exploited the latest teenage tastes, a belief likely to receive expression given the critical elite's attitude towards youth culture. Second, this commer-cialism sacrificed the artistic potential of the musical: by concentrat-ing upon the latest vulgar, teenage gimmick, the film risked debasing the richness of the genre for novelty. *Play It Cool* and other similar films faced condemnation because they replaced imagination in favour of ephemeral pop music. The movie's attempts to integrate

musical numbers into its narrative undoubtedly seemed risible to those well endowed with detailed knowledge on the Hollywood musical, but this concentration upon the form of the film ensured that they remained blind to the film's potential pleasures to its audience.

The revue format of many British pop musicals greatly damaged the reputation of the sub-genre. As the next section indicates, the critical applause for *A Hard Day's Night* and *Catch Us If You Can* largely resulted from the capability of these productions to overcome the low artistic status of pop star movies. Unlike the films from the Beatles and the Dave Clark Five, a low-budget, shoddily executed quickie like *Play It Cool* contained few pretensions towards artistic class and made no attempt to conceal its limitations. The 'amateurish and tatty air' of Michael Winner's Billy Fury vehicle becomes especially obvious in comparison to the better-produced American pop films. Durgnat's comparison to *The Girl Can't Help It* is very instructive. This US rock'n'roll film may have featured a revue format, but several of its musical numbers demonstrate visual flair, especially through the Julie London 'Cry Me A River' sequence. This number not only complements the narrative and characterisation of the film, but also features surrealistic imagery that matches the alcoholic and confused state of the hero bemoaning the loss of his star client, London. The film is photographed in bright Cinemascope with good integration between character, plot and music. In comparison, *Play It Cool* looks decidedly shoddy. While the earlier film stands as a relatively well-budgeted Hollywood product, *Play It Cool* fails to transcend its origins as a low-budget offering from a first-time feature film director (Winner) alongside two juvenile leads without previous screen experience (Fury and Palk).[18] These limitations appear particularly severe when the film's décor is considered: it looks tatty with no attempt being made to add atmosphere to the obviously studio-bound club sequences. The sets are practically bare, featuring no props or designs that contribute to the development of the characters or the film's themes: a new nightclub just presents the opportunity for more songs.

The critically respectable British pop film – *A Hard Day's Night* and *Catch Us If You Can*

If films such as *Play It Cool* contributed to the critical distaste for the British pop musical, then *A Hard Day's Night* and *Catch Us If You Can* obtained surprising acclaim. These vehicles for the Beatles and the Dave Clark Five contain much value for scholars of the British pop movie. First, these are possibly the two greatest British pop films. Second, the critical success that greeted *A Hard Day's Night* and *Catch Us If You Can* offers an opportunity to further investigate the differences between various publications. Specifically, leading on from the biases expressed by 'the interested third', how exactly did these preferences differ from the concerns of ordinary fans?

The initial critical reception for both *A Hard Day's Night* and *Catch Us If You Can* was complementary towards their respective merits. With the Beatles' film, such diverse judges as Dilys Powell of *The Sunday Times* and NME's Andy Gray offered comparisons between the Fab Four and the Marx Brothers.[19] Unusually for a pop musical, the hierarchy at *Sight and Sound* deemed *A Hard Day's Night* worthy of sufficient importance as to justify an extensive review, albeit months after its release. Echoing the earlier anonymous comments of the *Monthly Film Bulletin*, which declared that '*A Hard Day's Night* is streets ahead in imagination compared to other films about pop songs and singers',[20] Geoffrey Nowell-Smith acknowledged the positive strengths of the movie:

> [I]t works, or so it seems to me, on a level at which most British films, particularly the bigger and more pretentious, don't manage to get going at all. To feel this one has only to compare it with a typical British quality production like *The Pumpkin Eater* – so carefully thought out, so meticulously scripted, so acted, so heavily 'directed', so thoroughly pedantic and ultimately so worked over that it becomes totally self-cancelling. *A Hard Day's Night*, though not exactly a *film d'auteur*, is in all other respects exactly the opposite. It is utterly slapdash, but it is consistent with itself. It works as a whole. It is coherent and has a sense of direction to it and a point. [italics in original][21]

A Hard Day's Night certainly (if only temporarily) initiated a critical interest in the British pop movie. This partly accounts for the interest that greeted not only the Beatles' second film, *Help!*, but also the Dave Clark Five's *Catch Us If You Can*. At worst later critics have dismissed the Clark film as a pale imitation of the Beatles' debut

movie in a rather facile manner.[22] The release of these productions in summer 1965 saw *Films and Filming* devote a front page to 'Today's Pop Gods', featuring pictures of Clark, the Beatles and Presley. That this event had reduced Fellini to the small print on the front page hints at the centrality of pop stars in the mid-1960s cultural firmament.[23] Robin Bean's actual review of the Dave Clark Five offering concluded that:

> One of the most interesting and thought provoking of the British films of this year, *Catch Us If You Can* is a worthy achievement for John Boorman, producer David Deutsch and photographer Manny Wynn. But there seems to be a slight flaw, an elusive quality which is lacking. But this is a minor point and not intended to detract from the integrity and ambitious intentions of the film's makers.[24]

This applause also featured in other accounts of the film. The *Monthly Film Bulletin* surprisingly discussed Boorman's picture in the main section of its reviews with a named reviewer, Elizabeth Sussex. This seemed conspicuous not only due to *Catch Us If You Can*'s status as a pop musical, but also owing to its director's inexperience. The critic claimed that the film equalled 'an intriguingly unusual teenage musical: it is consistently worth looking at, and it finds intelligent expression for a genuinely youthful point of view'.[25] Although *Melody Maker* almost entirely ignored the film, failing to even review it in any form, both *NME* and *Record Mail* made positive statements about its achievements.[26] Gray described the movie as 'refreshing, fast-moving, unpretentious entertainment', while from Clark's EMI publicists at *Record Mail*, Norman Divall considered *Catch Us If You Can* as 'terrific . . . an amusing, diverting and thoroughly entertaining film that will surely be well received by all'.[27]

Directorial and technical innovation

The directorial and technical innovations of *A Hard Day's Night* and *Catch Us If You Can* have been outlined in other accounts of these films. It is not my intention to reiterate these existing arguments, but rather to complement them utilising contemporary review material.[28] I do not wish to discuss *A Hard Day's Night*'s artistic debt to the nouvelle vague or whether *Catch Us If You Can* provides a stepping stone on the road to *Blow Up* (1966) and *Performance*. The art

cinema references now synonymous with the Beatles and Dave Clark Five vehicles existed at the time of their initial release. Nowell-Smith commented negatively on the 'rapid gyrations of hand-held camera', referring to Richard Lester's use of ultra-fast cutting and jump cuts, while the *Monthly Film Bulletin* commented upon the director's use of 'a wealth of engaging ideas . . . [with] a freshness which overcomes its *neo nouvelle vague* air' (italics in original).[29] Similar applause greeted Boorman with Bean applauding the 'Pinteresque quality in both writing and visual approach' evident in the scenes between Dinah (Barbara Ferris) and her odious boss, the advertising executive Zissel (David De Keyser).[30] Sussex praised the 'intelligent' way in which the film balanced style with commentary. Nearly thirty years later, Jon Savage echoed her comparison with Fellini, while Pauline Kael noted similarities with Bergman's *Wild Strawberries* (1957).[31] Discussing *Catch Us If You Can*'s 'distinctly imaginative passages', Sussex mentioned

> Fast cutting around the poster of the meat girl; low-angled tracking shots through London; snowscapes and seascapes and Bath's Royal Crescent artistically photographed by Manny Wynn; a Felliniesque party that ends up with the leading characters, dressed as their favourite film personalities, involved in a frantic chase along a Roman bath . . . Remarkably, in view of the fact that John Boorman, who has worked for television, is only thirty-one and is making his first film, this is a director's picture from start to finish. Boorman's obvious feeling for the medium is rich in promise.[32]

Certainly both directors deserved their praise. It is difficult to believe that the jest that permeates both films does not partially initiate from the directorial techniques on display. The fast-cutting, jump cuts and hand-held camera work because they match the youthful spontaneity of the protagonists, best indicated by the 'Can't Buy Me Love' escape sequence in *A Hard Day's Night* and Steve (Clark) and Dinah's joyous ride through central London in *Catch Us If You Can*. Both scenes convey a feeling of effervescence: the immediate thrills obtained in that moment of freedom from the constraints of adult authority. The characters delight in their illicit actions, either through playing in a field like children in *A Hard Day's Night* or escaping from the film set in a stolen car, calling upon people to 'change their way of life'. With such events in mind, Medhurst rightly refers to 'the liberating jolt of nowness that permeates' *Catch Us If You Can*, a view that also applies to Lester's film.[33] Each

film obviously attempts to articulate the Pop Art spirit of mid-1960s youth culture where signs with 'Ripe and Ready', 'MEAT FOR GO!!' and 'Thrills' are positioned on the wall of the Dave Clark Five's home without any purpose or explanation. Through their use of techniques associated with contemporary culture, whether pinched from advertising, Pop/Op art designs, television or the French nouvelle vague, together with the iconographic use of pop stars as symbols of the present vibrancy of youth, Lester and Boorman obviously attempted to capture the moment in pop culture. Interestingly, Philip French positively compared Lester's mid-1960s youth films to the works of older directors attempting to explore Swinging London, for example John Schlesinger's *Darling* (1965). The apparent lack of pretentiousness of the Beatles' films conveyed the flavour of the times better than more weighty works of cinema because 'Lester's aim is to celebrate the present' via 'the instant, ephemeral and expendable use to which he puts it'.[34]

This extensive interest in the director's role did not exist among the popular publications. Lester presents the more complicated case, because the success of *A Hard Day's Night* ensured that he became (albeit briefly) a 'name' director synonymous with a recognisable style. By the time of *Help!* even *NME* wrote that 'Dick Lester's direction is brilliant as expected', although this success overshadowed the 'other aspects of the picture'.[35] A year earlier the same publication acknowledged that Lester's 'great flair for comedy' comprised 'a major contribution' to *A Hard Day's Night*'s success, although Gray argued that the real cause for celebration ultimately lay with the charm of the Beatles:

> At the Royal premiere, Paul was asked by Princess Margaret if he thought they were good actors and he replied: 'I don't think we're good, Ma'am, but we had a very good director'. True, Dick Lester has a great flair for comedy and the editing of the film is razor sharp, a major contribution to the success.
> But the Beatles have come through with flying colours. Whereas many pop stars sound unreal and even horrible when given films, the Beatles really punch them over with a naturalness, that is refreshing and they look good throughout. Hail the Beatles, the screen's latest comedy team![36]

The role of the director featured even less prominently with the popular sources relating to *Catch Us If You Can*. Extensive articles from behind the set, published in *Photoplay* and *Music Echo*, both

conspicuously failed to mention Boorman, a situation echoed in the final reviews from *NME* and *Record Mail*.[37] The only popular source, which I have seen, that acknowledges the director is a glossy star annual from Christmas 1965. Here, three colour pages are devoted to the Dave Clark Five, yet on the final page two monochrome pictures feature Boorman.[38] These photographs hint at the marginality of the director in the interests of the book's intended readership. In the top left right-hand corner, 'director John Boorman goes over the course with the boys – they are supposed to be filming a brisk training run round the common'.[39] Reproduced in Figure 5 the bottom left image shows 'director and cameramen surveying the scene before shooting'.[40] In both photographs Boorman appears as the servant of the Dave Clark Five. Nothing is mentioned about his artistic contribution to the film. In order to reassert the primacy of the group over the technical accomplishments two of the photographs centre upon the group: for the glossy star annual, the success of

5 The marginality of the director in fan publications

Catch Us If You Can belonged to Dave Clark rather than John Boorman.

The above examples relating to *A Hard Day's Night* and *Catch Us If You Can* illustrate the vast contrast between elite and popular sources relating to the role of the director. It should be remembered that the 1960s saw the heyday of auteurist studies attributing the artistic creation of a film to directors. Therefore the tendency among the *Monthly Film Bulletin* and *Films and Filming* critics to associate the two films' successes with their directors does not appear that surprising. The contrasting attitudes expressed towards Lester and Boorman explains the different interests of the readership of diverse publications. Given the predominance of members of 'the interested third' among the clientele of *Sight and Sound/Monthly Film Bulletin* and *Films and Filming*, such publications believed that the perceived artistic quality of the two pop films reflected the talent of their directors. Sussex's claim that *Catch Us If You Can* 'is a director's film from start to finish' was a natural assumption given the interest of her readers in the forms involved in the filmmaking process. People who read the elite film press did not want glossy colour pictures of Dave Clark or the Beatles smiling and joking on the film set: they desired commentary on whether the pop films contributed to the artistic cause of cinema.

Equally, did the stances of the music press and fan-orientated materials hint at an evasive attitude that denied the rightful place of the director as a factor in the success of a film? The answer is both yes and no. Although Gray acknowledged Lester's contribution to *A Hard Day's Night*, the achievement and talent of the Beatles surpassed that of the director. As far as the fan-related material on *Catch Us If You Can* indicates, Boorman may not have even existed for many Dave Clark Five fans, being perceived as marginal to its entertainment value. Yet, if publications adopt editorial strategies in order to capitalise upon the perceived prejudices of their readers, then this preference for star profiles and plot synopsis seems as natural as the elite magazines' concentration upon the role of the director. As indicated in the table above, most ordinary cinemagoers possessed a prime interest in the story, type of film and the stars involved with a particular cinematic experience: concern in the technical side of the cinema, best exemplified through direction, did not occur particularly often. In this sense, the relative absence of coverage relating to Lester and Boorman seemed very predictable,

considering the fan-orientated stance of the music press and film fan magazines/annuals. Rather than illustrating a denial of film art, the emphasis on the personalities of the Beatles and the Dave Clark Five and how they fitted into their movies legitimised their roles in the lives of young people. If the groups' fans wanted to read about their heroes and their cinematic adventures, then logically teenage orientated publications had to neglect discussions about direction, cinematography and editing.

Theme and plot in *A Hard Day's Night* and *Catch Us If You Can*

The other key aspect of *A Hard Day's Night* and *Catch Us If You Can* distinguishing these movies from earlier pop films lay in their cinematic ambitions to convey realism and thematic depth respectively. These intentions were evident in the comments of *A Hard Day's Night*'s producer, Walter Shenson, and those of Boorman:

> One thing I'm sure of, and that is the boys come across excellently. They are very professional – we kept to a budget of around quarter of a million due to their genuine interest in the picture and there was no temperament and lots of mutual respect.
>
> Director Dick Lester shares the same kind of humour as they do, he understands them, and liked working with them and that helped a good deal. The dialogue is important and that's why we wanted Alun Owen, he has written some first rate stuff.
>
> We wanted to get out as much as possible against natural backgrounds . . . and fortunately we were able to move around without being spotted too much.
>
> . . . The boys are very well disciplined. They are night birds and found it difficult to get up in the morning, but they were always punctual on the set. They did find the waiting around hard but that's not surprising – even the most seasoned actors do. One of my greatest responsibilities and worries was in not wanting to hurt the Beatles' image and therefore we did not ask them to do anything in the film that was not natural to them.
>
> But why isn't the film in colour?
>
> Replies producer Shenson:
>
> 'The Beatles are black and white characters as far as I am concerned, they are real people and I don't see them in colour. The film is factual, a slice of life, not a fairy tale type of picture such as, say, a Presley film. The songs are very natural and photographed in the most exciting way

and this is what we were striving for the whole time, a modern film, in its look, in its feel and its conception.'[41]

In a way the pop group was just a point of departure. I was also obliged to begin with them as that was what the public expected. What I wanted was not to disappoint their fans, but to engage them in something quite different. I think that what I really hoped to convey was my conflict with English society and the class system I'd encountered at the BBC.[42]

While Shenson explicitly stated that his prime concern lay with not damaging the Beatles' clean image, Boorman's comments hint that he possessed little interest in highlighting fun and frolics with the Dave Clark Five. The main narrative focus of the film is Dinah not Steve, while the rest of the group has very little involvement in the film. In both movies, there is a clear desire to break away from the restrictions of the pop musical format. Shenson's emphasis on realism and the 'natural' personalities of the Beatles positioned *A Hard Day's Night* against the output of other pop stars venturing into film. This was no 'quickie' in the *Play It Cool* tradition, but rather the first screenplay by a leading British television writer and playwright of the kitchen sink/socio-realist school, Alun Owen, that distanced itself from Presley-style escapism. By emphasising these artistic credentials, Shenson placed *A Hard Day's Night* on a higher cultural plateau than other British pop musicals from the moment of the film's conception. He saw the picture as a prestigious pop movie, a product to alter the poor popular and critical conception of the subgenre in a manner that echoed the Beatles' own impact upon the world of popular music. Boorman's comments also indicate that his film contained artistic pretensions beyond those usually synonymous with the pop musical. Dave Clark and company are merely used as the symbols for a sociological investigation into the world of young people and society, tools from which the director could initiate studies of the oppositions between youth and the middle-aged and advertising and the advertised.

Certainly, the realist aspects of *A Hard Day's Night* achieved qualified praise from diverse sources. The realist inclined critics of *Sight and Sound* and the *Monthly Film Bulletin* singled out the 'longish scenes of Ringo's escape and capture' and the 'Can't Buy Me Love' sequence as the most outstanding parts of the film.[43] Similar comments about the realistic depiction of the group originated from *Melody Maker* editor Jack Hutton:

They don't try to act. They are just themselves. Witty. Cheeky. Imper-
tinent. Human. Animated. Deadpan. Natural. And-if-you-don't-like-
it-lump-it sort of thing.

Each one is a star in his own right, but Starr is an extra special star.
At one point he becomes slightly disenchanted with the rest, and wan-
ders along a river bank. He wears a cloth cap and a long coat for dis-
guise. A young tramp with an expensive camera.

He chats with a grubby boy as though he'd met him in a Liverpool
street. He doffs his coat in a Walter Raleigh act for a smashing bird
who promptly disappears down a muddy hole.[44]

A Hard Day's Night does not reflect society or even the characters
of the Beatles: the film does not acknowledge the lower middle-class
backgrounds of Lennon and McCartney.[45] Like the 'kitchen sink' or
British new wave cycle of the early 1960s, *A Hard Day's Night*
arguably adopts a rather condescending attitude to working-class
characters from provincial England. The much-praised Ringo
sequence offers an example of this tendency and the critical reaction
also displayed an unwittingly patronising attitude towards north-
erners. The style of Ringo's visit to the riverside directly relates to a
similar scene from *Saturday Night and Sunday Morning* (1960)
where the protagonists enjoy an afternoon's fishing by the canal
bank. Lester's film connects back to the 'kitchen sink' cycle not only
through its close investigation of the environment in which the pro-
tagonist is located, but also through its romanticised vision of the
working class. The shots of Ringo at the canal contain similarities
with 'kitchen sink' films featuring what Andrew Higson terms as
'That Long Shot of Our Town from That Hill', in which the camera,
physically and metaphorically, looks down upon the characters in
order to privilege the director's romanticised vision of the industrial
landscape.[46] Starr is entirely passive: a good-natured young man who
resembles 'a tramp with an expensive camera' and 'chats with a
grubby boy as though he'd met him in a Liverpool street'. He sym-
pathises with scruffy kids playing truant from school, because the
film implies that his personality fits into the universal working-class
spirit of community and kinship. This in itself is not necessarily
voyeuristic, but the fact that Lester's direction swoops down on the
characters and their scruffy dress and appearance hints at a roman-
ticised form of fetishism. The scene does not offer intellectual con-
tempt for the milieu inhabited by Starr and the boy, but it presumes
that working-class people look and act in a certain manner.

The Ringo sequence from *A Hard Day's Night* contains an arguably patronising vision of provincials in London. In her consideration of northern media stereotypes, Esther Adams claims that the north is often presented in a quaint manner that makes characters appear as good-natured 'salt of the earth' figures. With regard to the Beatles, their likeable, comic personas and their distinct Scouse accents, complete with phrases such as 'fab' and 'grotty', confirms their status as typically northern comedians. While these are attractive characteristics, locating the Beatles in the tradition of Lancastrian favourites, such as Gracie Fields and George Formby, they also contain some negative connotations. Principally, as Adams argues, this sentimental depiction of the northerner is rooted in the past. The 'salt of the earth' stereotype presents a very limited conception about how northerners act and behave: in this case it restricts Ringo to the status of working-class comedian, and symbol of pity.[47] For example, when he accidently throws a dart in a sandwich and breaks pots in a London pub during his escape, the audience is encouraged to laugh at the drummer. Ringo himself finds the situation bewildering, and a further sign of his isolation from the Beatles and London, yet the north/south conflict is played upon for comic effect.

Hutton's *Melody Maker* comments indicated the extent to which the northern stereotypes were perpetuated by the review material on the film. Starr wears 'a cloth cap', a dress form usually associated with the industrial working class, immediately conjuring up images of the ordinary working man. The drummer also serves as a deferential servant towards his social superiors, through his valiant 'Walter Raleigh' act for a well-dressed young woman in a futile attempt to save her from the mud. These descriptions reveal that London-based commentators believed that working-class northerners behaved and acted in a certain way: Ringo is a good humoured and polite young man, albeit one who knows his place in society. Through making this scene largely silent, Starr remains a sentimentalised and passive figure, an honest reflection of the working-class Scouser without the desire to challenge or alter his position in society. He seemed 'natural' to the critics, solely because of their own assumptions regarding the northern working class being 'honest' and 'human', especially as such mythical characteristics had been perpetuated via the films of Fields and Formby. Critics believed that 'no attempt has been made to disguise the boys' personalities',[48] because they could not contemplate northerners being portrayed on

screen without being comic characters or objects of romanticised cinematic poetry.

Catch Us If You Can is more interested in social commentary based around particular themes than the naturalistic portrayal of a day in the life of the Dave Clark Five. Its exploration of the theme of youth led Sussex to claim that 'though distinctly inspired by the familiar formula, it doesn't deserve to be described as a teenage musical at all'.[49] She rightly recognised the film's roots within the pop musical tradition, yet attempted to distance it from the negative connotations associated with the sub-genre. With its emphasis on the battle between youth and experience *Catch Us If You Can* superficially differs little from earlier pop musicals such as *Play It Cool, A Hard Day's Night* and the Cliff Richard films. In such earlier productions, despite the obligatory happy ending reconciling young and old, adults are often simplistically depicted as unwanted intruders into the teenage culture. One of the central scenes of *A Hard Day's Night* depicts a meeting between George Harrison and an advertising executive who preys upon the latest teenage trends on television, although the Beatle successfully and wittily dismisses this attempt to exploit himself and his generation.

In *Catch Us If You Can* the difference between the generations is presented in a way that critics could appreciate. In the mid-1960s, intellectuals hostile to youth culture, typified by the *New Statesman*'s Paul Johnson, still maintained that pop fans constituted 'a generation enslaved by a commercial machine': they operated as 'fodder for exploitation' by unscrupulous adults eager to capitalise upon the supposed gullibility of young people.[50] Considering this context, the *Monthly Film Bulletin* unsurprisingly appreciated the rather pessimistic attitude towards advertising and the exploitation of youth portrayed in *Catch Us If You Can*. Visually detailed and full of socio-historical interest, the film's *mise-en-scène* perceptively illuminates the film's thematic concerns. Typified by Dinah, memorably described by Zissel's sidekick, Duffle, as 'rootless, classless, kooky, product of affluence', youth appears as energetic, romantic and rebellious. The older generation, symbolised by Zissel and the squabbling middle-aged couple Guy and Nan (Robin Bailey and Yootha Joyce), seem materialistic and petty-minded. At times this binary opposition becomes simplistic: the homes of Action Enterprises Limited, aka the Dave Clark Five, and Guy and Nan operate as rather obvious comparisons between the generations. While the

converted church turned home/gymnasium for the 'stunt boys' features ephemeral decorations for no purpose, the grand Bath residence of Guy and Nan contains antiques for the sake of appearances. As Guy explains, 'we don't do anything . . . we're collectors, we collect'. The converted church serves as a home for parties with dancing, drinking and loud music. Television sets, hi-fi systems, cardboard boxes and advertising ephemera with slogans such as 'Thrills' and 'Ripe and Ready' not only provide the decoration, but also represent a natural part of the youthful environment – a celebration of the trendiness of Swinging London and Pop Art. These decorations appear informal and disorganised rather than as museum pieces. This contrasts with the squabbling and mutual suspicion lurking inside the exclusive residence of Guy and Nan, which resembles a museum or antique shop, cold and impersonal with an emphasis on grandiose decorations rather than household comforts. Among the numerous antiques in the living room alone, there are large portrait paintings from the eighteenth century, chandeliers and a grand piano. Guy's study room contains old Edison gramophones, ancient telephones and movie cameras: in his own words used to describe a photograph of the Epsom Derby from 1908, such ephemera help to 'immortalise the moment'. Boorman's real aim with such images is to demonstrate the generational divide. The young people possess ephemera as a backdrop to their contemporary lives, while Guy and Nan's collection serves solely as decoration. The director demonstrates his preference for the young in two symbolic ways. First, while Guy and Nan are out of shot, presumably squabbling, Steve and Dinah position themselves at the top of the staircase. The young are physically and metaphorically placed upon a pedestal above what Guy calls the 'death-watch beetles' and 'dry rot' of his generation. Second, during a conversation between Dinah and Guy, when he shows off his antique collection, she comments 'isn't it awful how everybody has to grow old and everything get broken?' In reply, Guy sighs that 'young people are callously hopeful': his encounter with Dinah and Steve merely emphasises the dissolution of his own optimism.

The film's other great area of thematic interest lies with its binary opposition between the advertiser and the advertised. Typified by Zissel, a shady character complete with dark glasses and permanently dressed in black, the advertisers lack sentiment or feeling. He claims 'ours is a tasteless business', declaring that 'advertising is not

a game that can be played by the rules. Advertising is total war and must be played by any rules which come to hand'. Accordingly, the film uses Dinah as literally the 'Butcha Girl', a commodity exploitable at any moment. Her image appears superimposed across London, publicising the declaration 'MEAT FOR GO!!' The meat metaphor symbolises her status as a disposable commodity. Throughout her journey, she never manages to overcome the 'Butcha Girl' persona. The artificial character takes precedence over her real identity. In one incident, while Zissel meditates over a tape recording of Dinah discussing the delicacies of roasting beef, her face appears in a succession of poses on a large film screen, from smile to stare to gloom before finally sticking out her tongue. This moment encapsulates the relationship between advertiser and the advertised, exploiter and exploited. Dinah rebels against Zissel's authority, but she finds herself reduced to dissent from a distance, rather in the manner of a spoilt child. Her employer's power is challenged, but never fully destroyed as indicated by the film's ending which separates the two youthful protagonists. Dinah walks off with Zissel, while Steve is reunited with the rest of the 'stunt boys'.

Such content ensured that critics greeted *Catch Us If You Can* as very different from 'the routine pop musical'.[51] The mixture of satire and visual richness separated the film from the likes of *Play It Cool*. In the earlier film, the generational divide between Ann and her father is evident (it partly explains why she's sent away from England), but also left underdeveloped within the plot. As explained earlier, the Fury vehicle is visually poor, showing little idea about how *mise-en-scène* can enhance the overall theme and mood of a film.

Despite its artistic strengths, the content of *Catch Us If You Can* coincided with the era's dominant critical discourses. The film not only presented a black comedy attacking adults attempting to exploit the vitality of the young, but also its satirical message coincided with the contemporary belief that advertisers sought to poison the young with various gimmicks. Although the movie adopts a sympathetic and romanticised vision of the young, especially when compared to their elders like Zissel, it ironically provides a fictional endorsement of Johnson's belief that 'behind this image of 'youth', there are, evidently, some shrewd older folk at work'.[52] The reason why the *Monthly Film Bulletin* and *Films and Filming* accepted the film lies in the fact that they agreed with its satirical message, espe-

cially as they could sympathise with Boorman's attempts to capture the moment. As the comments of Sussex and Bean indicated, *Catch Us If You Can* provided the sort of 'intelligent expression for a youthful point of view' that appealed to critics:

> What it does is to try and find an identity for youth, and latches onto a youthful romanticism . . . The scenes with her boss have a Pinteresque quality in both writing and visual approach, particularly as he muses over slides of his 'meat girl' thinking where she might head for . . . They are cold, clinical, detached, emotionless . . . and cutting. The frightening antithesis of romanticism. His earlier description of the girl as being typical of youth now – 'rootless, classless, kookie' is apt in context with the film, a simple summing up of something which at the moment seems indefinable. Rootless, classless, yes; kookie in the sense of the things they surround themselves with the 'ripe and ready' and '3d' boards pinned over the boys' beds, the 'Are you the Fairy Snow man?' response to the intruder.
>
> It remains a mood that is intangible, listless, changing, warily uncertain. Director John Boorman, this is his first feature film, combining all these elements, comes so close to capturing the mood perfectly.[53]
>
> The presentation of the middle-aged characters as all essentially preying upon the young is part of the imperfect, gimmick-ridden world of half-measures and sometimes vicious compromises that youth discovers in the way of life of the older generation.[54]

Star image and critical distinction

If the *Monthly Film Bulletin* and *Films and Filming* devoted attention to the technical and formal processes involved in film production, the music press and film fan magazines bequeathed little space to details about direction or realism, except to enhance the status of the stars.

Clark suffered a great deal of patronising criticism, which continued in later summaries of the film. *Catch Us If You Can*'s scriptwriter, Peter Nichols, described the group as 'untalented amateurs . . . [who] couldn't learn the lines', while David Thomson congratulates Boorman for 'his circumscribing of the band's evident lack of acting talent'. Other commentators, such as Dilys Powell and Robert Murphy, have branded the Dave Clark Five's performances as 'without much dash' and 'dull'.[55] Sussex considered that 'the performances of the young people are for the most part negligible',[56] while Bean explicitly attributed the film's flaws to its pop star lead

actor: 'However there seems to be one fragment missing to make it work completely. Possibly it is in the handling of Dave Clark, in that [the film's producers] have deliberately evaded being introspective with his character. It may have been wariness over his limitations as an actor, as this is his first film.'[57]

Although Bean did not imply that Clark's acting was responsible for the film's flaws, by simply drawing attention to the star's performance, the critic subtly blamed the pop idol. Would he have made similar comments had a professional actor played the part of Steve? His views contrasted with those of *Record Mail*'s Norman Divall, who stated that 'Dave has the leading part in the film and makes a very good job of it. I can see this young man following the success of other pop artistes who have made big names for themselves in the film world.'[58] While EMI offered a glowing tribute to one of their top stars, Bean suggested that the film improved with the phasing out of the group from the narrative. His comments revealed contempt for the role of the Dave Clark Five and a dislike of zaniness, one of the crucial aspects of any 1960s pop movie required to obtain fan interest:

> In its early moments the film leaves one with an uneasy feeling. The dialogue tries to be both natural and amusing, without succeeding at either, as they are out of key with the subsequent mood in which the film is submerged. Having the stunt group going through the presumably routine procedure of getting up, the morning jog around the green, the mechanical rocking on some contraption in a kiddies playground, the pop-flakes-and-eggs comments over breakfast . . . The result is guardedly cynical, hesitantly humorous, uneasily awkward. But from here on the film slips into its mood, a rapid montage around London, the getaway, the flight to 'freedom' . . .[59]

Bean's comments were unfair. Not only did the Dave Clark Five hardly deserve censure for faults beyond their control (they could not have been omitted from their own film vehicle!), but also the critic failed to understand the opening sequences as a contribution to the packaging of the film as a pop musical. This was evident with regards to the consolidation of the group's identity and the issue of zaniness. The entire scene makes Bean's claim that the film 'does not try to expand or exploit an image . . . [or] fall back on zaniness' look rather hollow.[60]

The film's opening sequence manipulates and extends the macho image of the Dave Clark Five as symbols of healthy, vibrant youth.

Essentially Clark played himself in the film. The star's previous occupation as a film stuntman had been well documented by the fan magazines and the music press since the group's arrival on the national pop scene in 1963. Fans would almost certainly known that 'Dave Clark – pop star' also masqueraded as 'Dave Clark – film stuntman'.[61] The construction of a genuine group personality comprised a crucial marketing and image tool in 1960s pop music. Liz Jobey's comments relating to the production of photographic images can easily be extended to pop films of the era:

> Happy, smiley, clean-looking young men who all seem to be having a wonderful time in front of the camera. In those days photographers complied with a house rule that said that a group should be photographed *as a group* – and that no one member should be singled out. It was later, in response to fan-demand that individuals were celebrated by their own pin-up portraits. [italics in original][62]

The opening scene of *Catch Us If You Can* certainly corresponds to the above definition. This sequence expands upon the Dave Clark Five's image as representatives of youthful vitality. The stuntmen, i.e. the Dave Clark Five, are seen waking up before, almost immediately, launching themselves into a vigorous morning workout via a visual galaxy of fitness equipment. Throughout the frantic opening sequence, lasting less than three minutes, to the accompaniment of the ferociously energetic theme tune, the group visually and musically establish themselves as the epitome of youthful vibrancy. Steve lifts weights, spars with a punchball and performs press-ups on a climbing frame. To acknowledge the band's collective identity, the opening scene features shots of the other stunt boys and group members – Mike Smith, Lenny Davidson, Rick Huxley and Denis Peyton. This illustrates the group's obvious delight and their 'wonderful time' obtained through activities such as trampolining. Shortly afterwards the gang embark upon an early winter morning jog, occasionally stopping for a quick ride on the swings and roundabouts. The scene reinforces the group identity of the Dave Clark Five, fulfilling the desire of the film's producers and the group to exploit their healthy stuntmen image to its maximum commercial and creative potential. The Dave Clark Five are, literally and metaphorically, Action Enterprises Limited, a business dedicated to the pursuit of the healthy and clean-living youth on and off screen.

A review of the photographic material found within the fan magazines and annuals which accompanied *Catch Us If You Can* upon

its initial release reveals the extent to which the film consolidated the group's image. A common denominator revolved around the exploitation of images of the band and Barbara Ferris as symbols of youthful vitality. Although the movie strongly criticises the commercial exploitation of youth for profit by a manipulative older generation, ironically the film's own publicity implemented similar practices. Particular concern revolved around Clark's macho image, which *Photoplay* described in a behind the scenes report: 'Tall, tanned, fit and muscular from the day's gymnasium session – the boys are all ardent keep-fit enthusiasts – he had a tan that belied the cloudy day and a smile as big as his bank manager's'.[63]

The publication of various photographs from the set strengthened this image. For example, pictures of the Dave Clark Five involved in exercises, especially trampolining and skin diving, featured in *Photoplay*, *Record Mail* and *Melody Maker*. This situation corresponded with the cinematic text of *Catch Us If You Can*, particularly the early scenes of the film. The film and journalistic representations both sought the same objective, namely the expansion of the group's image associated 'having a wonderful time'. Figure 6, depicting trampolining, originates from the same set of photographs published in the *Star T.V. & Film Annual 1966* that featured in Figure 5.

6 Zaniness and the pop film: still from *Catch Us If You Can*

Originally printed in colour, it contains only the slightest difference to a picture that featured in *Photoplay*'s behind the scenes report. Obviously taken from the same reel of photographs, the group is seen wearing the same clothes as in the magazine picture. Figure 6 provides a colourful example of the images projected on the screen, principally reinforcing the group's collective identity and clean image.[64] On paper and on screen, the cinematic and journalistic texts unite to perform exactly what Bean claimed the film did not attempt: they meld together to 'expand and exploit' existing discourses concerning the image of the Dave Clark Five as symbols of energetic, clean-living modern youth.

The beginning of *Catch Us If You Can* also helps to explain the concept of zaniness. Although Bean believed that the film did not rely on this idea, it seems central to the movie and its attendant publicity. Principally associated with Lester's Beatles pictures, zany musical comedy became synonymous with quick-witted puns and frantic direction. Often an emphasis on pure novelty value emerged as a useful comic tool: for example, in one scene from *A Hard Day's Night*, John Lennon plays toy battleships with a fake Goons-style German accent in the hotel bath, while still wearing the trademark cap that he wears throughout the film. Such images not only entertained, but also offered the opportunity for young fans to witness their heroes engaging in childlike or unusual comic situations. The publicity photographs accompanying *Catch Us If You Can* demonstrated these requirements in an unusual, yet humorous way. Figure 6 exemplified the commercial motivation behind zaniness and its value to young audiences, because it encouraged people to think about how and why the group adopted such a pose in publicity photographs. Such stills might been artificial, but linked to review material they raised interest among potential viewers. For example, *Record Mail*'s review was accompanied with a photograph of the group dressed up in fancy dress. Among fans this could have raised such questions as why are the Dave Clark Five dressed up as film stars in fancy dress? What causes the group to appear in comic and zany situations in the photographs and presumably the film? What justification did Divall have for describing the 'fancy-dress party' as 'among the funniest scenes I have ever seen on film'?[65] Did the film really mark the debut performance of a pop star (Clark) with the potential to match the cinematic success of Cliff Richard, Elvis Presley and the Beatles as Divall assumed?

The above questions indicate the sort of issues that could have circulated amongst Dave Clark Fans at the time of the film's release. The photographs and descriptive narrative accounts of *Catch Us If You Can* did not adopt a stirring critique of the film as a work of cinema, but they were not intended to serve that purpose. Instead they provide an insight into the core priorities of the group's audience and promoters. They existed as a lifestyle guide offering a flavour of the entertainment evident in the film. The opening scene of *Catch Us If You Can* and the film's contemporary publicity within fan publications expected an understanding of the key cultural codes surrounding the image of the Dave Clark Five from the movie's intended audience. The material related to the band's stunt man image granted a special status of cultural distinction upon those fans who possessed a detailed knowledge about the group's history and star image. Bean's failure to appreciate the significance that the movie placed upon the Dave Clark Five's image hinted that elite critics possessed very little knowledge of the cultural codes that meant a great deal to the fan community. Just as the fan publications marginalised Boorman, the elite film magazines remained unable to appreciate the role of the Dave Clark Five.

According to John Fiske, one of the most notable aspects of fandom is based around the oral culture known as 'enunciative productivity'.[66] Through this concept the language and talk produced by fans relating to their favourite stars contributes towards their discussions in everyday life. This spoken culture plays a particularly important role within school and work providing a form of mutual strength and support network around areas of common interest. In the context of *Catch Us If You Can*, the questions raised above offer an indication of the queries and dialogue that could have been prompted by such publicity material. The photographs may not actually provide an example of criticism, but they might easily have comprised the basis of pleasurable conversations in potentially intimidating environments, particularly at school.

Regardless of their value for an examination of the Dave Clark Five, Fiske's ideas achieve greater significance when attached to *A Hard Day's Night*. Given the Beatles' status as the biggest stars in the world during the mid-1960s, the information published by popular sources would surely have enriched the cultural location of their fans. This not only emerged via oral culture, but also through 'capital accumulation'.[67] According to Fiske, dedicated fans attempt to

obtain as much insight into their favourite stars as possible, leading
to a process of popular cultural 'capital accumulation' which sepa-
rates fans according their varying degrees of passion for their heroes.

Clearly, much of the information originating from fan-orientated
publications surrounding *A Hard Day's Night* was calculated to
enhance the interest of fans. Gray's *NME* review provided a useful
example in this instance. His comments were rather conservative,
concentrating upon the Beatles' comic abilities as a sign of their suit-
ability for light entertainment. Yet, Gray also performed a valuable
service to his readers and Beatle fans, by paying attention to the
songs and noting the exact spot where the musical interludes
occurred. For example, during the early sequence in the train with
Paul's grandfather (Wilfred Brambell), he wrote that 'Grandpa goes
wild with a lady and has to be locked in the luggage van, where the
boys join him and sing "I Should Have Known Better", their first
number after the title song over the credits'.[68] Gray devoted special
interest to the group's comic performance, explaining the plot ram-
ifications and the roles of each Beatle. The zany aspects were singled
out for attention, including Lennon's bathtub scene:

> The Beatles are a hit all over again – as comedians! Screamagers have
> never allowed them to be heard conventionally before. But in their
> debut film, *A Hard Day's Night* . . . they emerge as the most successful
> wacky gagsters, way-out pantomimists and a great new comedy team,
> reminiscent of the Marx Brothers and the Goons.
>
> Their on-beat singing is terrific, as always, and they sing several of
> their new numbers twice. Yet it is their off-beat comedy that lifts the
> picture to hit proportions. Fans will be sitting in cinemas from early
> afternoon until late at night, seeing the picture over and over!
>
> Everyone will have to see it twice or more to get all the jet-fast gags.
> There's John Lennon slapping out the sarcasm, Paul McCartney the
> wit, George Harrison the high falutin', intricate phrases, and Ringo
> proving that he can say most by staying silent.
>
> Apart from the verbal barrier, there are many visual gags, like the
> romp in a field, when they scamper around and wrestle each other, the
> whole thing being filmed from a helicopter with hilarious results. Or
> John Lennon in a foam bath, playing submarines and warships, and in
> the end giving the impression that he's gone down the plughole.[69]

Given that in 1964 *NME* boasted that its total readership totalled
one million people, allowing for three readers for 'each copy of the
300,000-plus circulation of this paper', Gray's information poten-

tially contained inestimable value for fans.[70] It would be unsurprising if the information contained within his article contributed to oral discussions in schools, coffee bars, shops and buses. Gray maintained a totally uncritical stance: he failed to debate the 'terrific' quality of the film's soundtrack. However, this strategy facilitated oral fan culture: his descriptive accounts stressed what the fans wanted to read in 1964 – information about stars, story, music and entertainment value rather than extensive detail on Lester's stylistic borrowings from the nouvelle vague. This information almost certainly then filtered back into thousands of conversations occurring every day during the film's initial circulation regarding the Beatles' songs and performances. Gray's approach also permitted the process of 'capital accumulation'. For example, devout Beatles fans probably took pride in being acquainted with individual scenes and pieces of dialogue to separate themselves from those who only possessed a casual knowledge of the film. Gray's article singled out particular highlights of the movie, besides suggesting the necessity of extra viewings in order for full appreciation of its qualities.

A similar recognition of fan culture appeared in *Photoplay*. Even more than Gray's piece or the Dave Clark Five material, there is evidence about 'the sexualisation of childhood', aimed at girls in their early or pre-teens. Miriam Akhtar and Steve Humphries write that:

> Children of eleven, twelve and thirteen . . . wanted to dress fashionably and, in the case of girls, to wear make-up. They wanted to be more independent and have boyfriends and girlfriends like their older brothers and sisters. The new music and fashion industries increasingly saw children as a market for their sexualised products and reached them through the new pop music programmes on radio and television, and through teen magazines like *Jackie*, *Honey* and *Boyfriend*.[71]

Much of the Beatles' initial appeal to female fans, like that of Presley, was sexual. Writing about the scenes of screaming at the height of Beatlemania, Barbara Ehrenreich, Elizabeth Hess and Gloria Jacobs claim that such fan behaviour can be seen as an unconscious revolt against the restrictive standards of morality imposed upon girls during the 1950s and 1960s: 'To abandon control – to scream, faint, dash about in mobs – was, in form if not in conscious intent, to protest the sexual repressiveness, the rigid double standard of female teen culture. It was the first and most dramatic uprising of *women's* sexual revolution (italics in original).[72]

These claims are exaggerated in that girls were still expected to be the moral guardians of teenage life, and the Beatles' popularity did nothing to alter this situation. Equally the 'sexual revolution' allegedly encouraged by Beatlemania had potentially greater risk for women compared to their male counterparts: with greater liberation there was also an increased risk of pregnancy and sexual disease. However, Beatlemania was part of an ongoing process in which male pop stars were presented as suitably clean-cut romantic idols for young women. To this extent, their image was presented along the boundaries established by artists such as Elvis Presley and Cliff Richard. A *Photoplay* article from 1964 provides the best example of this tendency, an example of the romantic appeal of many teen idols to their female fans. Here an extra on the film, Tina Williams, described a 'dream come true' after 'I heard that I was one of the girls chosen to make a film with those fabulous Beatles.'[73] The entire article showed the Beatles and their forthcoming film in a hagiographic light, but this also indicated the importance of Williams's piece. She presented a privileged eye-view account of the Beatles' film, devoting attention to their personas in real-life and on screen. Accordingly, Starr lent her money after she accidentally forgot to bring any along to the shoot, while Harrison apparently was 'so rugged looking . . . even more so in person than his picture'.[74] She disclosed secret information about the film's story, particularly with regards to the roles of the Beatles. Like Gray, Williams chiefly concentrated upon the comic and zany elements of the film, emphasising the guaranteed laughs that the movie entailed: 'Ringo also has some very amusing scenes, where he goes into a pub and everything goes wrong for him. He wants so much to join in on the fun that everybody else is having but things don't work out that way. At one point he joins in a game of darts and one of the darts lands up in between somebody's sandwich.'[75]

Ultimately the chief importance of Williams' contribution lay in the fact that she wrote from the standpoint of a teenage Beatle fan. The glowing praise for the personalities and performances of her idols should appear as no surprise: she demonstrated how the romance stories of girls' comic books could come true. Throughout she used the heavily romanticised language of teenage magazines, claiming that 'I really did have the time of my life working with them' and that 'the film is an experience I'll never forget'.[76] Williams lived out the dream that millions of young women desired in 1964: a chance to work closely with the Beatles:

It was almost like a dream come true. In fact it was, the morning I heard that I was one of the girls chosen to make a film with those fabulous Beatles.

How did it all start?

Well, as a student of the Aida Foster School I was asked to attend an audition with the producer, director and casting director of the film. But when I saw the number of girls on a list who were also to be auditioned, well I gave up all hopes of getting the job.

. . . At the film company's plush Mayfair headquarters I was shown into the producer's office. I was asked all sorts of questions – 'What work had I done before?' 'Did I like The Beatles?' Just ordinary questions. And that was that! That was until the morning I heard that I had been given the role. I couldn't believe it!

. . .at last they burst into our compartment.

'Hello girls!' they all shouted. Well I was just dumb-struck for a second. I couldn't say anything.

They all looked great, especially Paul. He's so handsome when you meet him face to face. Almost immediately I found myself talking to Paul, George, John and Ringo, as though I'd known them for a long, long, time. It's the way they make you feel. They're so warm and friendly. I thought that perhaps they wouldn't talk to us, except in the scenes we play with them, but this wasn't so. They have no 'big star' temperament at all. They are just four ordinary fellas who enjoy life. And they proved to be so much fun. We were to spend the whole day with them and another day at Twickenham studios. We had lunch and tea with them on the train and both meals were quite a riot. You know it's almost impossible not to roar your head off when you're in their company. The jokes seem to flow all the time. These two days were really the craziest I have ever spent.[77]

Conspicuously, Williams' stage school links, via the Aida Foster School, were not elaborated. Instead her writing and appearance (throughout the pictures accompanying the article she wore the school uniform appropriate to her role as one of the schoolgirls who meet the Beatles on a train) made her resemble a typical teenager. Indeed, Ehrenreich *et al.* argue that the appeal of the unapproachable male hero was 'that you would *never* marry him; the romance would never end in the tedium of marriage . . . Adulation of the male star was a way to express sexual yearnings that would normally be pressed into the service of popularity or simply repressed' (italics in original).[78] It does not take much imagination to realise that her real-life experiences could easily have prompted much envious conversation among Beatle fans, while even her commentary might have been

replicated through individuals writing their own similar stories. Fiske describes the latter process of 'textual productivity' as providing an opportunity for fans to 'produce and circulate among themselves' various texts connected to their own fan community. As such texts are produced to demonstrate devotion rather than economic profit, they retain a centrality within the localised and often transitory fan culture.[79] Williams presented the fan dream come to life, a romantic legitimation of the dreams possessed by her contemporaries. Therefore, the article serves as an excellent example regarding how the fan magazines potentially enhanced the ordinary lives of their readers.

Conclusion – the decline of the British pop musical

In his review of *A Hard Day's Night*, Nowell-Smith maintained that despite the film's virtues, 'there is a lot of British B-Picture badness about it which could and should have been eliminated'. Much of the 'mediocrity' of the film lay within 'the formula, which is designed to protect the protagonists from themselves and against the consequences of being either too funny or too sad too long'.[80] These comments referred to the movie's leanings towards family entertainment, most evident through the casting of the comedy actor Wilfred Brambell as McCartney's grandfather, but also to the actual methods of production that the film encapsulated. His comments typified two crucial strands connected with elite criticism towards British pop musicals. If critics associated the light entertainment tradition with 'B-Picture badness', besides believing that the actual 'formula' of the sub-genre seemed ingrained with 'mediocrity', then the British pop film was doomed to critical failure.

Durgnat's contemptuous tone towards *Play It Cool* and the *Monthly Film Bulletin*'s dismissals of *What a Crazy World* and *Beat Girl* represented the prevalent attitudes towards pop films. Agency existed for critical deviation: Robinson's critique of Steele being the most conspicuous example, but this case study also illustrates that criticism operated within the cultural and social climate of its time. Had *The Tommy Steele Story* appeared five years later, its realism would probably have been deemed passé in the light of the British new wave: this scenario being the fate of *What a Crazy World*, which shares the London working-class milieu of the earlier film.

A Hard Day's Night, Help! and *Catch Us If You Can* represented obvious attempts to enhance the artistic status of the pop musical.

Through their numerous references to European art-house cinema alongside British pop performers, these three films contain an uneasy schizophrenic quality. Although *A Hard Day's Night* and *Help!* proved to be major box-office successes, *Catch Us If You Can* was overshadowed by the simultaneously released Beatles' second film. As the extensive fan-related material indicates, these pictures still possessed many attributes appealing to their respective audiences, but the question remains whether the musicians themselves remained satisfied by the results. At a time of enormous socio-cultural changes was it ever possible to balance the light entertainment tradition, typified by *A Hard Day's Night*'s use of Brambell, with the same film's artistic debt to art-house cinema?

A Hard Day's Night illustrated the difficulties in reconciling the interests of musicians, directors and the youthful audience within the confines of conservative family entertainment. As early as 1963, the Beatles expressed their dislike of the narrow artistic ambitions imposed by the structures of British show business. John Lennon stated that 'We don't want to learn to dance or take elocution lessons':[81]

> Well, first of all, we're not going to fizzle out in half a day. But afterwards I'm not going to change into a tap-dancing musical. I'll just develop what I'm doing at the moment, although whatever I'll say now I'll change my mind next week. I mean, we all know that bit about it won't be the same when you're twenty five. I couldn't care less. This isn't show business. This is something else. This is different from anything that anybody imagines. You don't go on from this. You do this and you finish.[82]

Lennon's comments expressed the sentiments of many of his contemporaries; the greatest British rock acts of the 1960s desired to concentrate upon their musical progression rather than pursue careers as family entertainers. An important reason for the demise of the pop musical lay with the anti-show business/light entertainment position adopted by many of the post-Beatles rhythm'n'blues-inspired, acts that operated at the forefront of mid-1960s British music. The likes of the Rolling Stones and the Who were rock rather than pop acts, whose loud music and rebellious image sat uneasily with British light entertainment. The Stones' manager, Andrew Loog Oldham, even described the band's 1965 single 'Get Off My Cloud' as 'the dividing line between art and commerce', a statement which Cliff Richard's promoters would never have made.[83]

Although the Beatles appeared in two major pop films, the acts that followed them took Lennon's distaste of traditional show business to its logical conclusion. Unsurprisingly, the Stones, the Who and the Kinks all failed to appear in a British pop musical during the mid-1960s. When Mick Jagger finally appeared in a British feature film (*Performance*), this venture emerged as the antithesis of *Summer Holiday*.

These developments in popular music spelt the end for the British pop musical. The Beatles apart, the sub-genre became associated with the 'squarer' acts of the era. Peter Laurie explains that by 1964 scholars of teenage culture could 'identify the old-fashioned groups by their use of a leaders' name'. Typified by acts such as Gerry and the Pacemakers, Freddie and the Dreamers and the Dave Clark Five, Laurie felt that 'a reasonably acute student of pop [could] identify these without hesitation as the squarer groups'.[84] Representing an older musical style, these acts fitted much easier into existing light entertainment paradigms than the likes of the Stones. Naturally, these acts also largely comprised the 1960s beat groups who made feature films: *Catch Us If You Can*, Freddie and the Dreamers in *Every Day Is a Holiday* and Gerry and the Pacemakers in *Ferry Cross the Mersey* (both 1964). Both Gerry Marsden and Freddie Garrity belonged to the Tommy Steele tradition of working-class pop star whose act blended pop with music hall-influenced comedy. Such a distinction made the pop film obsolete in the age of 'Satisfaction' and 'My Generation'.

A result of the pop musical's roots in light entertainment meant that concessions needed to occur within the film text in order to appease the widest possible audience. The zaniness of *Catch Us If You Can* and *A Hard Day's Night*, together with the Hollywood-style routines of Cliff and Presley movies undoubtedly succeeded in this way. However, such pleasures disguised an increasingly frag-mented audience, as Cliff admitted in 1965: 'I do think that [the Shadows and I] have moved out of the 12-year-old audience now. I believe that people aged, say 12, 13 and 14 go for the Beatles and the Rolling Stones and the other groups now, while the audience for the Shadows and me are from three to nine and then from 17 and 18 onwards.'[85]

Significantly Cliff believed that he had lost the teenage audience; instead the youngsters looked for musical acts in 'their own age group'.[86] This audience fragmentation needs qualification: estimates

from 1964 calculated the average age of Stones' fan club members at nine-years-old.[87] Yet it became increasingly obvious that the monolithic teenage audience did not exist in the mid-1960s. Just as pop acts, such as Herman's Hermits, became synonymous with making music for 'teeny boppers' and the more rebellious performers, typified by the Stones, with older rock audiences, the cinema adapted to the increasing divide among young people's cinematic tastes through producing movies with a youthful edge but not aimed at family audiences. A good example occurs with Michael Winner's *The System* (1964), which had a theme song by the Liverpool group, the Searchers. Based upon the premise of a group of young men attempting to arrange dates with female holidaymakers, this film gathered extensive attention from *Photoplay*. Numerous profiles of the film, its star Oliver Reed and a lengthy serialisation of the plot featured, with special emphasis placed upon the movie's youth appeal and risqué attitude towards sexual morality.[88]

Coinciding with the increasing distance between the pop film, musicians and social change lay an evident apathy among aficionados for the form. This disillusionment became evident from 1963 onwards, as fans began to complain to the press about the banality of pop musicals. To principally appeal to the pre-teen family market only succeeded in alienating older teenage fans, often with disposable income, who felt that pop movies insulted their intelligence. This situation posed a problem that the British pop musical never managed to overcome, therefore contributing to its own demise. For example, *NME* reader David Gillard complained about the childish revue style format of *Just For Fun*:

> Do film producers today think that teenagers are just a lot of backward kids? I have just seen the latest pop film offering *Just For Fun*. The songs and singers were great, but the story and jokes were plain-pathetic.
>
> With worn-out gags like water squirting out of a telephone into a man's face, I began to wonder if I'd walked into the Saturday morning children's performance by mistake![89]

Similar comments featured in the complaint of an Oxford University student, F. Robinson, whose views differed only slightly from the critics at the *Monthly Film Bulletin*: 'Can't some effort be made to produce a pop film with some imagination, which will not be an insult to the intelligence?'[90]

A specific example of fan disillusionment occurred with *Catch Us If You Can*. In a *Melody Maker* letter, a dedicated Dave Clark Five enthusiast from the group's home patch of Tottenham, Carol Mitchell, expressed discontent with the film and the pop musical tradition:

> Can someone please tell me why good pop groups have to fall over themselves in the rush to make a film the minute they have a couple of hits on their hands.
> The D.C.5. are the latest and having just seen *Catch Us If You Can* I can only say, as a Five fan of long standing, that I wish they'd never done it.
> They are great pop stars, but film stars, never!
> So please let's have more good singles and LPs and less mediocre films.[91]

If a partial fan felt embarrassed by the film, then the Dave Clark Five's cinematic venture obviously possessed problems in appealing to even devoted supporters of the group. Mitchell's comments revealed interesting trends regarding fan's attitudes towards mid-1960s pop films, showing distrust for the formula. Many fans felt saturated by supposedly second-rate films made without concern for the long-term career of pop performers. The letter also implied a dislike of the zaniness required to reach the family audience. The group dressed up in drag and playing in a children's playground seemingly distracted from their musical strengths. The film painfully exposes the group's acting inexperience: Clark seems wooden besides his fellow actors, while the remaining group members barely speak throughout the film – guitarist Lenny Davidson never utters a word. Evidently, the assumption that pop music and film comprised separate spheres of entertainment influenced many young people. Critical disapproval had always existed for the pop film, but the wider dissemination of such cynicism to the teenage audience ended the effective shelf life of the sub-genre.

However, as Medhurst argues, the primary reason for the mid-1960s demise of the British pop film 'lay outside the specific formal evolution of the genre'.[92] From *6.5 Special* and *Oh Boy!* in the late 1950s, television served as the key medium for bringing British pop performers to a wider public. Nearly every British chart act of the late 1950s owed some debt to early televisual appearances, whether Steele on *6.5 Special* or Cliff on *Oh Boy!* The greatest British pop programme, ITV's *Ready, Steady, Go!* started broadcasting in 1963,

helped to undermine the pop musical's credibility with fashionable teenagers through its connections with the mod subculture.

This ensured that the show offered 'more than just a TV programme'.[93] *Ready, Steady, Go!* not only disseminated mod to a wider audience but also, unlike the British pop musical, the show programmed trends rather than responding to cultural and social changes among the teenage public. Fashionwise, clothes and sets regularly were based around Pop/Op art designs, contributing to the show's zeitgeist feel. The show's role as a lifestyle guide also occurred with regards to popular music. Several key acts of the era, for example the Stones and the Kinks, obtained their 'first big break on the show'. The programme boasted that only three chart toppers from the past year did not receive their first recognition on *Ready, Steady, Go!*[94] Besides providing a crucial outlet for the British rhythm'n'blues-inspired acts, *Ready, Steady, Go!* encouraged American blues and soul music that had previously been largely neglected on screen either on television or via celluloid. While the British pop film largely lagged behind current taste by several months, youth television set the trends with regards to the best forms of popular music available. Considering the constantly evolving nature of British popular music during the mid-1960s, this situation ensured the inevitability of the pop film's demise.

Notes

1 A. Smith, 'Question Time With Dave Clark', *NME* (3 September 1965), p. 8.

2 *Ibid.*, p. 8; *Melody Maker* (14 August 1965), p. 16.

3 A. Medhurst, 'It Sort of Happened Here: The Strange, Brief Life of the British Pop Film', in J. Romney and A. Wootton (eds), *Celluloid Jukebox: Popular Music and the Movies Since the 50s* (London: BFI Publishing, 1995), p. 68.

4 R. Silvey and J. Keynon, 'Why People Go the Pictures', *Films and Filming* 11: 9 (June 1965), pp. 4–5, 36.

5 *Ibid.*, p. 5.

6 *Ibid.*

7 *Ibid.*

8 *Ibid.*

9 P. Bourdieu, *Distinction: A Social Critique of the Judgement of Taste*, trans. R. Nice (London: Routledge, 1984), p. 29.

10 C. Hutchins, 'Billy Fury Co-Stars With Anselmo', *NME* (23 April 1965), p. 3.

11 *Ibid.*, p. 2.
12 K. J. Donnelly, *Pop Music in British Cinema* (London: BFI, 2001), p. 14.
13 'Just For You', *Monthly Film Bulletin* 31:367 (August 1964), p. 122.
14 'What a Crazy World', *Monthly Film Bulletin* 30:359 (December 1963), p. 175.
15 R. Durgnat, 'Play It Cool', *Films and Filming* 8:11 (August 1962), p. 29.
16 'Play It Cool', *Monthly Film Bulletin*, 29:342 (July 1962), p. 95.
17 Durgnat. 'Play It Cool', p. 29.
18 C. Hutchins, 'Billy Fury Reveals His Film Set Secrets', *NME* (16 February 1962), p. 10.
19 A. Gray, 'Beatles Great Comics!', *NME* (10 July 1964), p. 3; D. Powell, 'A Hard Day's Night', reprinted in G. Perry (ed.), *The Golden Screen – Fifty Years of Films* (London: Headline, 1989), p. 206.
20 'A Hard Day's Night', *Monthly Film Bulletin*, 31:367 (August 1964), p. 121.
21 G. Nowell-Smith, 'A Hard Day's Night', *Sight and Sound* 33:4 (Autumn 1964), p. 197.
22 B. Neaverson, *The Beatles Movies* (London: Cassell, 1997), p. 120; J. Stokes, *On Screen Rivals: Cinema and Television in the United States and Britain* (London: Macmillan, 1999), p. 122.
23 *Films and Filming*, 11:11 (August 1965), front cover.
24 R. Bean, 'Catch Us If You Can', *Films and Filming* 11:11 (August 1965), p. 28.
25 E. Sussex, 'Catch Us If You Can', *Monthly Film Bulletin* 32:379 (August 1965), p. 118.
26 *Melody Maker* entirely ignored *Catch Us If You Can* except for a photo of Dave Clark and Barbara Ferris dressed in diving suits and a letter from a disappointed fan, Carol Mitchell, complaining about the film. See *Melody Maker* (24 April 1965), p. 5; *Melody Maker* (14 August 1965), p. 16.
27 A. Gray, 'Clark Film Fun', *NME* (2 July 1965), p. 6; N. Divall, 'You Should Catch This One!', *Record Mail* (August 1965), p. 2.
28 Neaverson, *The Beatles Movies*, pp. 15–20; N. Sinyard, *The Films of Richard Lester* (London: Croon Helm, 1985), pp. 20–7; Medhurst, 'It Sort of Happened Here', p. 68; J. Savage, 'Snapshots of the Sixties: Swinging London in Pop Films', *Sight and Sound* (May 1993), reprinted in J. Savage, *Time Travel: From the Sex Pistols to Nirvana: Pop, Media and Sexuality* (London: Vintage, 1996), pp. 302–10.
29 Nowell-Smith, 'A Hard Day's Night', p. 196; 'A Hard Day's Night', *Monthly Film Bulletin*, p. 121.
30 Bean, 'Catch Us If You Can', p. 27.
31 Savage, 'Snapshots of the Sixties', p. 306; P. Kael, 'Having a Wild Weekend', in *Kiss Kiss Bang Bang* (London: Arena, 1987 [1970]), p. 280.

32 Sussex, 'Catch Us If You Can', pp. 118–19.

33 Medhurst, 'It Sort of Happened Here', p. 68.

34 P. French, 'Alphaville of Admass, *Sight and Sound* 35:5 (Summer 1966), p. 111.

35 Hutchins, '"Help!" – but it's just in fun', *NME* (30 July 1965), p. 2.

36 Gray, 'Beatles Great Comics!', p. 3.

37 Gray, 'Clark Film Fun', p. 6; Divall, 'You Should Catch This One!', p. 2; W. H., '"Catch Us If You Can" – On Set With Dave Clark', *Photoplay* (June 1965), pp. 16–17, 69; C. Roberts, 'Dave Clark Five', *Music Echo* (10 April 1965), p. 6.

38 'Pop Locations', in *Star T.V. and Film Annual 1966* (London: Odhams, 1965), p. 41.

39 *Ibid*., pp. 40–1.

40 *Ibid*.

41 P. Mason, 'A Hard Day's Night', *Photoplay* (August 1964), p. 44, 60.

42 M. Ciment, *John Boorman*, trans. Gilbert Adair (London: Faber and Faber, 1986) p. 56.

43 Nowell-Smith, 'A Hard Day's Night', p. 197; 'A Hard Day's Night', *Monthly Film Bulletin*, p. 197.

44 J. Hutton, 'Fab! Fab! Four!', *Melody Maker* (11 July 1964), p. 11.

45 Lennon and McCartney were personally inclined towards European art cinema, typified by Bergman and Fellini. Ringo Starr was the only Beatle not to attend a grammar school. For details about the Beatles' cultural tastes at the time see: P. Norman, *Shout: The True Story of the Beatles* (London: Penguin, 1993), p. 157; M. Braun, *'Love Me Do!' – The Beatles' Progress* (London: Penguin, 1995 [1964]), pp. 25–36.

46 A. Higson, 'Space, Place, Spectacle: Landscape and Townscape in the "Kitchen Sink" Film', in A. Higson (ed.), *Dissolving Views: Key Writings on British Cinema* (London: Cassell, 1996), p. 134.

47 E. Adams, 'Approaches to "the North": Common Myths and Assumptions', in Y. Jewkes and T. O'Sullivan (eds), *Approaches to the North* (London: Arnold, 1997), pp. 110–12.

48 P. Wainwright, 'Those Beatles – A Real Riot', *Record Mail* (August 1964), p. 2.

49 Sussex, 'Catch Us If You Can', 118.

50 P. Johnson, 'The Menace of Beatlism', *New Statesman* (28 February 1964), reprinted in H. Kureishi and J. Savage (eds), *The Faber Book of Pop* (London: Faber and Faber, 1995), p. 197.

51 Bean, 'Catch Us If You Can', p. 27.

52 P. Johnson, 'The Menace of Beatlism', p. 107.

53 Bean, 'Catch Us If You Can', pp. 27–8.

54 Sussex, 'Catch Us If You Can', p. 119.

55 Ciment, *John Boorman*, p. 236; Powell, *The Golden Screen*, p. 216;

R. Murphy, *British Sixties Cinema* (London: BFI Publishing, 1992), p. 137; D. Thomson, 'Catch Us If You Can', in T. Milne (ed.), *The Time Out Film Guide* (London: Penguin, 3rd edn., 1993), p. 113.

56 Sussex, 'Catch Us If You Can', p. 119.
57 Bean, 'Catch Us If You Can', p. 28.
58 Divall, 'You Should Catch This One!', p. 2.
59 Bean, 'Catch Us If You Can', p. 27.
60 *Ibid.*
61 Roberts, 'Dave Clark Five', p. 6; W. H., 'On set with Dave Clark', pp. 17, 69; 'Dave Clark talks about his days as a stuntman', *Photoplay* (May 1964), pp. 24–5, 68.
62 L. Jobey, 'Introduction', in Jobey (ed.), *The End of Innocence: Photographs From the Decades that Defined Pop – the 1950s to the 1970s* (Zurich-Berlin-New York: Scalon, 1997), p. 10.
63 W. H., 'On set with Dave Clark', p. 69.
64 *Ibid.*, p. 17; 'Pop Location', p. 38.
65 Divall, 'You Should Catch This One', p. 2.
66 J. Fiske, 'The Cultural Economy of Fandom', in L. A. Lewis (ed.), *The Adoring Audience: Fan Culture and Popular Media* (London: Routledge, 1992), pp. 37–9.
67 *Ibid.*, pp. 42–3.
68 Gray, 'Beatles Great Comics', p. 3.
69 *Ibid.*
70 'A Million Every Week', *NME* (6 November 1964), p. 6.
71 M. Akhtar and S. Humphries, *The Fifties and Sixties: A Lifestyle Revolution* (London: Boxtree, 2001), p. 30.
72 B. Ehrenreich, E. Hess and G. Jacobs, 'Beatlemania: A Deviant Consumer Subculture?', in K. Gelder and S. Thornton (eds), *The Subcultures Reader* (London: Routledge, 1997), p. 524.
73 T. Williams, 'I Filmed with The Beatles', *Photoplay* (June 1964), p. 23.
74 *Ibid.*, pp. 25, 68.
75 *Ibid.*, p. 68.
76 *Ibid.*
77 *Ibid.*, pp. 23–4.
78 Ehrenreich *et al.*, 'Beatlemania', p. 532.
79 Fiske, 'The Cultural Economy of Fandom', p. 39.
80 Nowell-Smith, 'A Hard Day's Night', p. 197.
81 Braun, '*Love Me Do*', p. 31.
82 *Ibid.*, p. 52.
83 Advert for 'Get Off My Cloud', *Music Echo* (23 October 1965), p. 7. Oldham's attitude towards traditional show business was decidedly ambiguous: for information on his unfulfilled plans to make a pop film

with the Stones refer to his second autobiography, *2Stoned* (London: Secker and Warburg, 2002), pp. 153–70.

84 P. Laurie, *The Teenage Revolution* (London: Anthony Blond, 1965), p. 81.

85 R. Coleman, 'Cliff Close Up', *Melody Maker* (30 January 1965), p. 3.

86 *Ibid.*, p. 3.

87 C. Booker, *The Neophiliacs: A Study in English Life in the Fifties and Sixties* (London: Fontana, 1969), p. 221.

88 'The System', *Photoplay* (April 1964), pp. 28–9; P. Wright, 'The Fascinating Face of Oliver Reed', *Photoplay* (November 1964), pp. 48–50; Wright, 'The System', *Photoplay* (October 1964), pp. 13–14, 26, 51, 61.

89 'From Us To You', *NME* (29 April 1963), n.p.

90 *Melody Maker* (15 May 1965), p. 16.

91 *Melody Maker* (14 August 1965), p. 11.

92 Medhurst, 'It Sort of Happened Here', p. 69.

93 Dawnbarn, 'Ready, Steady, Go!', *Melody Maker* (3 October 1964), pp. 10–11.

94 *Ibid.*, p. 11.

Chapter 7

Conclusion

The pop film since 1965

To pinpoint the death of the pop film to 1965 seems exaggerated. Both Mick Jagger and David Bowie were captured on celluloid at the peak of their careers, in *Performance* and *The Man Who Fell to Earth* (1976) respectively. However, neither of the above productions is a pop film; rather they are dramatic productions starring rock musicians. With *Performance*, Warner Brothers desired a commercial venture modelled upon Presley/Beatles lines, featuring arguably the most charismatic star of his generation. Instead they got an arty confectionery of sex, violence and drugs with very little music.

The clearest sign of the obsolescence of the traditional pop movie format occurred with the emergence of the Monkees. This manufactured band was famously designed for a television series, before achieving musical success. Bob Neaverson argues that the show 'shamelessly exploited the style of the Lester movies (non-diegetic musical numbers interspersed with similar "chase" scenarios), and featured a four-piece "bubblegum" pop group whose coldly manufactured "zaniness" was blatantly modelled on the Beatles' early presentation'.[1] Yet the huge international success of the Monkees hinted that television was more effective than film when it came to launching the career of a previously unknown group. By the time of the inevitable spin-off film, the Monkees' initial popularity had waned, while the group and their director Bob Rafelson were disillusioned with the innocent zaniness of the television show. Instead of depicting the 'prefab four' getting into scrapes over teenage girls and good natured comedy, *Head* (1968) was an uncommercial, psychedelic extravaganza. The Monkees' movie deconstructed the epitome of manufactured pop, rather than exploiting their (fading) teen appeal.

Head's commercial failure, along with its distinctly non-teen pop friendly LSD-style psychedelic colouring, effectively closed the door on the 1960s pop film. If the Monkees could not revive the formula of the Elvis/Cliff style pop musical, then no one else could. Significantly, several of the teenybop acts of the early 1970s, most notably the Jackson Five and the Osmonds, consolidated their musical fame with television shows. This confirmed not only the viability of the Monkees' model, but also that television was more effective than film for publicising such acts. Despite vehicles for 1970s artists such as David Essex (*That'll Be The Day* (1973) and *Stardust* (1974)), Marc Bolan (*Born to Boogie* (1972)) and Slade (*Flame* (1974)), the British pop musical effectively became dormant in the mid-1960s.

The teen movie has never fully disappeared from the production schedules of British and American studios, undergoing significant revivals in subsequent decades. Today the genre comprises one of the dominant forms of commercial Hollywood production, ranging from romantic comedies to horror films. One pivotal difference exists from the teen movies of the 1950s and 1960s, namely the almost total disappearance of the pop star musical as exemplified by the output of Elvis Presley and Cliff Richard since the mid-1960s. Apart from *Grease* (1978) musicals aimed directly at the youth market have been conspicuously absent since Presley stopped making movies in the late 1960s. While the likes of All Saints' *Honest* (2000), Britney Spears' *Cross Roads* and Eminem's *8 Mile* (both 2002) obviously attempt to extend the artistic range of their stars, they are primarily dramatic rather than musical films. They therefore conform to the pattern of pop vehicles since the late 1960s, rather than representing a revival of the traditional rock musical.

However, granted the increasingly commercialised and manufactured nature of British chart music in the age of *Pop Idol* and *Popstars*, some revival of the 1950s/60s pop film should not be ruled out. Already a precedent exists: *Spice World: The Movie* (1997), one of the biggest British international hits of the past decade. Several commentators have emphasised the film's debt to *A Hard Day's Night*; the two films share the themes of escape from overbearing managers/television producers, comic adventures in Swinging/Britpop London and a final triumphant concert.[2] Yet *Spice World: The Movie* aimed largely at pre-teen children: the group's fans in the film are clearly aged under ten years old. Despite blatant plugging for

products advertised by the Spice Girls, such as Pepsi Cola, Polaroid and Walkers Crisps, *Spice World: The Movie* is a profoundly old-fashioned film, explicitly rooted within British light entertainment. A procession of self-serving cameos from the likes of Meat Loaf, Michael Barrymore and Jennifer Saunders co-exists with a flimsy plot, mostly non-diegetic music and song/dance routines. This makes the film resemble, probably unintentionally, a well-budgeted version of the *Play It Cool/Just For Fun* revue formula rather than *A Hard Day's Night*. Despite this point, the signs are that the British pop film might revive with subsequent efforts from All Saints and S Club. Formerly S Club 7, like the Spice Girls protégés of manager Simon Fuller, the latter released their debut film, *Seeing Double* (2003), after three successful Monkees-inspired television shows. However, these ventures into film by British pop idols do not augur well, despite *Spice World*'s financial success. The Spice Girls, All Saints and S Club all self-destructed shortly after their celluloid ventures, perhaps hinting that cinema and teen pop idols do not mix.

The trends outlined at the end of the previous chapter indicated the reasons for the demise of the British pop musical. Equally, apart from the Monkees, no major US pop act of the late 1960s went into the movies. As a prolonged cycle of production, the American pop musical died when the AIP beach movies and Presley films ceased. If the teen movie has continued to thrive, the same does not apply to the musical genre. In many respects the fall and rise of the pop star movie coincided with the gradual extinction of the traditional screen musical. The introduction of pop idols into the conventional film musical reinforced not only the careers of performers such as Presley, Cliff Richard and the Beatles, but also partially disguised the structural and artistic decline of the parent genre. Four decades after their release, *The Young Ones*, *Summer Holiday* and *A Hard Day's Night* remain the most commercially successful British musical comedies ever made. In retrospect, the 1950s and 1960s pop musical represented a transitional mode of entertainment. First, rock-'n'roll teenpics hinted at a musical framework and ideology that ultimately could not be restrained within the confines of traditional show business. Second, the decade 1955–65 almost directly corresponded with the artistic decline of the MGM musical from the mid-1950s onwards and the emergence of the rock soundtrack with *The Graduate* (1967). The pop musical of the 1950s and 1960s served as an intermediary between these two disparate artistic traditions.

Artists faced incorporation into a cinematic form that had entered permanent decline, while the rock soundtrack, which replaced live musical routines with non-diegetic pop and rock songs, had not yet been invented. Through utilising the latest pop sensations in a cinematic format largely incompatible with rock'n'roll, the pop musical simultaneously produced music too extreme for the traditional musical, yet operated in a form of family entertainment too conservative for many rock musicians and fans. The fact that most newly released teen movies acknowledge the power of popular music testifies to the importance of those films that helped to ease the progression from the Hollywood musical to the rock soundtrack era. In this way, the rock movies of the 1950s and 1960s became precedents for commercial cinema for the remainder of the twentieth century and beyond.

Rock movies and the definition of criticism

Considering the centrality of popular music and teen movies to British culture for nearly fifty years, it seems appropriate to briefly reiterate several key hypotheses covered by this research. What warnings do the misconceptions made by commentators during the fifties and sixties have for today's scholars of those decades and critics of present-day youth culture? What implications for work on film criticism does this book raise?

The question whether British cultural and social commentators ever adequately understood young people's cultural tastes provided a consistent theme throughout previous chapters. In the decade covered by this research many of the prevailing intellectual assumptions regarding teenagers and their perceived gullibility remained intact. The *Monthly Film Bulletin*'s critics regularly demonstrated a laughable lack of understanding of contemporary popular music and teenage tastes. Describing *Pop Gear* (1964), a British review film comprised of old newsreel appearances from the Beatles, the Animals and Herman's Hermits, the journal articulated a woeful ignorance at a decade of musical and social change: 'There is a general consistency not only in the long hair styles but also in instrumental make-up: electric guitar, with concerted vocals even if a soloist acts as principal guide and mentor. Pop groups, unlike jazz groups, evidently regard the double bass as expendable . . . The whole thing will no doubt have the teenagers screaming in the aisles.'[3]

In retrospect this unfamiliarity concerning youth culture appears alternately hilarious and disturbing, revealing two key discourses related to elite attitudes towards youth culture. First, as the writings of certain *Melody Maker* critics made clear, many commentators believed that jazz offered an artistically superior form of popular music to rock'n'roll. In this review, jazz's superiority received recognition through jazz musicians' use of the double bass, an acoustic instrument largely absent from pop since the late 1950s. By choosing to remain largely aloof from pop music and teen movies, many elite critics not only revealed their own cultural prejudices, but also their total ignorance of modern youth culture. Second, the *Monthly Film Bulletin* critic displayed a total contempt for the abilities of teenagers to discriminate, as exemplified by the final sentence, suggesting that music fans would consume any old rubbish.

Such commentaries inform the reader more about the cultural preferences of the critic than the values of the teenage audience. The danger for scholars of the pop musical and the teen movie is that such reviews receive attention in future academic studies without being balanced with material from fan-orientated publications. In this sense, Colin MacInnes' comments from 1958 still contain a great deal of validity. As this research has consistently reiterated, the academic researcher cannot obtain a fully comprehensive knowledge about teen movies unless the despised ephemeral sources are deployed:

> I'd like to say I think the abysmal ignorance of educated persons about the popular music of the millions, is deplorable. First, because pop music, on its own low level, can be so good; and I must declare that never have I met anyone, who, condemning it, completely, has turned out on close enquiry, to know anything whatever about it. But worse, because the deaf ear that's turned, in painful disdain, away from pop music betrays a lamentable curiosity about the culture of our country in 1958. For that music *is* our culture . . The point isn't that you've got to like this music, if you can't. It is that, if you don't know it, you lose a clue to what lies behind those myriad faces in the bus and tube – particularly the young ones. [italics in original][4]

Traditionally university libraries and archives have privileged certain kinds of writing on film culture. Even today, *Sight and Sound* is more likely to be found in higher education institutions than *Empire*, disguising the fact that numerous contributors write for both publications. On the subject of teen films, this situation is

potentially dangerous. Regardless of *Sight and Sound*'s BFI affiliations and analytical writings, the magazine can not cover the genre in the sympathetic manner that a publication aimed at teen audiences can achieve. As with other forms of cult media, the rock movie is best examined via a combination of appropriate critical material. This necessitates studying diverse discourses, regardless of perceived intellectual prestige. This book could not have been written solely reliant on the archives of *Sight and Sound*, *the Monthly Film Bulletin* and *Films and Filming*. Such information has proved illuminating, containing valuable insights into the nature of film criticism and cultural values. However, given the ambiguous attitude towards popular culture evident in much of the writing in these magazines, they have severe limitations when studying 1950s/60s rock movies. First, the sociological preoccupation of the BFI publications, although politically progressive, blinded critics from experiencing the full qualities of films that failed to meet expectations of realism. Ironically *Sight and Sound*'s political left/liberalism indicated a political commitment to film criticism arguably missing in 1960's auteurism and *mise-en-scène* analysis. Second, unlike the music press or film fan magazines, the likes of *Sight and Sound* did not directly need the teenage consumer: they provide scant information on how pop films were promoted to their intended audience compared to *NME* or *Picturegoer*. Third, the publications aimed at teenagers have greater historical value for explaining how pop films and their stars were consumed by viewers.

In these circumstances, I reiterate my comments from chapter 1; namely that 'film criticism' has frequently failed to negotiate source material that does not meet certain academic or literary standards. Not only does this limit our understanding on how popular cinema is produced, marketed and consumed, but it also privileges publications, like *Sight and Sound*, with an educational remit. This does not mean that I deny the differences in emphasis between various sections of the music or film press, but rather that our understanding of what the academy defines as 'criticism' contains severe limitations. What stands as 'film criticism' on university modules represents a small selection of valuable writing on film, a position that is clearly untenable as Film Studies starts to treat popular cinema and cult films with greater seriousness.

Certain key theoretical assumptions also emerge from this project. First, an understanding of the specific historical conditions that

coincided with a particular film's release remains paramount for any study of review materials. Staiger writes that: 'Readers do not just "decode" hegemonic texts; readers are complex historical individuals capable of acting within the contradictions of their own construction as selves and as reading selves. Readers are developed historically, and the interpretitive event occurs at the intersection of multiple determinations. Thus, the *interpretation is contradictory and not coherent*' (italics in original).[5]

Several of the reviews contained within this research might appear surprising on first acquaintance. The enthusiasm of the *Monthly Film Bulletin*'s critics for *The Tommy Steele Story* and *Catch Us If You Can* provided the best examples of elite critics embracing youth culture. Equally the populist *Picturegoer* initially expressed extreme hostility to American rock'n'roll movies. It is not possible to generalise about the critical positions adopted by particular publications without a thorough examination of the historical context inhabited by contemporary commentators. To avoid dangerous assumptions about critics and their publications, it becomes necessary to consider the full range of social, cultural and political factors that could easily have influenced reviewers. For example, chapter 4 explained how to understand the reaction to the American rock'n'roll movies it becomes vital to consider critical attitudes towards Americanisation, the Hollywood musical, the changing nature of commercial film production, moral fears over juvenile delinquency and the issue of declining cultural standards. A detailed knowledge of the complexity of the review material is only available through rigorous historical scrutiny.

Second, although many of the discourses might appear contradictory certain discernible and consistent trends were maintained over the decade covered by this research. Several points related to Bourdieu's theories were consistently echoed throughout various chapters. Certain taste formations might appear contradictory to today's researchers, but the actual stances adopted by particular critics and their stars emerged in a rather predictable manner given the historical circumstances influencing the initial critical discourses. Within their distinct fields of cultural production, commentators from elite and popular publications classified films and stars according to their existing critical values. To adopt Bourdieu's comments, the critical success or failure of particular films among the discerning elite always depended upon 'implicit' references to the cinematic canon,

those 'typical works' that represented the best examples of popular film. Rock movies were 'consciously or unconsciously' approved or condemned because they either endorsed or refused 'the qualities more or less explicitly recognized as pertinent in a given system of classification'.[6] Those works that directly opposed the critics' cultural values faced inevitable condemnation. The reactions to Pat Boone and Elvis Presley indicate that a similar correspondence between critical values and cultural taste also existed at popular publications such as *Picturegoer* and *Melody Maker*.

Third, this research argues that the presumed binary opposition between 'elite' and 'popular' critics and publications actually succeeds in disguising the similarities among a diverse range of commentators. Through utilising Bourdieu's work on field theory, this project suggests that although operating in diverse fields of production elite and popular critics did occasionally concur. The use of field theory ensured that simplistic assumptions claiming that the critical elite opposed every film endorsed by the fan magazines and the music press were avoided. A key idea related to the diverse positions adopted by commentators writing in different fields of production did emerge from this study. All writers and publications adopted their editorial stance to meet the expectations and cultural leanings of their presumed readership. *Sight and Sound* and the *Monthly Film Bulletin*, as distinguished publications intended for a minority readership, well-endowed with cultural and educational capital, presumed that their clientele possessed sufficient knowledge to understand the technicalities of the cinema. Their occasionally 'esoteric' and 'abstract' references to script, direction, realism and cinema history were 'accessible only to those who possess[ed] practical or theoretical mastery of a refined code, of successive codes, and of the code of these codes'.[7] This ensured that while the elite BFI publications could endorse popular cinema, they described commercial film in a language alien to the presumed audience for pop musicals yet perfect for discerning cineastes.

The fan-orientated publications always had to recognise the commercial imperative not to alienate their presumed readership. The values adopted by the music press and film magazines complemented the critical approach adopted by elite commentators. Given that the esoteric tone of the elite film publications appealed to the minority of film viewers interested in the cinema as an art form, the fan magazines and newspapers produced information intended to

appeal to the interests of teenagers. Inevitably this ensured that popular publications concentrated upon the aspects best suited to maintaining and expanding their positions within the market place. The likes of *Photoplay* and *NME* concentrated upon gossip, star profiles, interviews and plot details because they believed that such information provided teenage fans with what they wanted. This might have reduced the level of critical analysis in certain reviews and interviews, but they presumed that their readers did not desire detailed consideration of direction, editing and script writing. To negatively judge publications such as *NME* as uncritical in comparison to *Sight and Sound* is fundamentally misguided. This project suggests that these two enterprises operated within different fields of production and appealed to greatly contrasting readership interests. *NME* adopted a more populist critical stance than *Sight and Sound* because the cultural values and demands of the paper's readership necessitated this position.

The rock movies of the 1950s and 1960s represent not only a now lost innocence, but also an insight into youth culture at the time of its greatest ever transition. With the advent of the teenage revolution of the mid-1950s, youth culture changed the world forever. Elvis Presley and the Beatles remain among the definitive cultural icons of the twentieth century while, regardless of his unfashionable status, Cliff Richard has proved a British celebrity of great durability for nearly fifty years. Whatever their faults as works of cinema, films such as *Beat Girl*, *Expresso Bongo*, *King Creole*, *Loving You* and *A Hard Day's Night* remain satisfying and unpretentious documents of their era that compare favourably to movies more prestigious at the time. Despite its very mid-1960s feel, *Catch Us If You Can* today seems much more vital and contemporary than *Georgy Girl*, which not only shared the same scriptwriter, Peter Nichols, but also gathered Academy Award nominations. That 1950s and 1960s rock movies and their stars are now recognised as subjects for academic study and beloved by cult movie enthusiasts confirms their position as richly diverse, enjoyable and entertaining works of popular cinema.

Notes

1 B. Neaverson, *The Beatles' Movies* (London: Cassell, 1997) p. 120.
2 R. Agananian, '"Nothing Like Any Previous Musical, British or American": The Beatles' Film *A Hard Day's Night*', in A. Aldgate, J. Chapman

and A. Marwick (eds), *Windows on the Sixties: Exploring Key Texts of Media and Culture* (London: I. B. Tauris, 2000), p. 110; K. J. Donnelly, *Pop Music in British Cinema* (London: BFI Publications, 2001), p. 243.

3 'Pop Gear', *Monthly Film Bulletin* 32: 375 (April 1965), p. 58.

4 C. MacInnes, 'Pop Music and Teenagers', *Twentieth Century* (February 1958), reprinted in H. Kureishi and J. Savage (eds), *The Faber Book of Pop* (London: Faber and Faber, 1995), p. 197.

5 J. Staiger, *Interpreting Films: Studies in the Historical Reception of American Cinema* (Princeton: Princeton University Press, 1992), p. 48.

6 P. Bourdieu, *Distinction: A Social Critique of the Judgement of Taste*, trans. R. Nice (London: Routledge, 1984), p. 52.

7 Bourdieu, *The Field of Cultural Production: Essays on Art and Literature*, ed. R. Johnson (Cambridge: Polity Press, 1993), p. 120.

Filmography

April Love (Henry Levin, 1957, US)
Beach Blanket Bingo (William Asher, 1965, US)
Beach Party (William Asher, 1963, US)
Beat Girl (Edmond T. Greville, 1959, UK)
Blackboard Jungle (Richard Brooks, 1955, US)
Blow Up (Michelangelo Antonioni, 1966, UK/It.)
Blue Hawaii (Norman Taurog, 1961, US)
Catch Us If You Can (John Boorman, 1965, UK)
Don't Look Back (D. A. Pennebaker, 1967, US)
Dragstrip Girl (Edward L. Cahn, 1957, US)
The Duke Wore Jeans (Gerald Thomas, 1958, UK)
East of Eden (Elia Kazan, 1955, US)
Every Day's A Holiday (James Hill, 1964, UK)
Expresso Bongo (Val Guest, 1959, UK)
Flaming Star (Don Siegel, 1960, US)
Follow That Dream (Gordon Douglas, 1962, US)
Fun in Acapulco (Richard Thorpe, 1963, US)
Giant (George Stevens, 1956, US)
G I Blues (Norman Taurog, 1960, US)
The Girl Can't Help It (Frank Tashlin, 1956, US)
Girl Happy (Boris Segal, 1965, US)
Girls! Girls! Girls! (Norman Taurog, 1962, US)
The Golden Disc (Don Sharp, 1958, UK)
The Graduate (Mike Nichols, 1967, US)
A Hard Day's Night (Richard Lester, 1964, UK)
Head (Bob Rafelson, 1968, US)
Help! (Richard Lester, 1965, UK)
Hound Dog Man (Don Siegel, 1959, US)
I Was a Teenage Werewolf (Gene Fowler Jr., 1957, US)
It's Great to be Young (Cyril Frankel, 1956, UK)
I've Gotta Horse (Kenneth Hume, 1965, UK)

Jailhouse Rock (Richard Thorpe, 1957, US)
King Creole (Michael Curtiz, 1958, US)
Love Me Tender (Robert D. Webb, 1956, US)
Loving You (Hal Kanter, 1957, US)
Mix Me A Person (Leslie Norman, 1962, UK)
Muscle Beach Party (William Asher, 1964, US)
Performance (Donald Cammell and Nicholas Roeg, 1970, UK)
Play It Cool (Michael Winner, 1962, UK)
Rebel Without a Cause (Nicholas Ray, 1955, US)
Rock, Rock, Rock (Will Price, 1956, US)
Rock All Night (Roger Corman, 1957, US)
Saturday Night and Sunday Morning (Karel Reisz, 1960, UK)
Shake, Rattle and Rock (Edward L. Cahn, 1956, US)
Spice World: the Movie (Bob Spiers, 1997, UK)
Summer Holiday (Peter Yates, 1962, UK)
The System (Michael Winner, 1964, UK)
Three Hats For Lisa (Sidney Hayers, 1965, UK)
Viva Las Vegas (George Sidney, 1964, US)
West Side Story (Jerome Robbins and Robert Wise, 1961, US)
What a Crazy World (Michael Carreras, 1963, UK)
Wild in the Country (Philip Dunne, 1961, US)
Wonderful Life (Sidney J. Furie, 1964, UK)
The Young Ones (Sidney J. Furie, 1961, UK)

Bibliography

Please note that individual articles published between 1955 and 1966 from the following periodicals are cited at the end of each chapter: *Films and Filming, Melody Maker, Mersey Beat, Monthly Film Bulletin, Music Echo, New Musical Express, Photoplay, Picture Show, Picturegoer, Record Mail* and *Sight and Sound*.

Abrams, M., *The Teenage Consumer* (London: London Press Exchange, 1959).

Abrams, M., *Teenage Consumer Spending in 1959* (London: London Press Exchange, 1961).

Aldgate A., J. Chapman and A. Marwick (eds), *Windows on the Sixties: Exploring Key Texts of Media and Culture* (London: I. B. Tauris, 2000).

Altman, R., *The American Film Musical* (London: BFI Publishing, 1989).

Altman, R., *Film/Genre* (London: BFI Publishing, 1999).

Anon., *Picture Show – All Star Special 1961* (London: Fleetway Publications Ltd., 1960).

Anon., *Valentine Pop Special* (London: The Amalgamated Press, 1959).

Anon., *Boyfriend 63 Book* (London: City Magazines, 1962).

Anon., *Boyfriend 64 Book* (London: City Magazines, 1963).

Anon., *Boyfriend 65 Book* (London: City Magazines, 1964).

Anon., *Star T.V. & Film Annual 1966* (London: Odhams, 1965).

Baker, B., 'Picturegoes', *Sight and Sound* 54: 3 (Summer 1985), pp. 206–9.

Bakhatin, M., *Rabelais and His World*, trans Hélène Iswolsky (Blooming- ton: Indiana University Press, 1984).

Barker, M., *A Haunt of Fears: The Strange History of the British Horror Comics Campaign* (London: Pluto Press, 1984).

Bennett, T. and J. Woollacott, *Bond and Beyond: The Political Career of a Popular Hero* (New York: Methuen, 1987).

Bogdanor, V. and R. Skidelsky, *The Age of Affluence 1951–1964* (London: Macmillan, 1970).

Booker, C., *The Neophiliacs: A Study of the Revolution in English Life in the*

Fifties and Sixties (London: Fontana, 1969).

Boone, P., *'Twixt Twelve and Twenty* (Kingswood, Surrey: The World's Work, 1959).

Bourdieu, P., *Distinction: A Social Critique of the Judgement of Taste,* trans. R. Nice (London: Routledge, 1984).

Bourdieu, P., *The Field of Cultural Production: Essays on Art and Literature*, edited and introduced by R. Johnson (Cambridge: Polity Press, 1993).

Bradley, D., *Understanding Rock'n'Roll: Popular Music in Britain* (Milton Keynes: Open University Press, 1992).

Braun, E., *The Elvis Film Encyclopedia* (Woodstock: The Overlook Press, 1997).

Braun, M., *'Love Me Do!' – The Beatles' Progress* (London: Penguin, 1995 [1964]).

Calhoun, C., E. LiPuma, and M. Postone (eds), *Bourdieu: Critical Perspectives* (Cambridge: Polity Press, 1993).

Chambers, I., *Urban Rhythms: Pop Music and Popular Culture* (London: Macmillan, 1985).

Ciment, M., *John Boorman*, trans. G. Adair (London: Faber and Faber, 1986).

Clarke, D., *The Rise and Fall of Popular Music* (London: Penguin, 1995).

Clarke, P., *Hope and Glory: Britain 1900–1990* (London: Penguin, 1996).

Clayson, A., *Beat Merchants: The Origins, History, Impact and Rock Legacy of the 1960s British Pop Groups* (London: Blandford, 1995).

Cohn, N., *Awopbopaloobop Alopbamboom: Pop From the Beginning* (London: Minerva, 1996 [1969]).

Cook, P. and M. Bernink (eds), *The Cinema Book – 2nd Edition* (London: BFI Publishing, 1999).

Corner, J. (ed.), *Popular Television in Britain: Studies in Cultural History* (London: BFI Publishing, 1991).

Crenshaw, M., *Hollywood Rock: A Guide to Rock'n'Roll in the Movies*, ed. T. Mico (London: Plexus, 1994).

Davis, J., *Youth and the Condition of Britain: Images of Adolescent Conflict* (London: Athlone Press, 1990).

Doherty, T., *Teenagers and Teenpics: The Juvenilization of American Movies in the 1950s* (Boston: Unwin Hyman, 1988).

Doherty, T., *Teenagers and Teenpics: The Juvenilization of American Movies in the 1950s* (Philadelphia: Temple University Press, 2002).

Donnelly, K. J., 'The Perpetual Busman's Holiday: Sir Cliff Richard and British Pop Musicals', *Journal of Popular Film and Television* 25:4 (Winter 1988), pp. 146–53.

Donnelly, K. J., *Pop Music in British Cinema* (London: BFI Publishing, 2001).

Doss, E. L., *Elvis Cultures* (Lawrence, Kansas: University of Kansas Press, 1999)

Dyer, R., *Heavenly Bodies: Film Stars and Society* (London: Macmillan/BFI Publishing, 1987).

Dyer, R., *Stars*, with a supplementary chapter by P. McDonald (London: BFI Publishing, 1998).

Ehrenstein, D. and B. Reed, *Rock on Film* (London: Virgin Books, 1982).

Epstein, B., *A Cellarful of Noise* (London: New English Library, 1981 [1964]).

Feuer, J., *The Hollywood Musical* (London: Macmillan/BFI Publishing, 1992).

Fishman, J. (ed.), *The Official Radio Luxembourg Book of Stars No. 2* (London: World Distributors Ltd., 1963).

Frith, S., *Sound Effects: Youth, Leisure and the Politics of Rock'n'Roll* (London: Constable, 1983).

Frith, S. and H. Horne, *Art Into Pop* (London: Routledge, 1989 [1987]).

Frow, J., *Cultural Studies and Cultural Value* (Oxford: Oxford University Press, 1995).

Fyvel, T. R., *The Insecure Offenders: Rebellious Youth in the Welfare State* (London: Pelican, 1963).

Gelder, K. and S. Thornton (eds), *The Subcultures Reader* (London: Routledge, 1997).

Gorman, P., *In Their Own Write: Adventures in the Music Press* (London: Sanctuary Publishing, 2001).

Gramsci, A., *Selections from the Prison Notebooks,* ed. and trans. Q. Hoare and G. Nowell-Smith (London: Lawrence and Wishart, 1971).

Gramsci, A., *Selections From Cultural Writings*, ed. D. Forgacs and G. Nowell-Smith (London: Lawrence and Wishart, 1987).

Grant, B. K., 'The Classic Hollywood Musical and the "Problem" of Rock-'n'Roll', *Journal of Popular Film and Television* 13:4 (1986), pp. 195–205.

Guralnick, P., *Last Train to Memphis: The Rise of Elvis Presley* (London: Abacus, 1994).

Guralnick, P., *Careless Love: The Unmaking of Elvis Presley* (London: Little, Brown, 1999).

Hall, S. and T. Jefferson (eds), *Resistance Through Rituals: Youth Subcultures in Post-War Britain* (London: Hutchinson, 1976).

Hall, S. and P. Whannel., *The Popular Arts* (London: Hutchinson, 1964).

Hand, A. (ed.), *Elvis Special, 1964* (London: World Distributors Ltd., 1963).

Harper, S. and V. Porter, 'Cinema Audience Tastes in 1950s Britain', in A. Kuhn and S. Street (eds), *Journal of Popular British Cinema*, Vol. 2. – Audiences (Trowbridge: Flicks Books, 1999), 66–82.

Hartley, J., *Popular Reality: Journalism, Modernity and Popular Culture* (London: Arnold, 1996).

Hay, J., '"You're Tearing Me Apart!": The Primal Scene of Teen Films', *Cultural Studies* 4:3 (1990), 331–9.

Hebdige, D., *Subculture: The Meaning of Style* (London: Methuen, 1979).

Hebdige, D., *Hiding in the Light* (London: Routledge, 1988).

Higson, A., *Waving the Flag: Constructing a National Cinema in Britain* (Oxford: Clarendon Press, 1995).

Higson, A. (ed.), *Dissolving Views: Key Writings on British Cinema* (London: Cassell, 1996).

Hill, J., *Sex, Class and Realism: British Cinema 1956–1963* (London: BFI Publishing, 1986).

Hoggart, R., *The Uses of Literacy: Aspects of Working-Class Life with Special Reference to Publications and Entertainments* (London: Penguin, 1992 [1957]).

Hollows, J., P. Hutchings and M. Jancovich (eds), *The Film Studies Reader* (London: Arnold, 2000).

Hoskyns, B., *Waiting For the Sun: Strange Days, Weird Scenes and the Sound of Los Angeles* (London: Bloomsbury, 1996).

Houston, P., *The Contemporary Cinema* (London: Pelican, 1963).

Jenkins, H., *Textual Poachers: Television Fans and Participatory Culture* (London: Routledge, 1992).

Jenkinson, P. and A. Warner, *Celluloid Rock: Twenty Years of Movie Rock* (London: Lorrimer, 1974).

Jobey, L. (ed.), *The End of Innocence: Photographs From the Decades that Defined Pop: the 1950s to the 1970s* (Zurich-Berlin-New York: Scalo, 1997).

Johnstone, N., *Melody Maker – History of Twentieth Century Popular Music* (London: Bloomsbury, 1999).

Kael, P., *Kiss Kiss Bang Bang: Film Writings 1965–1967* (London: Arena, 1987 [1970]).

Klinger, B., *Melodrama and Meaning: History, Culture and the Films of Douglas Sirk* (Bloomington: Indiana University Press, 1994).

Kureishi, H. and J. Savage (eds), *The Faber Book of Pop* (London: Faber and Faber, 1995).

Lacey, J., 'Seeing Through Happiness: Hollywood Musicals and the Construction of the American Dream', in A. Kuhn and S. Street (eds), *Journal of Popular British Cinema*, Vol. 2. – Audiences (Trowbridge: Flicks Books, 1999), pp. 54–65.

Landy, M., *British Genres: Cinema and Society, 1930–1960* (Princeton: Princeton University Press, 1991).

Larkin, C. (ed.), *The Virgin Encyclopedia of Fifties Music* (London: Virgin Books, 1997).

Larkin, C. (ed.), *The Virgin Encyclopedia of Sixties Music* (London: Virgin Books, 1997).

Laurie, P., *The Teenage Revolution* (London: Anthony Blond, 1965).

Leslie, P., *Fab – The Anatomy of a Phenomenon* (London: MacGibbon and Kee, 1965).

Lewis, J., *The Road to Romance and Ruin: Teen Films and Youth Culture* (London: Routledge, 1992).

Lewis, L. A. (ed.), *The Adoring Audience: Fan Culture and Popular Media* (London: Routledge, 1992).

MacDonald, I., *Revolution in the Head: The Beatles' Records and the Sixties* (London: 4th Estate, 1994).

MacInnes, C., *Absolute Beginners* (London: Penguin, 1986 [1959]).

Marcus, G., *Dead Elvis: A Chronicle of a Cultural Obsession* (Cambridge, MA: Harvard University Press, 1991).

Marcus, G., *Mystery Train: Images of American in Rock'n'Roll Music* (London: Plume, 4th edition, 1997).

Marsh, D., *Before I Get Old: The Story of the Who* (London: Plexus, 1983).

Marsh, D., *Elvis* (New York: Thunder's Mouth Press, 1992).

Marwick, A., *British Society Since 1945 – 3rd Edition* (London: Penguin, 1996).

Marwick, A., *The Sixties: Cultural Revolution in Britain, France, Italy, and the United States, c.1958–c.1974* (Oxford: Oxford University Press, 1998).

Marx, K., *Selected Writings*, ed. David McLellan (Oxford: Oxford University Press, 1977).

Maschler, T. (ed.), *Declaration* (London: MacGibbon and Kee, 1958).

McCabe, C., *Performance* (London: BFI Publishing, 1998).

McCann, G., *Rebel Males: Clift, Brando and Dean* (London: Hamish Hamilton, 1991).

Melly, G., *Revolt Into Style* (London: Penguin, 1970).

Miles, B., *Paul McCartney – Many Years From Now* (London: Vintage, 1997).

Miller, J., *Almost Grown: The Rise of Rock* (London: William Heinemann, 1999).

Milne, T. (ed.), *The Time Out Film Guide* (London: Penguin, 3rd edition, 1993).

Ministry of Education, *The Youth Service in England and Wales* (The Albemarle Report), Cmnd. 929 (London: HMSO, 1960).

Morris, G., 'Beyond the Beach: Social and Formal Aspects of AIP's *Beach Party* Movies', *Journal of Popular Film and Television* 23:2 (1993), pp. 2–11.

Mundy, J., *Popular Music on Screen: From the Hollywood musical to music video* (Manchester: Manchester University Press, 1999).

Murphy, R., *Sixties British Cinema* (London: BFI Publishing, 1992).

Neale, S., 'Questions of Genre', *Screen* 31:1 (Spring 1990), pp. 45–66.

Neale, S., *Genre and Hollywood* (London: Routledge, 2000).

Neaverson, B., *The Beatles Movies* (London: Cassell, 1997).

O'Brien, K. (ed.), *Guinness Book of British Hit Singles* (London: Guinness Publishing, 1999, 12th edition).

Oldham, A. L., *Stoned* (London: Vintage, 2000).

Oldham, A. L., *2Stoned* (London: Secker and Warburg, 2002).

Oliver, J. (ed.), *Top Numbers' Book of the Stars No. 2* (London: Tolgate Press, 1960).

Osgerby, B., *Youth in Britain Since 1945* (Oxford: Blackwell, 1998).

Ottaway, R. (ed.), *Picturegoer Film Annual 1957–1958* (London: Odhams, 1957).

Ottaway, R. (ed.), *Picturegoer Film Annual 1958–1959* (London: Odhams, 1958).

Perkin, H., *The Rise of Professional Society: England Since 1880* (London: Routledge, 1989).

Powell, D., *The Golden Screen – Fifty Years of Films*, ed. George Perry (London: Headline, 1989).

Rodman, G., *Elvis After Elvis: The Posthumous Career of a Living Legend* (London: Routledge, 1996).

Rogan, J., *Starmakers and Svegalis: The History of British Pop Management* (London: Queen Anne Press, 1988).

Romney, J. and A. Wootton (eds), *Celluloid Jukebox: Popular Music and the Movies Since the 50s* (London: BFI Publishing, 1995).

Ross, A., *No Respect: Intellectuals and Popular Culture* (London: Routledge, 1989).

Savage, J., *Time Travel – From the Sex Pistols to Nirvana: Pop, Media and Sexuality, 1977–96* (London: Vintage, 1996).

Schaefer, E., *'Bold! Daring! Shocking! True!': A History of Exploitation Films* (Durham, NC: Duke University Press, 1999).

Sconce, J., '"Trashing the Academy": Taste, Excess, and an Emerging Politics of Cinematic Style', *Screen* 36:4 (Winter 1995), pp. 371–93.

Stacey, J., *Star Gazing: Hollywood Cinema and Female Spectatorship* (London: Routledge, 1994).

Staiger, J., *Interpreting Films: Studies in the Historical Reception of American Cinema* (Princeton: Princeton University Press, 1992).

Stokes, J., *On Screen Rivals: Cinema and Television in the United States and Britain* (London: Macmillan, 1999).

Stokes, M. and R. Maltby (eds), *Hollywood Spectatorship: Changing Perceptions of Cinema Audiences* (London: BFI Publishing, 2001).

Street, S., *British National Cinema* (London: Routledge, 1997).

Strinati, D. and S. Wagg (eds), *Come on Down? Popular Media Culture in Post-War Britain* (London: Routledge, 1992).

Swann, P., *The Hollywood Feature Film in Postwar Britain* (London: Croon

Helm, 1987).

Turner, S., *Cliff Richard – The Biography* (London: Lion Press, 1994).

Walker, A., *Hollywood England: The British Film Industry in the Sixties* (London: Harrap, 1975).

Warman, E. (ed.), *Preview 1959 – Hollywood-London* (London: Andrew Dakers, 1958).

Warman, E. (ed.), *Preview 1960 – Hollywood-London* (London: Andrew Dakers, 1959).

Warman, E. (ed.), *Preview 1961 – Hollywood-London* (London: Andrew Dakers, 1960).

Webster, D., *Looka Yonder! The Imaginary America of Populist Culture* (London: Routledge/Comedia, 1988).

Wenner, J., *Lennon Remembers: The Rolling Stone Interviews* (London: Penguin, 1975 [1970]).

Wilson, D. (ed.), *Sight and Sound – A Fiftieth Anniversary Selection* (London: Faber and Faber, 1982).

Index